COMMERCIAL
PHOTOGRAPHY
HANDBOOK

*Business Techniques for
Professional Digital Photographers*

Kirk Tuck

Amherst Media, Inc. ∎ Buffalo, NY

This book is dedicated to my patient, indulgent, and loving parents.

View the companion blog to this book at: http://commercialphotographyhandbook-tuck.blogspot.com/
Check out Amherst Media's other blogs at: http://portrait-photographer.blogspot.com/
http://weddingphotographer-amherstmedia.blogspot.com/

Published by:
Amherst Media, Inc.
P.O. Box 586
Buffalo, N.Y. 14226
Fax: 716-874-4508
www.AmherstMedia.com

Publisher: Craig Alesse
Senior Editor/Production Manager: Michelle Perkins
Assistant Editor: Barbara A. Lynch-Johnt
Editorial Assistance provided by: John S. Loder, Carey Maines, and Sally Jarzab.

ISBN-13: 978-1-58428-260-0
Library of Congress Control Number: 2009903888

Printed in Korea.
10 9 8 7 6 5 4 3 2 1

Contents

Preface .5
A Brief History of Commercial Photography6
Distilling the Business of
 Commercial Photography10

1. The Basics .12
The Role of the Client12
Selling Images or Licensing Usage Rights?14
"Best Practices" for Long-Term Profitability . . .17
 Have a Signed Contract17
 Get Model and Property Releases18
 Keep Your Copyright20

2. What's Your Niche?23
Architecture .23
Spotlight: Paul Bardagjy24
Product and Still-Life Photography27
 Food Photography30
Fashion Photography .33
Retail Photography .37
 Wedding Photography38
 Portrait Photography41
Spotlight: Will Van Overbeek44
Advertising Photography47
Will Advertisers Take a Chance on Newcomers? .48
 Jobs on the Photo Shoot48
 Equipment .49
Corporate Photography51
 Encouraging Repeat Business52
 What You'll Need to Deliver53
 Understanding Corporate Culture54
 Equipment .55
 Breaking In .55
Some Axioms for Doing Business55
Where Does Stock Photography Fit In?56

3. Learning the Kind of Photography
 You'd Like to Do .59
Photo School .59
Assisting .60
 Getting the Most Out of the Relationship . . .63
Spotlight: Wyatt McSpadden64
 The Friction Zone69
 Common Sense Stuff70
Professional Organizations71
The American Society of
 Media Photographers71
Professional Photographers of America72

The Karma (Instant and Otherwise) of
 Disparaging Other Photographers96
Nondisclosure Agreements97
Taxes .97

6. Setting Up Your Fledgling Business99
Your Business's Name99
Collecting Sales Tax99
Becoming a Business Entity99
Accounting .100
Getting Right with the IRS100
Ensure that You Are Well Insured102
 Health Insurance102
 General Business Insurance102
 Auto Insurance104
 Disability Insurance104
 Life Insurance .104

7. Pricing What You Sell and License105
The Cost of Doing Business105
Pricing Theory .105
 The Day Rate versus Fee Based Work108
Bids and Estimates109
 Corporate Bids and Estimates110
Getting Paid .112
The Special Case that Drives
 Freelancers Crazy113
You Set the Rules .115
Writing a Contract115

**8. Financial Strategies for Running
 Your Business** .117
Undercapitalization117
Clogged Cash Flow117
More Debt than Assets118
 A Case Study .118
Predictions .121

Epilogue .122
Resources .123
Index .125

4. Marketing .73
Effective Marketing Requires Six Steps74
Mass Marketing versus Targeted Marketing . . .75
Marketing Tools .76
 Internet Marketing76
 Direct Mail .81
 Sourcebooks .83
 Face to Face Meetings85
 Professional Associations86
 Additional Avenues88
Designing Your Marketing Pieces91
Summary .91

5. Ethics and Standards94
Never Give Your Work Away94

Preface

To people outside the industry, commercial photography seems like a fun and carefree business. The image that usually comes to mind is that of a young photographer making great money by taking photographs of some beautiful, scantily clad models on an exotic beach location for a benevolent client who really values creativity. At its core, commercial photography is a service that involves making art for paying clients. The reality for most photographers is more in line with the realities faced by legions of small business owners in every industry, in every sector: How to find clients who will pay enough for specific products and services to make the photographer's business profitable; how to effectively advertise the things that make a business special and different from competitors; and how to make sure that the business (and product) continues to evolve and grow during periods of prosperity and plenty as well as periods of recession and gloom.

The most important of all the parameters listed above is the ability to evolve. In nearly every kind of photography, styles, tastes, and public perceptions change, and for every photographer who masters change, there are a disproportionate number who don't evolve. According to business statistics, only one out of every ten new businesses will survive after five years. And the rules are simple: there are no rules, because no one can predict what the future will hold.

But there are general principles and steps you can take to ensure that your business will be one of the exceptions to the statistics. The first is to make sure that your products (your images and the way you package them) fit the markets in which you are trying to sell them. Second, you must find ways to expose your products to the customers who have the money and the desire to buy them. In order to do that you need to differentiate your offerings from those of your competitors and be able to couch the differentiators as benefits and advantages for your intended customers. Finally, you have to make good financial decisions and understand the real value of your work to clients in order to maximize your profits and minimize your overall expenses.

If you master these things, you'll have a fighting chance to be one of the 10 percent of businesses who will still have the lights on and the credit card processing terminal humming half a decade from now.

I'm assuming that, since you bought this book, you are diligently focused on being one of the exceptions to the rule. In the upcoming chapters, we'll focus on what kind of photography you'd like to pursue; how to find your niche; whether or not to attend a photo school; how to negotiate, estimate, and charge for your work; and how to market. We'll also cover the ground rules and ethics of being a photographer, why you should join a professional organization, and a bunch of real world stuff that I have lived through as a photographer for over twenty years.

Who am I, and why should you listen to me? I am a photographer who specializes in corporate photography and advertising, and I have been doing this work for several decades. From the economic disasters of 1987 and 1992, to the wholesale shutdown of the economy following the events of 9/11/2001, I have been able to stay in business during the worst periods and have been able to prosper during the happier periods. At the same time, I've watched many of my peers, friends, and competitors leave the business because of economic issues. I believe that my longevity and relative prosperity during these years are the re-

sults of hard work, good marketing, and planning for a rainy day. I've tried to distill the things I've learned about the photography business into this book so that you don't have to reinvent the wheel in your own business. The bottom line is that a successful photography business is all about the business. Remember, it's not a business unless you figure out how to consistently get paid for the products and services you want to offer!

There are many good resources available to photographers who need specific information about contracts and forms, business structures, and accounting. In the resources section of this book I'll point you toward all the technical information you'll need to set up and run your business. This book will concentrate on presenting an overview of the industry, coupled with real world experiences.

▶ A Brief History of Commercial Photography

Since photography was invented there have been "starving artists" and very successful "entrepreneurs." The starving artists thought along the lines of Kevin Costner's character in the movie *Field of Dreams*,

where he remarks, "Build it and they will come!" In the movies that may work out well, but in the real world things are a little different. The spoils have always gone to the photographers who have built it, advertised it, sold it, and reinvented it. Shoot it and they will come only if you've built up your brand, primed the market, showed consumers how to find and buy your work, and have created a compelling desire for your images.

The earliest commercial photographers were those who mastered the nascent technology of the Daguerrotype (one of the earliest forms of photography) and sold them to a ready market of middle-class people who could not afford to have a painting of themselves or their loved ones done. There was a pent-up demand for portraits and, in the era beginning in the 1850s and extending to the 1890s, many people learned the difficult craft and opened studios or traveled around the country making portraits. Many made small fortunes, and others lost money. Most of the practitioners eventually died from the mercury poisoning they were exposed to while coating the small silver plates that would serve as the finished art in their practices.

An interesting complication of the early years of commercial photography is that there was no way to duplicate a Daguerrotype. If a client wanted two pictures of himself or his loved ones, they needed to be created, one at a time, in the camera. This made each photograph a very limited edition, one of a kind. This made each plate more valuable, but it also limited any future income that a photographer could derive from each assignment.

Toward the end of the 1800s several processes were introduced that allowed for the duplication of images by contact printing. This allowed photographers to create multiple editions of albums that could be sold to collectors. One of the most famous examples of this expansion of enterprise can be found in the success of the *Sketchbooks of the Civil War*—handmade albums filled with original images—by American photographer Mathew Brady.

Left—Daguerrotype from the mid 19th century.

Left—An early twentieth-century paper print. **Right**—Early photographer, circa 1900, with a plate camera. From the author's private collection.

Brady and his crew took tremendous risks documenting the American Civil War and photographed several of its famous battles. The resulting photographs were packaged as albums and sold to collectors. The ability to duplicate the images and sell the albums to many buyers was the key to Brady's profitability. The ability to duplicate, reprint, and resell (or relicense) images continues to be the secret to profitability today.

Though books and magazines were being produced in the time period, no one had mastered the technologies of half-tone printing that would enable the large-scale reproduction of photographs within them.

The invention that led to the widespread growth of the photographic industry was the flexible film created by the Eastman Kodak company. Until their introduction of dried silver gelatin film, delivered on an acetate base (in the 1890s), films consisted of glass plates of various sizes that had to be wet-coated in the dark right before they were exposed in the camera. It required incredible patience and technical ability. It also required a horse-drawn wagon, as the glass plates were very heavy and delicate. The introduction of packaged film meant that, for the first time, photographers could go out without chemistry sets and sheets of glass and make images that could be developed hours or days later. This is the point at which photography, both as a hobby and a profession, began to take off. Kodak's new inventions lowered the technical barriers to entry, motivating many to take up photography professionally.

In the early part of the twentieth century, the know-how to create black & white photographs in magazines printed on presses was finally worked out. This led to a great demand for news, advertising, and

Top—Late nineteenth-century paper print made by contact printing. **Bottom**—Late nintenth-century paper print portrait.

documentary photographs. For the first time in history a photograph could be disseminated rapidly to millions of readers.

Even with the advent of better films and equipment, photography required a fair amount of technical skill and know-how right up through the 1960s. A well-rounded photographer working as a generalist in a major regional market might shoot a wide assortment of assignments during a typical week, including lots of portraits for families and for business use, prod-

ucts and buildings for businesses, and images for use in ads. Most commercial images were shot on 4x5 view cameras using black & white film since the most prevalent use was inclusion in black & white newspapers. Before 1960, only national ads and editorial work were typically published in color.

A commercial photographer in a medium-sized market needed to know how to use a view camera, light with "hot lights," expose film without the benefit of Polaroid tests or digital flash meters, develop film in his own lab, and make black & white prints destined for various media in his own darkroom.

Commercial photographers at the time did not charge a day rate for advertising photography; rather, they charged a fee to produce the photographs and a usage fee that represented the value of the use for that image. In the major markets it was typical for advertising photographers to charge a percentage of the total ad placement budget for their work. As the ad placement budgets grew so too did their fees! It was not unusual for a nationally known advertising photographer to earn upwards of $10,000 for a single ad photograph by the end of the 1960s. Adjusted for inflation that would be over $100,000 in 2009 dollars.

Editorial photographers charged for their work in a different way. They were guaranteed a "day rate" for each day on which they shot stories on assignment. This was a guarantee against a space rate. They were paid a certain amount for each photograph used in the final story, and these rates were based on the size of the image in the final magazine layout. In this way the photographers whose talent shone brightest were rewarded in direct proportion to their skills. If a story was killed, they were still paid their day rate—their guarantee.

From the 1970s till the dawn of digital photography, commercial and editorial photographers worked consistently and profitably because, even though films got better and better, development more consistent, and testing methods more foolproof, photography still required a broad range of technical skills and large investments in cameras and lighting equipment. These were sufficient barriers to entry to ensure that the

middle and higher levels of the market were protected from the encroachment of casual hobbyists and rank amateurs. As corporations grew dramatically, so did their global reach and their budgets. During the last thirty years of the twentieth century, the American economy was largely strong, robust, and growing, and commercial photography went along for the ride.

During this time, the tools became more refined, and reproduction in major glossy magazines was much improved. By the middle of the 1990s, most pros were shooting with medium format cameras and banks of very consistent and well-engineered studio electronic flash equipment in order to take full advantage of the improvements in the media. Most worked in their own studios. Even though there were ups and downs in the economy, the overall market for most commercial photographers was positive. Then the paradigm shifted.

The advent of readily available digital cameras and low-cost computers seemed to change the whole market. The apparent quality of digital files and the ease of their production almost immediately decimated the bottom end of the commercial markets starting in 2000 as businesses realized that a lot of their advertising and communications materials and messages were moving to the Internet. The files needed for good reproduction at small sizes on the Web could be of much lower quality than the images required for high quality, four-color press printing. Now a business could produce its own photographs, inexpensively, in-house.

Basic ID head shots, photographs of houses for sale, simple product shots, and more moved from a practice that nurtured entry-level photographers to extinction. Another consequence of the amazingly rapid acceptance of digital cameras by businesses and consumers was the launch of the "dollar stock" digi-

tal stock industry. Prior to the digital revolution, stock agencies held and maintained huge physical libraries of color slides and larger transparency films. Requests for images would come from clients who would pay for both the research to find the right picture and the FedEx charges for shipping the images. Fees were based on usage and could range from hundreds of dollars to tens of thousands of dollars for a single use.

With the price drop for Internet bandwidth, digital storage, and automated administration, the market was "disrupted" by the appearance and rapid growth of royalty-free, cheap stock. Now the clients could do their own online searches for images, retrieve the images as a web download, and pay the very low fees with a credit card at the end of the transaction. Not only has this change roiled the waters for commercial photographers, but the very agencies that engineered the original web-based stock photography market, Corbis and Getty Images, are quickly being eaten by their own offspring.

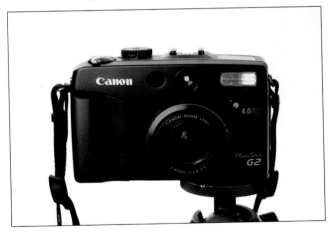

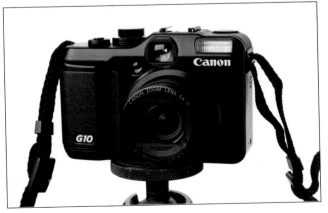

Top—The Canon G2 was one of the early digital cameras that created files which competed with 35mm film. It was in the vanguard of inexpensive cameras that started to erode the professional market's "barriers to entry." **Bottom**—The new Canon G10, with a hot shoe, 15 megapixels of resolution, and very detailed files further blurs the distinction between professional and amateur cameras.

With the supporting foundations of entry-level photography decimated, and with clients moving their marketing predominately to the Web, many are wondering whether photography as a profession will disappear entirely to be replaced by an amalgam of part-time practitioners, cheap stock, and homemade content. Reading all of this you're probably wondering if entering the field is somewhat financially suicidal. I contend that though the markets have changed, much of what we're experiencing is cyclical (amateurs will realize the work that goes into creating a really great image and find new hobbies, while corporations will seek differentiation by going back to great production values), but even the parts of the market that will never cycle back have evolved into new markets that savvy imagemakers can move into and profit from.

So, what does the market look like today? The dollar is at an all-time low. The bank industry is on the brink of failure. Record home foreclosures are the "top of the fold" newspaper headlines. At this writing, inflation is at its worst in twenty-nine years. The short-term prognosis from the federal government is grim. And amateur photographers are crowding into the market and begging to work for free!

So, what does a commercial photographer do when confronted with all this bad news? Well, I'll remember that the economy is much more "granular" than ever before, which means some industries are getting clobbered, while others are growing. I'll spend some time this week looking for alternative energy clients—companies producing technology and products for wind or photovoltaic power. I'll do some research to find out which markets are strong and which ones fit with my strengths. I'll remember that most of my competitors will buy into the "doom and gloom" and become paralyzed by the bad news, so I'll try to buy market share by increasing my advertising efforts and my public profile. I'll keep a close eye on what's new in the market and keep learning about new products and services to offer to my prospective and current clients, and I'll market my traditional strengths. In a nutshell, I'll follow the advice in this book while always remembering that the markets are cyclical and that the gloom and doom will be replaced by new prosperity, given time. Hopefully you will do the same. But let's be frank. If you are "risk averse," need a guaranteed monthly source of income, and become anxious when confronted with ambiguity, you'll need to put this book back on the shelf and reconsider your career path. Because, going forward, there are no guarantees.

▶ **Distilling the Business of Commercial Photography**

Much as we would like to believe that we are different because we are "artists," the business of commercial photography is a service industry that, at its core, involves producing creative content for clients who pay to use that content for communications, advertising, and decoration. You may produce like Picasso, but in the end you'll want to emulate a real estate investor who specializes in renting properties. Because in the real estate market the people who make money reliably are the ones who build or buy good rental properties and lease out the use of these rental properties, year after year—always at a profit. If you sell the house, you make a one-time profit. If you lease the house, you make a profit year after year, and at the end of your career you have a portfolio full of appreciating properties (assets).

Photographers can and should apply the same model to their businesses. They should get paid to create an image (which the photographer owns) and then license that image for additional fees for specific uses and specific lengths of time. Any additional uses or extensions of time should be paid for just like the rental of a house. Before you roll your eyes and assume that clients will demand ownership of all the images and all the rights, be aware that the above description is just the way the bulk of the advertising photography market has worked for decades and decades. If you need analogies and examples from other industries you need look no further than a good ole American business called Microsoft. You've probably never read all the lines in the contract that you "clicked through" when you loaded their software, but you don't own

Right—A simple food photograph, well executed, has the potential to be sold over and over again as stock. This image was shot in 1992 and has been sold many times since. If I had signed away all rights I would have gotten a one-time fee that would have been a fraction of its real value! (Shot on 4x5 inch color transparency film.)

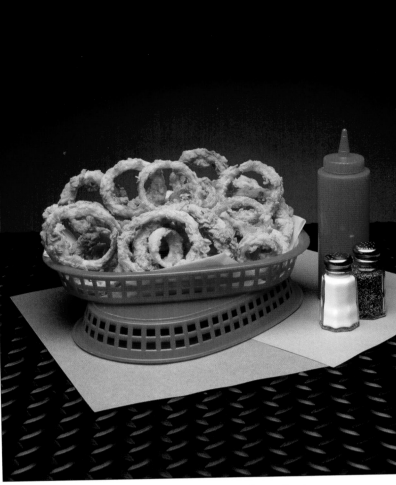

their software! You have been licensed the right to use the software on your personal machine only. It is illegal to share it or even load it on another machine concurrently (unless you buy additional licenses). This is the model that most truly successful photographers have adapted.

Advertising photographers and their peers, the highly successful wedding photographers, don't sell their images to clients. They license specific rights while keeping the copyright. Their images are their intellectual property.

The most important question you need to ask yourself before you accept one more job is, "Am I in this for the long term?"

If you are, you need to look carefully at all the presumptions you've made up to this point. If you are young and have very little overhead, you may have convinced yourself that you'll be able to build a successful business by undercutting the other photographers in your geographical area or your area of specialization. You are wrong. Pricing for the short term will be hazardous to your long-term business health.

Done properly, a photographer's business should be able to provide a solid middle-class standard of living. You deserve a decent house, a reliable car, health insurance, vacations, and all the other things that make life comfortable. Note that when you undercut the market you create a new "lowest common denominator" for your area, which you will spend the rest of your career fighting against as your lifestyle changes and your needs expand.

Eventually, the fees that sustained a single person crashing on their best friend's couch, while processing images with "borrowed" software, will begin to feel constricting once you've acquired a mortgage, a family, and kids who want to go to college and need

new shoes. Eventually you will be physically and spiritually incapable of increasing the sheer number of hours you'd need to work to make your old fee structure stretch to cover your new needs.

The goal is not to make some money from selling your photography but to make lots of money licensing your images again and again. Every client has a potential use for your images. Your bill to your client should closely match the value of the image's final use.

An old adage among doctors and other professionals is "Charge for what you know, not for what you do." Don't look at the time you spend on a project; look at the value you bring to the project. Understand what the inclusion of your photo into a project brings to the table.

1. The Basics

▶ **The Role of the Client**

For years, I've heard photographers and advertising people joke that these industries would be a lot more fun and effective if only they could get rid of the clients. What they are really saying is that the client's demands can impinge on the creative impulses of image makers and content creators. It's true. There is always friction between the goal of photographers (to have fun taking really creative images) and the client's goal (to cost effectively acquire images that reliably help to sell product).

Many in the creative industries routinely couch the relationship between clients and themselves as an ad-

versarial one. They describe their negotiations as heated battles where each side attempts to conquer the other. Some photographers even seem convinced that clients are out to squelch their creative output and force photographers to create staid and boring work instead. They go so far as to believe that clients are acting against them because they are jealous that they are not in a "creative" industry like ours.

So, what does this adversarial point of view buy you? Generally ulcers, migraines, early death, and little else. I hate to be the one to tell you this, but clients are the most important single thing in your whole business. Your customers are more important than the latest cameras and lenses and much more important than that brewing debate about lighting styles on your favorite blog. They are even more important than the overall economy. They are your sole financial resource. They make everything you eventually do in your business possible.

If you step back and think of your clients as business partners, research their industries, and try to put your feet in their shoes, you'll come to realize that they are really seeking a collaboration or a blending of their skills and insights with yours to achieve a successful outcome for their business goals: maximum profit. When you drop the adversarial approach and become a truly integrated part of their team (whether in editorial, advertising, or weddings) you'll be in a position to better sell your creative ideas, maximize your budget, and build the kind of long-term relationships that create a good framework for consis-

Left—If food service is an industry you serve, you'll want to subscribe to their trade publications to stay knowledgeable. Knowledge is profit.

tently getting assignments and making real money from them.

Here are the four most important things I do to build my relationship with clients:

1. Understand their industry and their position within that industry. Read everything available about your client's business, from the mission statement on their web site to the last page of their annual report, and from the current news in the *Wall Street Journal* to the blogs that flame the company. You should also know what their competitor's photography and use of advertising looks like. You'll have a better understanding of what kinds of budgets are reasonable and even when their business is going (hopefully temporarily) into the toilet, prompting you to get busy building relationships in other industries.

2. Build my relationship with the person I collaborate with. This can be as simple as sending interesting articles about intersections between our industries (articles in *Photo District News* or *Advertising Age*), clipping newspaper comics that are relevant to their industries, or pointing them to interesting webcasts. It can escalate to monthly lunches where you meet and discuss big issues, present fun new work, and generally get to know your client as an individual. Anthropological research has shown time and time again that sharing food creates bonds between humans. The more bonds you can build with your clients, the better you'll understand their needs and the more disposed they will be to award you work. This can be especially important with clients who are constrained by their companies to solicit competitive bids. In a surprising number of cases you will build genuine friendships that will last over the long course of your career. Constantly remind yourself that it's far easier to nurture an existing relationship than it is to "beat the pavement" looking for new work.

3. Go into every negotiation looking for ways to sell your vision or style without alienating those you should be collaborating with. In my mind this means accommodating the other person's point of view. If you feel you are always right or that you always have the best solution for every project, you need to take a few moments to consider that you may be wrong! In the past, I would have vehemently argued my position in many instances. I have since learned to listen first for all the details. When I do that I realize that I sometimes argue from a position of "ego." If I have all the facts, I can more clearly see my client's point of view and we can then work together to create a collaborative work that effectively combines the best of both our skills. I have a little note attached to my computer. It has helped me retain many clients over the years and has helped me to generate more profits. The note just says, "What if the other guy is right?"

4. If you become a "commodity," you're dead meat. The most important single thing you need to get across to your clients is that you bring a unique vision and a unique set of attributes to your projects. If you compete just on price and you offer the same styles and types of images as everyone else, your potential clients will be inclined to look at all photographers as commodities. When a product or service becomes a commodity (an interchangeable product like wheat or machine screws) the clients immediately reduce the parameters of their selection process to price. Competing on price alone means that your business has entered a "death spiral" from which it is hard to escape. You must have powerful differentiators that add value to your photography for clients. Only then will you succeed financially.

Learn right now to befriend, nurture, and educate your clients and you'll find that they do the same for you by smoothing your working process within their company and by connecting you with people in their social and business networks who can offer you additional work. You might even make some nice friends.

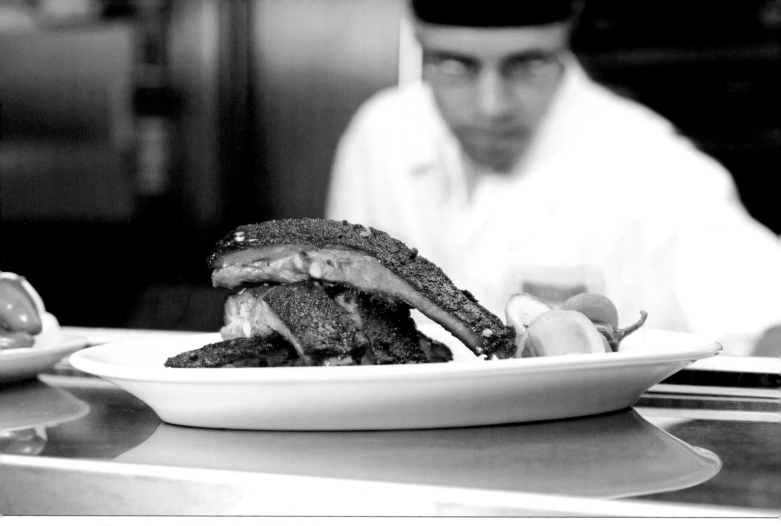

Above—*A wonderful stack of BBQ ribs from Austin restaurant, Lamberts. Shot for a story on BBQ that ran in* Tribeza *magazine. Editorial photography provides the opportunity to try new creative approaches. This was done with two off-camera, battery-powered flashes.*

▶ Selling Images or Licensing Usage Rights?

Pity the portrait photographer who creates nice portraits and then gives the clients a disc of images and instructions on how to have them printed at Sam's Club, Costco, or Walgreen's. He's left the majority of his potential money "on the table." Also, pity the commercial photographer who delivers a disc of images to his business client and then signs a "work for hire" agreement and waits for his check. He's left the lion's share of his images' value on the table as well.

No matter what part of the business you decide to go into, the most important single business decision you can make is whether you will give away all your rights for a meager, one-time payment or whether you will keep control over the content that you create and license each client just the usage rights that they need—at a rate that reflects the value of those images in your client's context.

This is the difference between a "blue collar" photographer who works for an hourly rate and a "white collar" photographer who runs a company which makes a profit. Given the choice, we'd all rather be owners. Given the choice, we'd all rather create a product one time and sell it over and over again.

Take the example of the wedding photographer. His choices are much like the difference between an all-you-can-eat buffet restaurant and a fine dining establishment. In the first restaurant your customers pay a fixed price at the door and then pile their plates high. Every return through the buffet line is money down the drain for you. When you consider that most all-you-can-eat restaurants exist near the bottom of the

restaurant food chain and that their profit margins are painfully thin, you can see that this pricing model can be quite precarious. The only things you can do to increase your profits are to cut back on the quality of your product or increase the number of "average consumption" clients you deal with. You'll always fear the school bus full of football players who will consume huge amounts while paying the same one-time fee.

At the other extreme is the fine dining restaurant where everything is presented à la carte. Each product is priced separately. Each product comes with its own profit margin. Sell the well-priced bottle of water and you make a profit (there is undoubtedly more profit in the $6.00 bottle of sparkling water than in the entire buffet meal!); sell a bottle of great red wine and you'll make a really nice profit. At each point in the dinner experience the fine dining restaurant has the potential to increase sales and generate profit. So, what's the trade-off? Easy. The fine dining restaurant has to consistently make a much more compelling creative product, and it has to communicate the extra value of the creative product to the correct target market of consumers. The easiest way to stay in business? Attract highly affluent clients who crave a unique and creative approach to the product or service in question and allow them to add more and more products to create more and more profit. It is exactly the same in photography.

Motivated consumers consistently say that price isn't the first thing on their radar when picking a desired product or service. The top of the list for products is design, followed by features. The top of the list for creative services like photography is style followed by how people emotionally position the photographer's brand image in their own minds.

Design and features are the reasons people paid a premium for products such as iPhones and iPods from Apple. Style and reputation are the reasons people flock to wedding photographers like Denis Reggie and Hanson Fong. Consumers want, and are willing to pay for, the styles they like. Once you market based on just about anything else, like price, you become a commodity. When you become a commodity the con-

Below—This image series was used in print ads and mailers for a high-end lakefront condominium project. The creative director and I scouted the project beforehand and planned each shot in detail. Developers depend on great photography to help sell multimillion-dollar properties.

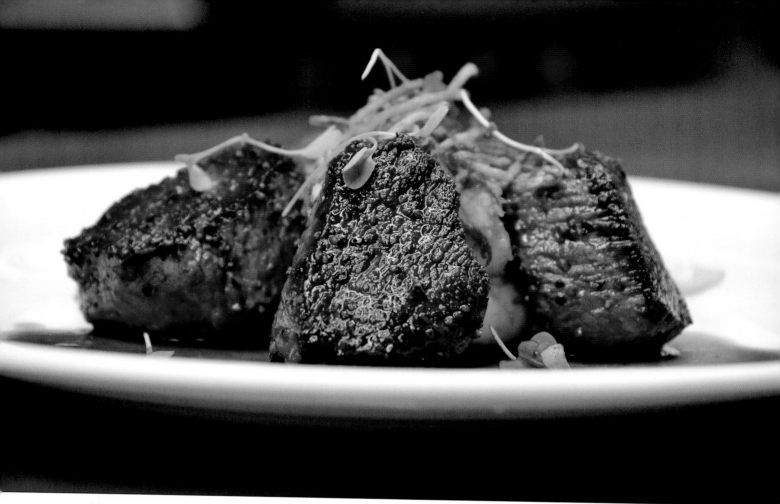

Above—*Medallions of beef, prepared at Sicola's Private Dining in Austin, TX. Getting good food shots during regular dinner service requires making quick decisions as well as an ability to previsualize the effects of your lighting.*

sumer has the luxury of shopping for the lowest price. When you charge the lowest price you'll make a few dollars for a hard day's work at the bottom of the market rather than the tens of thousands of dollars that can be and are made at the top.

The successful wedding photographer charges a fee for the creation of his images and extra fees for the various uses of his images. An album filled with photographs commands a certain price. Prints command an additional price. The same images can be sold over and over again to guests and families online via Pictage, Photo Reflect, or Smugmug. Over time the passive income from additional products (usages) can be like the passive income of stock dividends, with fat checks arriving regularly.

I often meet for coffee with a professional portrait photographer. His sitting fees are around the average for our market in Austin, but his print prices (which reflect his Photoshop skills and his skilled use of very high resolution cameras, as well as his social connections and location) are quite a bit higher. His average print sale from a single sitting is around the $3,000 mark. His average sitting lasts an hour or two. He never sells the "golden eggs" (the copyright or the negatives). At the other end of the spectrum is a local photographer who sells his work by taking images with his modest digital camera and then putting JPEGs on a disc. He wants to give the images to the client and never see that pesky client again. His work is not great, his delivery doesn't inspire confidence, and at the end of the portrait sittings his one and only reward is $125. What a difference.

In the advertising business there is a great deal of pressure to sign work-for-hire agreements, which give a client all the photographs you create and an unrestricted right to use them wherever he or she wants,

with no additional payment to you. The client would even have the right to sell the images as stock to anyone in the market. In fact, you could find that you are your biggest competitor as each "all rights" sale floods your own market with cheap images that are just as good as the ones you are trying to charge a higher, one-time fee for! Think philosophically about the ramifications of your business creating content for the business model that makes yours irrelevant!

▶ *"Best Practices" for Long-Term Profitability*

Hopefully, the above examples show you how everyday business decisions can affect the long-term health of your business. For more information about pricing and licensing models you should look at the materials on the subject that are available on the American Society of Media Photographers (ASMP) web site: www.asmp.org. Also, check the books recommended in the resource chapter at the end of this book.

Every industry has a series of "best practices." What this means is that there are tried-and-true approaches that ensure smoother and more efficient ways for companies to do everything from manufacturing and design, to sales and accounting. There are a number of protocols that transcend every industry. Photographers have been generally very lax about utilizing these basic "best practices" and, as a result, are often bitten by the ramifications of their oversights down the road. Most of these should be basic common sense. The problem is that these kinds of best practices are taught in business schools but not in many photography programs. You would learn most of them if you worked as an executive in most industries, but you won't have learned them if you are self-taught—and most photographers are self-taught.

Here are the three best practices as they relate to photography as a business:

Have a Signed Contract. First, always have a signed contract between photographer and client before you start any project. (A contract is not an adversarial document; rather, it is a summary of all the things you covered in your negotiations leading up to being offered a project. It should cover the basics: What is the service you will be delivering? What are

Below—These two images were shot as part of a campaign for the Greater Austin Chamber of Commerce in preparation for a high-tech trade show. The images were used in a multi-panel mailer and also for large display panels.

your client's responsibilities for making the project work? What rights are you licensing? How much will you be paid for your production and for the rights you are licensing? When and how will you be paid? What sort of remedies will each party have if the other party doesn't do what they agreed to? It's the basic who, what, when, and where of journalism adapted to a business agreement.

An addition to the first best practice is to prepare and use "change orders" or "bid modification" forms throughout the project. Every time there is a change to the project (e.g., additional photography, a location change that makes the project more expensive to produce, or the addition of a model or prop), you should whip out a "change order" or "bid modification" form, fill in the blanks as to what has been changed or added to the scope of work specified in the original contract, add an estimate for the additional fees and costs, and have the client sign to grant their approval. These forms need not be complex. In fact, when I worked as a creative director at a regional advertising agency the form we used (we called it a "job modification agreement") consisted of five or six "fill in the blanks" with one short paragraph of legal text and spaces for date and signature.

Contracts are wonderful legal instruments that protect both parties by ensuring that there is an "objective memory" about agreements. In fact, most problems that arise between clients and suppliers have nothing to do with dishonesty or failure to perform; they arise because, by the very nature of most verbal agreements, each party remembers the agreement differently. A good, simple contract keeps everyone on the same page and gives you a reference to return to time and again.

So, with a contract issued, every parameter of the job and the expectations of both parties are spelled out in enough detail to prevent ambiguity, and both parties get a signed copy. You wouldn't buy a used car if the seller was vague about the price or the mileage, so why would you expect a client to hire you if your can't describe what you'll be delivering and at what price?

Get Model and Property Releases. You'd better not license or sell an image without a release.

In the United States, all people have the right to control the use of their own likeness in any and all commercial applications. That means you can't use a person's face or a distinctly recognizable photograph of them without their express, written permission. This guarantees that every noncelebrity has a solid right to privacy. There are exceptions. Editorial uses are exempt from this rule as long as the photograph of a private citizen is taken in a location or setting where "they do not have a reasonable expectation of privacy or are engaged in a newsworthy event." So, here's how to think about whether or not you need a model or property release: If the person is recognizable and you have any intention of selling any usage rights to the photograph, you *must* get a release. If you work for a newspaper, magazine, or other editorial outlet that informs the public, you can use a newsworthy photo in that outlet without a release.

There are exceptions to the editorial exemption. If you take a photograph of someone in a place where they have reasonable expectation of privacy, you might not be able to make the editorial argument stick. Example: A stripper slapping the mayor of your city at a restaurant open to the public is fair game. A stripper in the stall of a bathroom is not fair game!

The basic rule of thumb is always (unless you are covering hard news) to get a model release. A model release can be a simple document like the one on the facing page (you can pick these up in most photography stores), or it can be very complex. Most professional models and actors who are represented by agencies will provide their own releases, which carefully explain what rights are being licensed and for how long. If a model or actor is professionally represented, they will generally refuse to sign any release other than one prepared by their agent. This protects them from unanticipated uses that might damage their careers either by overexposing them or from competing uses. The rationale is as follows: Imagine you book a model who is just starting out, get her to sign an "all rights until the end of time" model release, and pay

MODEL RELEASE

Date _____

For valuable consideration, I hereby irrevocably consent to and authorize the use by you, or anyone authorized by you, of any and all photographs which you have this day taken of me, negative or positive, proofs of which are attached hereto, for any purpose whatsoever, without further compensation to me. All negatives and positives, together with the prints, shall constitute your property, solely and completely.

Model _____
(Signature of the Model)

Address _____ Phone _____

City _____ State _____ Zip _____

Signature of Parent or Guardian _____
(If Model Is A Minor)

Witnessed by _____
(Signature of Witness)

Above—I buy pads of simple model release forms from my local camera store. While they are not as detailed as the examples in ASMP's Professional Business Practices in Photography, they aren't intimidating to nonprofessionals. It's usually easier to get a signature from people with nonthreatening paperwork.

her $20 for her trouble. Down the road she is discovered for the incredible talent that she is, and a large company decides to use her as a spokesperson. A few days before the contract is inked you sell usage rights to images of the same talent to a local gentlemen's club for use in their television advertising. The very conservative large company's marketing director happens to see the commercial and wants to make sure that consumers never confuse their products with the services of the gentlemen's club. Therefore, they pass on the first model and start the search all over again.

I think blanket releases without very healthy financial compensation are morally wrong, though models and photographers use them all the time. I go back to the idea of a creative team being a collaborative model. I like to have models sign releases for specific uses. If new uses arise, I think models and other talent should have the right to share in the results of our collaborative efforts. There are stories of legions of photographers who have paid a token $5 to make a model release binding and have then been able to sell the image usage rights over and over again with no

additional recompense to the models. How can we expect to be treated fairly by the people who license our images if we don't treat our valued collaborators with the same respect? Mine is not a mainstream viewpoint. Most photographers insist on a blanket release.

But whether you agree with me or not about the exploitation of models, you should be certain about one thing: If you ever intend to sell any usages to a photograph with an identifiable person, you must get a signed model release. In the same vein, any identifiable property (house, office, farm, distinct wagon, etc.) used in commercial work must also be similarly released. This applies if you are using a single property as a part of your composition. If you have included the skyline of a city you are okay without a release. If you photograph your neighbor's house as the backdrop for your Calvin Klein underwear ad, make sure you get the signature.

If you feel the need for more detailed model releases (and I would encourage that for large, for-profit jobs), look at the examples in the ASMP's book, *Professional Business Practices in Photography.*

Above—*My favorite designer of all time, Belinda Yarritu, and I were working on a brochure for one of Austin's first luxury, high-rise residential towers, and I had the opportunity to photograph one of the most famous Texans of all time: Former Governor, Ann Richards. She lived just a few blocks from the Whole Foods flagship store and we secured permission to photograph her there shopping.*

Keep Your Copyright. The third holy rule is this: Only sell your copyright or sign a work-for-hire agreement if the client offers you so much money that you might never have to work again. Time and time again in this book I'll discuss the pricing model that has made commercial photographers the most money over the long haul. It is based on the idea, ratified by the U.S. copyright law, that the artist or creator automatically owns all the rights and the copyright to his or her images the instant that they are created. The owner may decide exactly how he or she wants to profit from the products of their brilliant creative work.

The fairest way is to decide what value each use of an image has and to price those uses accordingly. Obviously, a local, one-shop retailer placing an ad in a local newspaper will derive a smaller amount of value than the same ad in a national or international news-

paper or magazine. The retailer might be paying $2,000 for a one-time insertion of his ad in the local rag. A retail chain might spend $20,000,000 to run the same kind of ad in a selected handful of prestigious magazines and newspapers published around the globe. In the first instance, a photograph incorporated into the ad has a value that is some percentage of the local retailer's $2,000 insertion. Without the right photograph the ad will likely be a waste of time and money for the retailer. He has a vested interest in buying the rights to a good enough image to reasonably ensure a good return on his advertising investment. Perhaps he'll license the use of an image from you for 20 percent of his media buy. You'd get $400 for the one-time use of the image. Since it is a local use you would be able to resell the image in noncompeting markets the very next day. The retailer wins because he gets a great image at a reasonable price. You win because you made a reasonable profit for your present use and you've retained the potential for an almost infinite number of reuses.

So the image has an absolute price tag, right? No. Its value is measured in relation to the scope of the usage. In the second example, with the large retail chain advertising internationally, the client expects a reasonable return for their marketing efforts. The

Below—During the 1990s, the semiconductor industry ploughed billions of dollars into infrastructure and liked to show it off. My assistant adds a human element to an image of one of Motorola's advanced water treatment facilities.

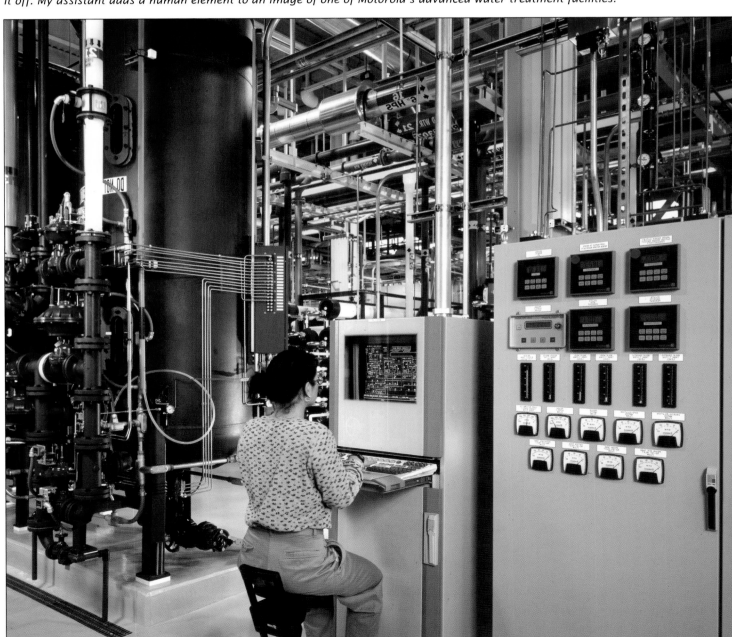

image becomes the keystone of that wide campaign. Its value increases dramatically because the reach of the media buy is so extensive. If the client really wants your image (perhaps it tests very well with a focus group), the client will weigh whatever price you negotiate against the cost of producing a similar image from scratch, but without the assurance that the resulting images will, in fact, be as good as the one they now have in hand. Given that the production costs of ad images can be hundreds of thousands of dollars, the client may decide that $50,000 for a sure thing is a bargain. Again, it's a win–win. You walk away with a ton of money, keeping ownership of the image for future, noncompeting sales, and your client launches their breakthrough campaign with their new, signature image.

And none of these scenarios would be yours if this image had been produced while working on a story for a magazine that ended up paying you a paltry $400 for a full day's work while demanding that you sign a work-for-hire contract—with you providing the use of thousands of dollars of camera and lighting equipment, and paying for your own medical insurance and retirement. And of course, if you did sign the work-for-hire agreement, the magazine could turn right around and license your image to another client without paying you a cent.

I hope I've convinced you that retaining ownership of all your images is the cornerstone of building long-term wealth as a photographer. It should be. The licensing model has been a best practice in the commercial photography industry for decades!

Below—*Whether you want to make money in the stock photography market or have the ability to resell an image in multiple markets, you'll want to retain your copyright. This is a simple image done for a magazine assignment, but it could be sold to the restaurant, the purveyor of the natural beef, and conceivably even to the maker of the range that is out of focus in the background—but only if you have rights to the image!*

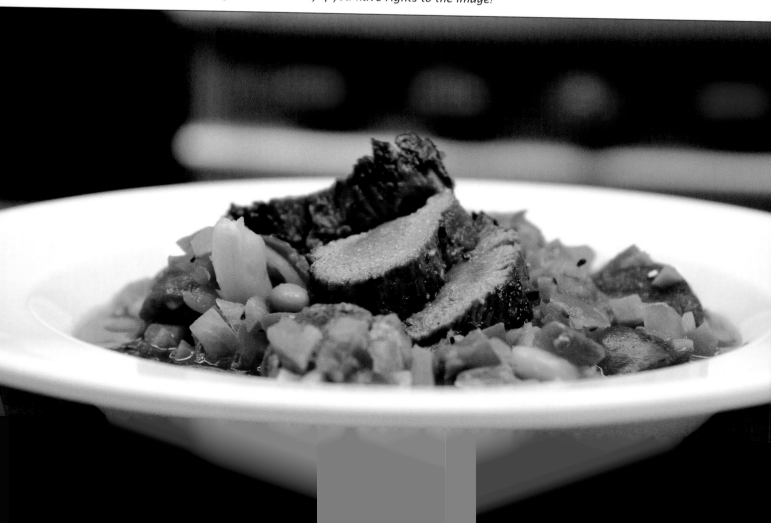

2. What's Your Niche?

Commercial photography encompasses a wide variety of specializations that include product photography and still lifes, lifestyle images of people for advertising, architectural photography, fashion, and even retail photography (which is mainly concerned with producing wedding coverage and portraits for families and other, nonbusiness uses). Event photography and my favorite specialty, corporate photography, are also included.

You can do a little bit of everything or you can specialize in one of these disciplines. Photographers seem naturally drawn to one field or another, and it's actually rather rare to come across an architectural photographer who is also a really good portrait photographer. As a generalization, studio still life photographers don't make the best wedding photographers and vice versa.

In larger markets where there are many clients available it is both common sense and good business practice to brand yourself as a specialist in something. But be careful, because the discipline in which you choose to brand yourself will be the one that clients pigeonhole you into for all time.

Let's look at each category, go over what is required by clients looking for top talent, and look at examples of "best in category" work.

▶ Architecture

This is one of several categories that seems resistant to the encroachment of "dollar stock." Architectural photographers create images of custom houses, office buildings, public structures, and interiors of all kinds. Their clients are generally large architecture firms who hire photographers to document their best projects for advertising and public relations. Secondary clients would include the owners of the building who would use the images in advertising aimed at prospective tenants, the contractors who did the actual physical work on the projects, and the subcontractors who provided tile work, floor coverings, furnishings, and lighting design. Additional markets for the images of commercial buildings would also be shelter and design magazines such as *Architectural Digest, Luxe,* and others.

When photographing residential properties, clients would also include the final owners and local shelter and lifestyle magazines. With so many potential participants in every architectural project, it makes absolutely no sense to sign any sort of work-for-hire agreement that might limit your ability to profit from your photographic taste and expertise.

What's required to do the job? Architectural photographers who are working at the top of their game have a skill set that is unique. They need to be well versed in new styles and trends in architecture and design, and they need to be able to bring good taste to bear in styling the interiors they will photograph. These aesthetic skills are above and beyond the ability to render a technically accurate image. Though some photographers still make use of flexible 4x5-inch film view cameras, the vast majority have switched to using digital cameras for their work. Because Canon was the first camera company to come out with a trio of "tilt–shift" lenses, you'll find most photographers have adopted Canon cameras as their top choice. It doesn't hurt that Canon also currently produces the 35mm style digital cameras with the highest pixel count. This is always a plus for architectural shooters as they need to render as much detail as possible.

If you are a Nikon user, take heart. Nikon has just released new 24mm, 45mm, and 85mm tilt–shift

Spotlight: Paul Bardagjy

The images below and on the facing page were created by Paul Bardagjy. He is currently considered one of the top architectural shooters in the United States. In his work, technique (though he is a master) is secondary to the implementation of clean design and a point of view informed by a deep understanding of art history. Paul's unique lighting style comes from using specialized Dedolight tungsten spotlights, which are highly controllable light sources.

Left—Paul Bardagjy is not your ordinary architectural photographer. Paul studied design and art history before coming to photography. He's spent the last twenty-plus years interpreting architects' work with a variety of large format cameras. Now working with high resolution Canon cameras, his clients come to him for his point of view and an intuition informed by world travel and a sense of modern style. **Below**—Stairway detail. ©2008 Paul Bardagjy.

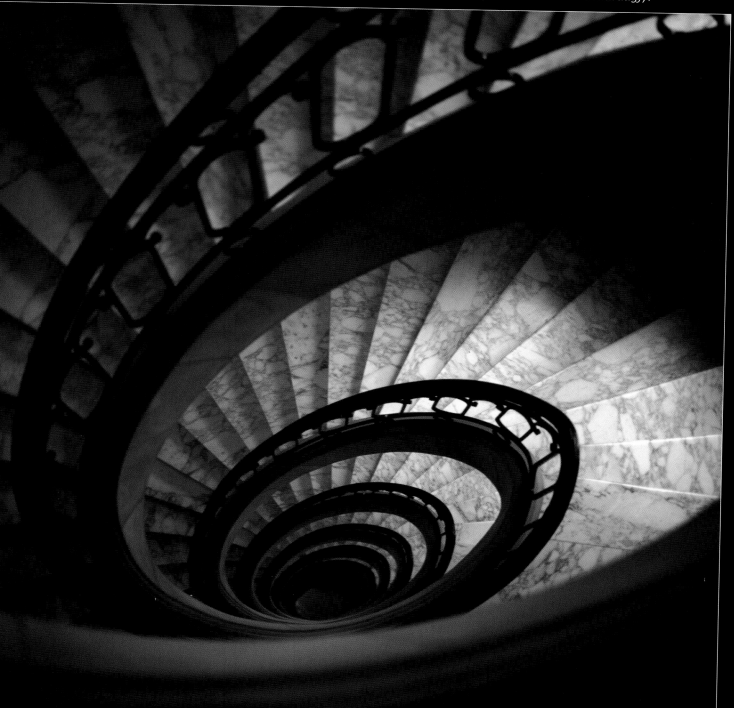

Top—Entryway. ©2008 Paul Bardagjy. ***Bottom left***—Hospitality. ©2008 Paul Bardagjy. ***Bottom right***—Residential ar-

lenses that are getting rave reviews from discerning users. It is clearly no longer a one-horse race. Nikon has also introduced a 24.5 megapixel version of the D3 that evens the field between Nikon and Canon and begins to threaten the medium format digital cameras!

In addition to understanding how to use tilt–shift lenses to control distortion and render perspective correctly, these photographers have to be very good at augmenting the existing light from fixtures found on location to make the best-possible images. Though the vast majority of less skilled people working in the field settle for creating a soft wash of light that raises the overall illumination while filling in dark shadows, the real artists use a variety of lights including small, almost surgically exact, spotlights to accentuate form and texture.

For images that will be used in advertising, architectural photographers generally work with a small crew of people including an assistant to help transport the necessary cases of lights and stands, a stylist who selects props, flowers, and even furniture for use in each shot, and a stylist's assistant, who will work under the direction of the stylist and photographer to help create a distinct look for the shoot.

In 2008, a good regional photographer could command a basic rate of $2500 per day to shoot a commercial property with a national usage package rate of $2500 per day on top of that. He would derive additional income by selling the usage rights to the images, in noncompeting media, to other participants in the overall project. With full participation top shooters can hope to bring home upwards of $10,000 per day on the most spectacular projects.

If this is the kind of photography you want to do, you'll need to put together a portfolio of photographs that are of the same quality as those in national magazines. The best place to start (you'll need access to projects) is to find the lifestyle and shelter magazines in your area and approach them for initial assignments. You'll probably start out shooting custom houses for architects and designers, and, as you shoot more and more interesting projects you'll keep moving up the

ranks until you are presented with the best projects. It's a long process, but it is one that can be quite rewarding.

What do you need in order to get started shooting? I surveyed several "heavy hitters" in the business, and this is what I learned: You'll want a full frame, digital camera that's at least 12 megapixels and optimally 22–25 megapixels. Add a lower-priced camera body from the same manufacturer as a backup. (A real pro never goes on assignment without a backup camera. It's just not done.) The consensus is that while it's good to have more megapixels, it's not nearly as important as having the right lenses.

Depending on which system you buy into, you'll definitely want some well designed, wide angle shift lenses. Both Nikon and Canon have great 24mm and 45mm tilt–shift lenses. Nikon also makes a really good 85mm tilt–shift macro lens that photographers rave about, and Canon fills out their line of perspective control lenses with a 90mm tilt–shift lens. The Nikon optics are nearly a decade newer and incorporate a lot that has been learned about optimizing optics to digital sensors. My favorite Austin-based architectural photographer also has quite a collection of 28mm shift only lenses, including the venerable Nikon 28 f/2.8 shift lens as well as a 28mm Schneider shift lens. In one corner of his equipment cabinet he also has the Nikon 35mm shift lens, which has been discontinued for years. As a Canon shooter he also has the full range of Canon tilt–shifts for the EOS cameras as well. All the third-party and Nikon lenses have been custom adapted to work with his Canon camera bodies.

Most generalists will, at this point, insist that they can do just as good a job using the latest wide angle zoom lenses from Canon and Nikon, fixing any distortion or aberrations with a healthy dose of Photoshop. The top pros all agree that this is wrong and that the best work in still being done in the same optical manner as it was with view cameras. This kind of stringent correction, done by sliding the lens up or down or sideways to correct the "point of view" is a visual effect that cannot be precisely imitated by software. You can convince yourself otherwise but be aware that ar-

chitects are tough critics and will want images that render their designs "correctly."

There are exceptions to every rule and there are good photographers working with other cameras and other methods. I would categorize the equipment I described above as "the standard." Some veteran photographers are still working with their 4x5-inch film cameras. The recent announcement about the demise of Polaroid will likely move even the most resistant holdouts to digital in some form. Medium format digital cameras are becoming increasingly popular as the price of the systems keeps falling and more shift lenses and wide angle optics are added. The medium format backs have the benefit of providing good differentiation from amateur gear, with larger geometry sensors equipped with bigger pixels.

Keep in mind that no matter how happy the owner is to have his house, building, or church photographed at the moment, it is a good idea to get a signed property release, at the time of the shoot, giving you the right to republish the images in other media in the future. It's sad to miss a sale on an image you've got in your files because you can't find the owner after the fact. And people do change their minds over time.

If you live in a smaller city, you may not be able to make enough money to support yourself in the manner you'd like to by just pursuing architectural assignments. Like it or not, the bulk of new and exciting architectural work is being done in large, vibrant metro markets like New York City, Los Angeles, and Chicago. Other markets include cities like Austin, TX, with its growing inventory of multi-million-dollar custom homes and downtown filled with cranes towering over a new crop of beautifully designed, high-rise residence and business towers. It might be tougher going in Des Moines or Tulsa.

▶ Product and Still Life Photography

If you love problem solving and design, you might be a candidate for still life and product photography. While shots of beautiful models fire up the general public, really good product photography is a vibrant part of commercial photography and, in many ways, is more fun than the other categories. Why do I say that? Well, once you have a comp (comprehensive layout, the mock-up of the ad that the advertising agency creates as a loose blueprint) and the product in hand, the rest is very much up to you. You won't have to deal with models who partied too much the night before, gained a bit of weight between the fitting and the sitting, or who have a list of interesting psychological tics. You won't have to go on location and get rained out. You don't even have to leave your studio. But you will need a studio.

Every product in every market is photographed for a wide variety of uses including many different kinds of ads, images for the packaging design, web images, owner's manuals, point-of-purchase displays, posters, catalogs, and much more. Product photography is another category that still requires large doses of technical expertise as it is the second category that usually requires the use of cameras with lens and back movements (like 4x5-inch view cameras) or access to tilt–shift lenses that cover a wide range.

Here's a glimpse into the process of product photography: The product and the comprehensive layout arrive at the photographer's studio and he immediately starts building his set. He may enlist the aid of a set builder, or he and the client may have decided on using a white, black, or gray prefabricated background, which is already in the studio's inventory. After the photographer builds or assembles the set and the props, he or she lines up the shot through the lens of the camera. The basic lighting is set in place and the hard work of fine-tuning the shot begins. Most practitioners at the top end of the category have begun using HDTVs or HD monitors to preview their shots. Others tether their cameras to their computers and check the ongoing evolution of the shot on their large, flat-screen monitors. Having a 42-inch plasma screen with the direct output of the image from the camera is a great help to a whole team of professionals, from the stylists to the client, in collaborating on the direction and the details of the shot.

The photographer will select from a variety of softboxes, strip lights, grid spots, and optical spotlights in

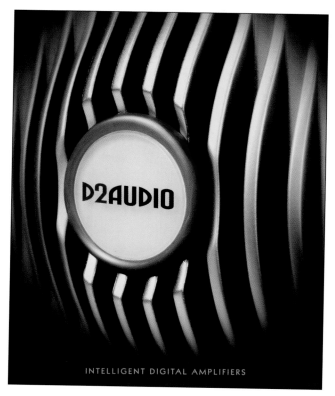

order to build the precise lighting design and illumination effects that he and the client have discussed in preproduction meetings.

Once the styling, the lighting, and the composition are perfect, the photographer will capture the final shot, which is inevitably handed off to a retoucher for a final polishing before it is incorporated into an ad or other media.

Within the category of product and still life photography there are many subspecialties including jewelry (with its own subcategories of watches, gold, precious gems, rings), food, macrophotography (think tiny high-tech products and the itty-bitty constructs that are the building blocks of most micro chips), and art documentation. Each subspecialty requires advanced knowledge but all use basic optical and lighting principles that are common across the still life/product spectrum.

Nearly all of the work has three parameters in common: (1) It calls for the highest degree of quality avail-

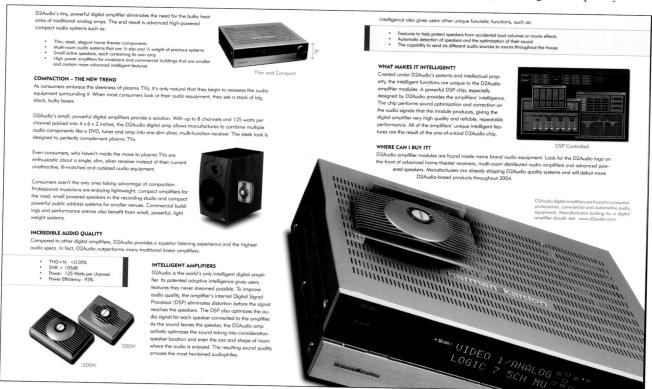

*Top—Brochure cover for D2 Audio. A classic studio still life for a high-tech client. **Bottom**—Here's the inside spread. The studio provides the control you need to distribute light across shiny objects, do double exposures for a classic cutaway shot, and also control the ambient light so that the display on the receiver reads well.*

able. (This makes it the most compelling category for using the new generations of medium format digital cameras with 50 and 60 megapixels of razor sharp resolution. Note that the files generated by these cameras are well over 100 megabytes when opened in Photoshop. With the addition of a few adjustment layers the files can quickly grow to over a gigabyte in size. You'll need a very fast computer, loaded with memory, to work efficiently in this field.) (2) It takes place in a controlled environment, typically a studio. (3) It calls for numerous lighting tools and the ability to use high-output flashes. The power is needed in order to provide small apertures such as f/22 and f/32 for maximum depth of field while working at low ISOs like 50.

You can easily spend over $100,000 to properly outfit a first-class product studio. But if you are working in a large market and your work and marketing are good, you can expect to recoup the investment in a reasonable amount of time. So, what does a working studio's gear box look like? Here's an overview:

You'll find a camera system like the Hasselblad H3 with a 50 megapixel digital back; a Leaf AFi7 camera with a 32, 39, or 60 megapixel back; or a Leica S2 camera as the basic camera for most work. A well-equipped studio would also have a traditional 4x5-inch view camera like a Sinar Px or Linhof coupled with a scanning back for images that require extreme traditional camera movements. The studio might also keep a high pixel count Canon or Nikon around for quicker work. Because Canon and Nikon keep increasing the pixel density of their cameras and the resolution and correction of their lenses, the distinctions, when compared to medium format systems, are beginning to blur.

Lighting would include a number of Broncolor or Profoto (or some other really cool European brand) strobe generators in the 3200 to 5000 watt-second range with a collection of flash heads. Light modifiers would include a wide range of softboxes and Plexi-

Right—This entire brochure for a high-end office park was shot on a Sony R1 camera with a fixed zoom lens. Seeing clearly trumps equipment almost every time.

boxes ranging in size from a 12x12-inch box up to a 5x6-foot softbox, and everything in between.

That's the "no holds barred approach." Is it the only way to go? Heck no. The tool kit I described above would only be found in the largest markets and is really set up as a high volume production studio. There are thousands of good practitioners across the country doing nice work with 12 megapixel cameras equipped with various macro lenses and a new generation of remarkably good general lenses. The real secret to any kind of still life work is the ability to evolve a style of lighting and a visual point of view that appeals to your market. Many pros are working effectively with old Speedotron lights or Norman lights, even AlienBees strobes. No microprocessors required.

Your gear selection will be dictated to a certain extent by what you end up specializing in. If you shoot food (a subset of product and still life photography), you'll be pleased to know that there is a photographer named Lou Manna who's been shooting for top

NATURE & SUCCESS

AS VIEWED *from* THE TERRACE

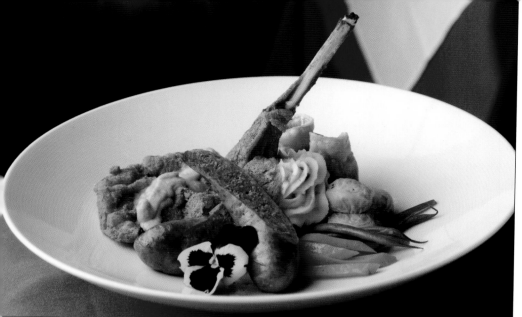

In every part of every industry there are exceptions to the rules of thumb. The only constant is to turn out work that is as polished and technically excellent as your field demands.

Food Photography. Food photography is, to me, the most interesting subcategory of still life and product photography, and when done well, the results can be amazing. There are two general categories (and numerous subcategories) in the realm of food photography: editorial and advertising.

Most editorial food shots end up in lifestyle, shelter, and food magazines, and it's this branch in which the most creative work is done. Photographers, food stylists, and chefs are free to create, prepare, and display food in any way that they choose so long as it meets the needs of the magazines. They aren't constrained to follow the rules that advertising photographers and their crews must work under.

Editorial. Editorial shoots usually consist of the photographer and a food stylist or chef. When we are assigned by magazines to go out to shoot food at high-end restaurants,

Top—Mixed Grill at Hudson's on the Bend. A small camera (Nikon D300) and inexpensive lens and three battery-operated strobes were used to create the shot. Styling makes all the difference. Bottom—Beautiful sashimi from Uchi. A knowledgeable and imaginative chef is a wonderful ally. For Tribeza *magazine.*

clients in New York for years using 8 and 10 megapixel Olympus DSLR digital cameras and their really nice lenses. He published a book several years ago that showcases his unique style while explaining why he uses the equipment he's chosen.

we don't use food stylists, we depend on the creative talents of the restaurant's chefs. We're interpreting their recipes and their presentations, so it just makes sense to collaborate with them. Not every chef is a Rembrandt of presentation, so it does make sense to put together a little "food" first aid kit to carry along. Mine has chopsticks (perfect for rearranging delicate foods on a plate or "aerating" a risotto dish to give it additional loft and definition), several sizes of small paint brushes for applying a little olive or walnut oil in just the right spots, some FunTak (a putty-like adhe-

sive that doesn't dry out; available at office supply stores) to angle up plates of food and to keep utensils from sliding around, and cotton swabs and gauze bandages to clean up "drifting" sauces, juices, and other "sliders."

The current style in food photography for magazines is very equipment friendly. It consists of keeping small parts of the plated food in sharp focus and letting everything in front and behind the point of sharp focus go quickly soft. This requires using fast, long lenses at wide apertures like f/4 so that the sharp areas are really sharp and the soft areas are really soft.

Using wide apertures like this means you don't need to worry about hauling around a ton of powerful lights. Small battery-operated flashes will give you all the power you need, even if you aim them through nice white diffusers. We use similar lights to keep the background at a middle key, and when we feel ambi-

Below—*A cake and ice cream dessert at the Driskill Hotel. A clean and simple design coupled with an uncluttered background is a good start for any food shot.*

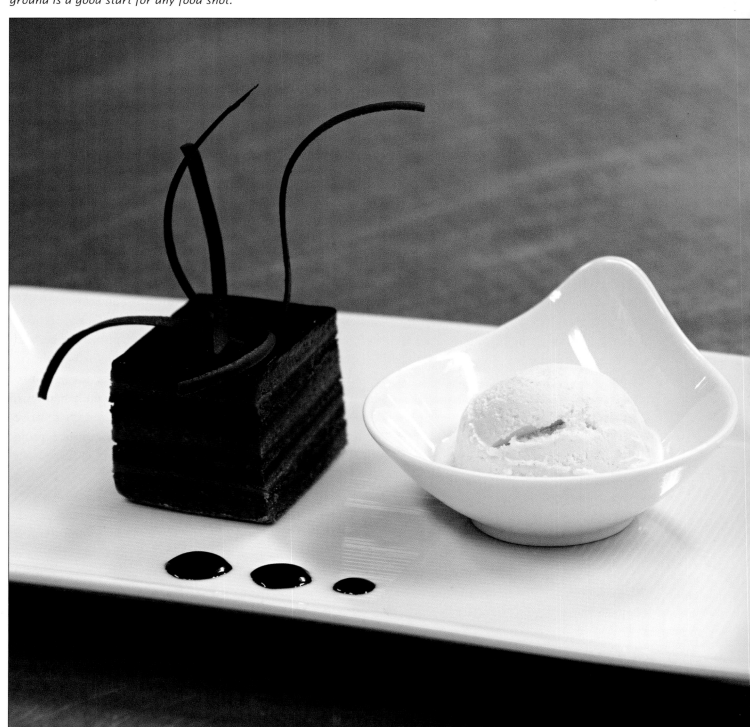

Advertising. Editorial food photography is fun and relatively easy. Shooting food for advertising is a whole different ball game. In this category clients (or their advertising agencies) will show up with very, very precise comprehensive layouts. And the layouts aren't detailed just because the client's art director suffers from severe obsessive disorders (though that can never be ruled out) but because the photos will likely be wrapped around packaging with tight technical requirements for placement or used in very large point-of-purchase displays that will show off any photo errors you might introduce.

If you work with one of the huge food conglomerates, you will likely spend the day shooting with medium format digital cameras complete with very high density backs and precisely adjustable lights capable of banging out lots of watt seconds with every flash.

In this scenario you'll likely have the following crew working in a studio with a fully equipped kitchen: photographer, first assistant, set stylist (responsible for the look of the plates, silverware, props, flowers, vases, and even tabletops and chairs), a chef (who will prepare the dishes required and whose expertise includes knowing how to cook for photography and film), and a food stylist (who will take the prepared food and make sure it sits properly on its plate and is well presented and garnished). The crew will also include an art director, who will want to see the images on a well-calibrated computer monitor so he can make sure that they fit the final layout exactly,

tious, we even add a little backlighting to rim the food.

My favorite setup is to use a huge diffuser to one side and a large reflector to the other side of the food. A lot of photographers use a different setup, which is a variation on using a light from the back of the set to wash over the food from the opposite angle from the camera. In this setup, a reflector is used on either side of the camera to reflect light back into the shadows.

Your inventory of equipment for this kind of work might include one 12 megapixel digital camera, three battery-operated flashes that can be triggered with optical or radio slaves, 60 and 105mm macro lenses, and perhaps a 70 to 200mm zoom lens that has close focusing capabilities.

Add to your lighting kit several large pop-up, white diffuser panels and their attendant stands and holders and you are done. There's no need to use the fastest camera on the market because the food doesn't move too quickly.

and a product manager from the client's offices who will make sure that every photograph of his product fits the style and guidelines of the company.

These shoots will be the culmination of much pre-production. If the client's product is a hamburger, decisions will have been made about what products to show with the "hero" product, what kinds of props will surround the setting of food, and what the character of the light will be. The art director and client will have chosen a color range in which to place the look of the overall set, and many people will have approved the layout that will form the blueprint for the shoot.

The food stylist will spend hours searching for the perfect bun (and if the bun is part of the product [e.g., a hamburger from McDonald's or Wendy's], it will have to be a bun that a customer could conceivably get when shopping at the chain); the perfect patties; and the best condiments she can find while making sure that the products conform to those that could be ordered by consumers.

The set stylist will have spent many days rounding up just the right table or booth to use as a background, and arranging to have it shipped to and from the studio. If there are paper placemats, they will be perfect ones selected from thousands of candidates. In the course of the shooting day, dozens or maybe hundreds of copies of the product will be made. Some will sacrifice themselves as "stand ins" so that the photographer can carefully compose and light the set with real food in place. When everything is set, the "stand ins" will be swept out of the way and the "hero" put in their place. In a few minutes the lettuce will wilt, juices from the meat and condiments will turn the bun soggy, and the whole hot dish will cool down and die. At this point, if the art director is still not satisfied, another hero will be rushed in. And another. In many ways the discipline of shooting jewelry and shooting food for advertising are similar. Both require high quality equipment and careful technique. But jewelry doesn't decompose right before your eyes.

Want to shoot food for a magazine? Easy as pie. Just head to your best local lifestyle and shelter mag-azine, show them some samples, and get started. Want to shoot food for major advertisers? Better head to New York, Chicago, Dallas, or San Francisco and start your apprenticeship, because this is one field where you'll have to show that you can do it the way the masters do before you'll get a chance at the big budget shoots.

If you love the great outdoors, drinking piña coladas with supermodels, and hearing the zing of the fast motor drive, you might want to give the various permutations of product photography a pass. You won't be happy. You might, however, find some joy as a fashion photographer.

▶ *Fashion Photography*

Fashion is the category of commercial photography that dreams and movies are made about. It's a field in which it seems, to the outside observer, that anything goes. Photographers like Terry Richardson and Juergen Teller turn in assignments to major fashion magazines taken with crappy point-and-shoot cameras that spit out grimy, poorly lit images of disheveled models who appear to be clinically depressed, decidedly downcast. While the grunge, minimal-equipment aesthetic did dominate the field for a season or two, the reality is that good fashion photography is the result of lots and lots of hard work and planning. Most real fashion photography takes place in studios in the fashion capitals of the world like Milan, Italy; New York City; Paris, France; and London, England. These are where the "critical mass" concentration of clothing designers, retail store headquarters, and fashion magazines are to be found.

The usual career path for successful fashion photographers, working internationally, is to assist for a "name" photographer in one of the aforementioned cities. After getting experience in both the business and the creative sides of the field, aspiring photographers develop a unique style and garner experience by working for smaller editorial magazines and web sites. If they are talented enough and lucky enough, their next move will be to try and break into a very small circle of clients with big budgets. It is very clearly a

market where schmoozing and networking is critical. And to work in the higher-end markets it is critical that you live in the markets you intend to serve. That puts most of us at a major disadvantage. So, do you just give up on your dream to be a fashion photographer if you live in a smaller market with no real fashion nexus?

Actually, you can do fashion in many smaller markets across the United States. You might not be able to depend on fashion alone to supply all of your income, but you could get a good bit of experience shooting locally. There is one photographer who worked in the Austin, TX, market shooting fashion spreads for citywide lifestyle magazines. He supplemented his editorial income by doing headshots for aspiring models. His wide network of young models made him more valuable to the magazines, which came to depend upon him to find and supply new talent for their projects. His close relationship with the magazines made him more valuable to the models who were routinely presented with the rare opportunity to be photographed for a magazine spread. Eventually the photographer saved up enough money to move to Spain and work for magazines in that country for nearly a year. The things he learned in that national market helped him to take the next step and work in markets in Los Angeles.

By diligently following his muse, this photographer effectively worked himself up to the point that he was working in several national markets. He was never able to crack the New York City/name designers' market, but the trade-off is that he gets to stay in his home town.

If you are desperate to shoot fashion and you live outside the major markets, you need to figure out where the demand for these kinds of images might be. Most hip cities have at least one really well-designed, glossy lifestyle magazine that runs fashion stories. This is obviously your first stop. As with the Austin fashion photographer, it seems like a natural progression to shoot model's headshots to supplement the meager fees paid by the publications. You might also look to independent fashion retailers who are eager to create

and leverage their own brand to better compete with national retail chains. Forget the chain stores; their advertising is all done through their main offices, and they are not likely to need supplemental work from local photographers.

If you really want to break into the "magic circle" in one of the major markets, there are a few requirements to consider: You will need to be young (under thirty-five) and relatively good looking (fashion editors are famously concerned with appearances). You will need to have an in-depth knowledge of fashion trends and an even better knowledge of how to produce a large shoot with a substantial crew. Finally, it will help if you do an apprenticeship (as an assistant) with a "name" photographer in the industry so you can learn the "ins and outs" on someone else's dollar. Being referred to a client by a giant in the industry doesn't hurt either.

So, how would a big fashion project look? I was able to sit in on a project a friend of mine was producing for a Dallas cosmetics company. The photographer and her producer had worked for weeks with the agency, doing test shoots to define a look, and searching for the right faces for this campaign. When real money is on the table photographers and their clients don't depend just on model sheets, web sites, or head shots to cast from. Each model whose head shot made the first cut was called in for a "go see." It's a quick face to face interview where the photographer and her client check out the model in person and perhaps even take a test shot to determine whether or not the model is right for the project.

After the preliminary casting was complete there was a period of preproduction that was dominated by scheduling complexities. Several models had schedule conflicts with the preferred hairstylist, and the photographer had several schedule conflicts with the head makeup person. It was eventually resolved by a booker at one of the modeling agencies who could do magic with a spread sheet program.

The shoot took place in the studio, and most of the images were fairly tight on the faces of the models. This made wardrobe selection easier as every shot

was from mid-chest up. There were eight models in all and each would be photographed twice—first, in no makeup whatsoever and then fully styled in the client's products.

Since the entire shoot needed to happen over the course of one day, two makeup people and two hairstylists were hired to work side by side. Their attention to every detail in the studio was phenomenal. I never knew people could be so professionally compulsive. Every part of the day was choreographed, from the music on the sound system to the menu for lunch.

The photographer, working with two assistants, set up and tested the lighting for the shoot the night before. The client was represented by two product managers, one art director from the company's advertising agency, and her assistant. The photographer was also supported by her representative (who kept the client happy) and her producer, who made sure every subcontractor's job was done well, all the checks were written to the subcontractors, and that the assistant understood what kind of files needed to go to each person from the client's side.

The total budget for the production, not counting the photographer's fee was somewhat more than $60,000 for the day. While it sounds wonderful it does create a certain amount of tension the second anything goes wrong—and no shoot is perfect.

What's in the gear box? The photographer shot with the Hasselblad H2 digital camera for the entire project. She was using the 33 megapixel back but confided to me that she would have been just as happy with the 22 megapixel back. I asked why she needed to use medium format for this particular project and she gave me two reasons: She likes the way medium format cameras handle skin tones, and it's what big time clients expect to see.

As far as lighting goes, everything was Profoto—the most prevalent being the D4 packs. She used a gridded spot on a gray seamless background and a large (5x7-foot) softbox directly in front and over the models' heads. Right below the softbox was a 24-inch beauty dish as a bright secondary light source.

The total number of people in the studio that day was surprising. In addition to the eight models, the two regular assistants, the digital assistant, the two hairstylists, the two makeup artists, two product managers, two agency people, the photographer's rep, and producers, there were also one photography intern, one advertising agency intern, a catering company with a staff of three, and a production assistant who seemed to deal with transportation issues having to do with the models. With me and the photographer, the head count came in right at thirty.

Left—Glamour and fashion are intertwined and tend to reference each other. This is my interpretation of a period glamour shot as fashion, referencing the late 1970s. Equipment consisted of an AlienBees ringlight and a Mamiya DL28 medium format digital camera.

When you have all these people in your studio for a day you are also responsible (in addition to doing great photographs) for their care and feeding. If the shoot starts at nine, that would include some sort of "eat on the run" breakfast; a sit down, hot lunch; snacks for the day; and alcoholic drinks and finger food for the end of the day. (Good marketing always seems to call for a congratulatory glass of wine at the end of every fashion shoot.) And the food needs to be commensurate with the status of the crew. Bringing in Taco Bell for a client like Neiman Marcus would signal the end of a photographer's career with that client!

Not all shoots are like this. Many editorial photographers use a bare-bones staff. A small project on location might include just the photographer, her assistant, a makeup person, a wardrobe stylist, and the model. If budgets are tight, breakfast might take place at the closest Starbucks and lunch might consist of deli sandwiches consumed on the fly.

Many big names in the business will sometimes go out on a shoot with no one but their favorite model. All kinds of approaches are valid in a field that rewards unique visions and points of view.

So, if you are just starting out and you are not in one of the major markets, are you doomed to abject failure? Not necessarily. You'll need to find the most fashion-forward retail stores and magazines in your market and get to work. You'll need to find models to work with, and if your town doesn't have talent agencies filled with beautiful people, you'll have to find them yourself.

You can try one of the online resources like model mayhem.com, you can place a free ad on craigslist .com, or you can go right back to the owners of the retail shops you've selected as potential clients and enlist them to tap their best-looking customers. Just remember to get a model release.

A quick survey indicates that if you're going to go into the fashion business, a unique point of view beats expensive equipment every day of the week. In fact, this is one category in which people are still shooting film from time to time. Sometimes it's fashionable to suggest that film renders nicer skin tones than digital. Then film will be a trend for several months until one of your competitors suggests that vintage digital is "of course" the best-possible solution for great skin tone. And so on.

▶ Retail Photography

The nuts and bolts of actually taking photographs is technically the same whether you photograph skateboarders for in-flight magazines or screws and fasteners for a hardware manufacturer. The big difference between all the kinds of photography we've discussed so far and the category I call "retail photography" is

Above—I found Noellia performing at a local theater and cast her in a series of ads for the Austin Chamber of Commerce. She is an accomplished actor, which makes her a wonderful talent to work with. Getting involved with a local theater group can be a wonderful way to practice your craft while meeting perfect talent.

this: retail photographers market to and serve the public consumer—the moms and dads, brides, and seniors. When they create an image like a family portrait, its usages are fairly constrained. Most people are buying a print (some will get CDs or DVDs), and the print is being licensed for "private display."

Since the senior portrait photographer, for example, owns the copyright to all of her images, her clients can't resell their images to other users (such as advertisers) without the photographer's permission. Most sitters will be reticent to sign blanket model releases allowing strangers the right to use, and profit from, im-

ages of their children and other loved ones—especially when they derive no benefit from those uses. And frankly, although many of the images being created by retail photographers are true masterpieces, they don't fit into the ethos, style, and parameters of lifestyle advertising.

The marketing of images directly to individual, retail customers is the only market within commercial photography in which sales are not directed to business users. This is the largest single category of commercial photography in terms of both the number of practitioners and in dollar volume. It is also the most public face of professional photography. No matter what specialty you practice, at some point in your career you will be asked if you "do" weddings or kids' portraits.

Wedding Photography. In years past photographers in other specialties looked down on wedding and consumer portrait shooters. (Even today's organizations like the ASMP will only consider as general members those photographers who routinely "publish" their work. While there is an ongoing debate about what "publish" really means in the Internet age, the current, prevailing definition is clearly aimed at printed material in magazines and annual reports.) But as the economy shifts and stock erodes, some of the traditional, nonretail photography market—weddings and commissioned portraits—are assuming a new stature in the minds of profit-minded photographers.

A new breed of wedding photographers who shoot with sophisticated and highly dynamic lighting, state-of-the-art cameras and lenses, and a style that rivals the best of "lifestyle" advertising shooters is quickly garnering new respect for the most successful practitioners. And it remains one of the few segments with a relatively stable base of prospective customers.

What It Takes to Be Successful. The typical wedding photographer working at the middle to high end of the market might run their business out of their home, assembling a temporary staff of "second shooters," assistants, and postproduction people as needed. Most of the market is dominated by photographers offering a combination of "reportage" or unposed coverage intermingled with traditional posed group shots. While previous generations of photographers worked from a list of essential shots, the current generation truly believes in quantity. It is not unheard of for a wedding photographer and a team of second shooters to capture over 3,000 images at a single event. Not all the photographs are truly candid. Very few photographers can resist asking a subject to do something a second time so that they can better capture the moment. And most photographers will set up lighting and carefully pose the large group shots that have been a staple of wedding coverage for decades. But most of the images of these weddings are captured moments snatched from the flow of events.

A currently popular style (aided by the rapid development of digital cameras that excel at high ISO performance) is to shoot as much as possible by available light, using fast lenses and wide open apertures. The resulting image can be very effective with shallow depth of field guiding the viewer's eye to the main subject. There is also a greater emphasis on using the same techniques to capture the many details of a wedding including close-ups of flowers, food, place cards, shoes, and more. Each image features an object mostly in focus (generally only one plane is sharp) with the background going romantically out of focus.

If you want to make money in the business, you'll need to think about the way you set up your pricing and how the rights to the images are handled. The most successful photographers are careful to retain the copyright to their images and to sell only display rights to the wedding customers. A typical contract might specify photographic coverage for a certain amount of time and a book with a certain number of images. In most second-tier markets (areas outside the expensive cities like NY, Los Angeles, West Palm Beach, and San Francisco), a starting price for good wedding coverage by a well-known, local photographer starts around $3,600 (2008 dollars) and goes up from there.

The beauty of selling clearly defined packages and retaining all rights to the images is that all residual sales of prints are very profitable. A single shot of a well-photographed bridal party of thirty might yield

over a thousand dollars in reprints! Parents might fall in love with an image of their daughter caught by the camera in a special moment and order a large canvas print for $800 to $1000. Most photographers also have the images hosted on a commerce enabled web site (such as www.smugmug.com, www.photoreflect .com, and www.pictage.com, among others) that allows all of the guests to go online to view and order photographs. This is so much more efficient than the old practice of passing around proof books from relation to relation and allows the photographer to make good money, passively. Most web sites will take the order, have the images printed, bill the client, and ship the prints directly to the customer. Then a large percentage of the sale is passed along to the photographer. What a wonderful business model! And what a contrast to the short-sighted photographer who shows up, shoots the wedding, and then provides all of the images on a disc, while giving up all future rights to the images. He will earn a much smaller, one-time fee with no hope for future profitability from that job. (Note that if the bride prints images from the disc given to her by a "sell all rights" photographer at the local drug store, and the prints are of very low quality, the blame will always be placed squarely on the photographer. What a blow to a budding reputation!)

Many high-end wedding photographers sell additional images online, but the bulk of their sales to the bride and groom are done during sales meetings where images from the wedding are projected onto large screens or shown on large-sized plasma or LCD high-definition television sets. The images are incorporated into very professional, production-quality slideshows complete with music and elegant transitions between images.

The effort in each show is to maximize the number of pages or images (depending on whether a traditional album is being offered or a bound, printed book) that are sold in addition to the minimum stated in the contract.

Equipment. So, what's in a typical wedding photographer's camera bag? Two camera bodies are a must. A backup is critical to prevent a lawsuit if your primary shooting camera fails. The cameras of choice are the Canon 5D2 and the Canon 1DS Mk2 and Mk3 from Canon and the Nikon D3 and D700 from Nikon. The 5D, D3, and D700 are all acknowledged to be incredibly good performers at ISO 1600, 3200, and beyond. All are "full frame" bodies, meaning the sensor is the same size as traditional 35mm film so the ability to make the backgrounds go out of focus is superior to that of "cropped frame" cameras from the same manufacturers.

Fast zoom lenses are the bedrock of most wedding photographers' glass inventory. Both Canon and Nikon make incredibly good 70mm to 200mm f/2.8 zoom lenses, and both have the added benefit of built-in vibration reduction, which helps photographers handhold their camera systems at lower shutter speeds while reducing camera shake.

The most useful lenses are without a doubt the 24mm to 70mm f/2.8 zooms, which cover the range most photographers will want for groups, casual portraits, and general shots. Many photographers also add a number of fast prime lenses to their collections because they can be used at wide-open apertures to do incredible depth of field techniques. Canon makes two very special lenses: a 50mm f/1.0 lens and an 85mm f/1.2 lens. Each is very sharp wide open and each boasts the fastest aperture in its respective class. They impart a unique look to photos created with the lenses at their maximum apertures.

Several of the wedding photographers I interviewed have abandoned their zoom lenses and have assembled kits consisting of three or four very high speed, very high quality prime lenses. As an example, one shooter carries the following (all Nikon): the very pricey 28mm f/1.4, the manual focus 35mm f/1.4, the 58mm Noct Nikkor f/1.2, the 85mm f/1.4, and the 105mm f/2. His rationale? All of these lenses provide one or two stops more light-gathering power than the zooms, and the ability to shoot wide open gives him more control when he really wants the backgrounds to go out of focus.

Top wedding photographers end up adding lights when the illumination drops too far or where the ex-

isting quality of light is not flattering to the subjects. Most candid work is done with one flash used off camera, or with two flashes. In a two-flash setup the photographer will use a flash on a TTL connecting cable, off to one side and above the camera, using the second light (usually held by an assistant) to either light up a dark background or to backlight, or otherwise accent, the main subject.

Increasing numbers of wedding photographers are also choosing to bring along studio lights such as monolight flashes or even power pack and flash head units. These are used to good effect in lighting large group shots in dark churches. The larger, more professional lights allow for the unfettered use of light enhancing attachments such as umbrellas and softboxes, which serve to soften the light and create more flattering renditions of skin tone while reducing overall light contrast. Meeting these objectives is usually beneficial in portrait work.

Also included in the camera bag are a plentiful supply of memory cards, batteries, and a good contract.

What makes a good wedding photographer? The best in the business are people who enjoy being around other people. They are outgoing, friendly, and engaging. They have a good eye and an excellent command of the technical skills demanded by their particular field (i.e., calculating exposures, use of flash, composition, and achieving focus must be second nature). From the business perspective they write good contracts, charge profitable rates for both their time investment and products, and constantly improve the quality and presentation of their offerings. They also market well. Their most important market is local and they find that "word of mouth," face to face meetings, great samples, and a fun web site generally are the bedrock of their marketing success.

Contracts. Every photographer should have written agreements with their clients before undertaking any project. It's important in any part of the commercial photography industry. But wedding photographers should be even more prudent. Why? Because for most couples their wedding will be a once in a lifetime event and will be the biggest single event expenditure they will ever make. If anything goes wrong they will be more likely to start a lawsuit. If a product photographer fails to make the right photograph, he will most likely have a chance to reshoot with no real repercussions. On the other hand, if a wedding photographer misses a once in lifetime moment, she will be held responsible. Additionally, most wedding customers, once they have depleted their budgets on all that a wedding entails, may remember spoken agreements differently than the photographer and may be reticent to pay final bills. A good contract helps all the parties to remember all their agreements.

A good contract will have specific remedies for most problems and will be a godsend should your wedding coverage be impeded by acts of God or conditions beyond your control. For example, think about a December wedding held in a small town up north. The photographer wakes up forty miles away to find that a blizzard hit the night before and is going full blast even now. The wedding party may all live within walking distance of the church and decide to go on with the wedding. The photographer is physically unable to get there by any means. Without a contract covering things such as weather, the family may feel that the photographer is liable to them. And though they may not prevail, defending yourself against any lawsuit is a costly and frustrating undertaking.

Less dramatically, the contract reminds all involved parties exactly how much each print costs, what payment terms are, how many hours will be spent at the wedding for a particular fee, and so on. If you plan to photograph weddings, you should seek out a sample contract from one of the major professional photographer's associations (I'd recommend the Professional Photographers of America [PPA]) and then run that contract past an attorney in order to catch any parts that may be out of sync with laws in your state.

Can you make a living as a wedding photographer? Every medium to large size city seems to support a number of wedding photographers and, even though their incomes will fluctuate with the state of the economy, people will always get married and will universally want good photographic coverage.

The best way to get started is to get yourself hired as second shooter for an established pro who works in a style that you admire. After you've gotten a number of jobs under your belt you'll see just what is involved in covering a wedding as well as doing the pre- and postproduction.

Marketing. The best marketing for wedding photographers is word of mouth and a good web site. The best marketing tools are sample albums, books, and prints that show off the quality of the work you do!

Pricing. When you set out to price your wedding assignments you'll need to know just how much time and materials are required to successfully complete the job. The first expenses start with the time you will spend creating marketing materials such as business cards, stationery, sample albums, prints, and advertising. Add in the cost of meeting with brides to show your wares and to deliver your value proposition (the things that make you a unique and compelling choice to a bride). If you are lucky, you will be able to sign a contract with the bride on the first meeting, but more than likely the first appointment will be part of a time-intensive shopping experience on the part of the bride. Once you've agreed to the parameters of the wedding and the pricing you'll have a signed contract and the fun will begin.

Workflow. You'll probably have one long meeting with the bride to discuss all the details and the time-line for the entire day. If you work with a team of people (second shooters, assistants, makeup artists, etc.), you'll need to have a preproduction meeting with them to discuss all the logistics and the style and mood that the wedding party wants.

On the wedding day, you'll be shooting and supervising your team. If the wedding is large and well funded, you could be looking at a twelve-hour commitment, or more. Once the day is over, you'll need to get the memory cards from all your shooters, download the RAW files, and duplicate all the images onto one or, better yet, two other storage devices just to ensure that nothing happens to the pictures. Then you will spend days going through the images, editing, color correcting and converting from RAW.

Once the digital grunt work is done you'll need to upload the images to a web site for print sales, then put together a custom presentation for the bride and groom. Their session alone could take hours as they try to decide which images they want and how to sequence them in the book or album they agreed to buy.

Finally, you'll have to have the book (wedding album) created and you will personally have to quality check it before you put it into the hands of the wedding couple. As you can see, there is a lot more to bill and cover with your fee than "just" the day of the wedding. You'll need to have a good idea of what your time is worth, and your fee will need to cover your time and return a good profit if you want to be successful. As I've said before, there is precious little room allowed for failure. Though most people only see the "tip of the iceberg" (the actual shooting on the day of the event), new wedding photographers quickly learn that producing one wedding can take up the better part of a week, and the marketing required to get each job requires a large expenditure.

Many people with the technical and business skills required to run a wedding photography business have tried and exited the market in a short time. The reason? The stress involved. Professionals in the field didn't coin the phrase "Bridezilla" for nothing.

Portrait Photography. Another subset of retail photography is traditional portrait photography, which includes portraiture of all kinds, from babies to high school seniors, to families, to boudoir images. And, like all the other realms of photography, this segment of the profession is also changing rapidly. Tens of thousands of people who have had modest success shooting photographs with their new digital SLR cameras have flocked to what they perceive to be a lucrative job. Many of them are doing portraiture as a part-time undertaking or just to supplement their newly acquired hunger for more and more equipment. For the most part they are happy if they make enough money to pay for their gear and have a bit left over for a nice meal at a decent restaurant.

They are moving people away from traditional portraiture by radically undercutting the prevailing pric-

ing models, but the nasty little secret is the quality of their portraiture is not very good. In general the beginners are not very good at posing (which is vital) or using artificial lighting (which can be very flattering and dramatic), and they don't have a well-developed critical ability when it comes to retouching and printing their own work.

In spite of these legions of "spoilers," it is still possible to make a decent living as a portrait photographer. You won't be successful by competing on price. And you won't be able to compete with the chain stores that offer portrait work in their studios. You will only be successful if you aim toward the top of the market and offer work that is much better technically and aesthetically than your lower-priced competitors. The market is cleanly divided: You can work on volume (school photography, etc.) or you can work as an artisan whose work has intrinsic value.

Facing page—I had an assignment from Private Clubs *magazine to photograph Yeurgin Bertels, the CEO of Westin Hotels and Resorts while he was in San Antonio, TX, working on a new resort. I used one very large softbox to Mr. Bertels' left and dragged the shutter to bring up the room lights in the background. When photographing CEOs, you need to get in, set up, and test the setup before the CEO arrives so everything is ready when he walks in. It's important, therefore, that you charge by the use, not for the time you spend shooting!* *Above*—This photo of Ben is in my favorite style—with one big, soft light from one side and deep shadows to the other. The image was shot with a Kodak SLR/n and a Nikon 105mm f/2.5 AIS lens. *Right*—I have a portrait style that is very different from the prevailing approach. It differentiates me from the market and ensures that I end up shooting things that are pleasing to me, not just done for profit.

Spotlight: Will Van Overbeek

I've included three images (shown below and on the facing page) from Will Van Overbeek's overflowing portfolio of national work to show both his range and the best use of advertising. Will puts together crews of producers, makeup artists, and other professionals to help him pull off a wide range of people ads that win awards and sell products. He is a master of "gesture" and "nuance," and his subtle humor infects every ad he touches. It is precisely these intangibles that make him so sought after in a very competitive industry.

Left—Will Van Overbeek is one of a select group of top-tier advertising photographers entrusted by clients with tight deadlines, big crews, and bigger concepts. He has worked for McDonalds, Quaker, ESPN, Canon, and many other big-name clients.

Top—"I cleaned my bowl!" An ad campaign for Quaker Oats. Will's ability to direct kids is amazing, and that's what clients are paying for, not the equipment he brings! ©2008 Will Van Overbeek. **Bottom**—This was photographed for an ESPN ad and features Gold Medal gymnast Mary-Lou Retton. ©2008 Will Van Overbeek. **Facing page**—A fun ad for a portable printer product from Canon. Casting, direction, and gesture is so critical. Will makes it look so easy. ©2008 Will Van Overbeek.

I've seen school photographers at work, and I'd much rather choose the role of artisan.

In order to do better work you must have better knowledge. To this end you'll want to either apprentice to a photographer whose work and working methodologies you admire or you'll need to take courses in portraiture from a photo school or workshop. You could learn through trial and error, but reinventing the wheel is time consuming and expensive—and what if you spend all that time and your wheel comes out square? Won't you feel dumb?

Pricing. Pricing portrait photography is a bit different than other niches, but setting your prices should follow the same basic business guidelines. Figure out all of your actual costs, then figure out how much time you'll need to spend on each project. Next, you'll need to decide how much profit you want from each sitting and how many sittings you can do in one year. (We'll cover this in more detail in chapter 7.)

If I were to establish a career specializing in retail portraiture the first thing I would do, before I bought my first light, would be to join a professional organization like PPA and start attending all of their business education workshops. Organizations like PPA can give you a vital framework to use to establish your pricing and your general business practices. Their "nuts and bolts" workshops will teach you the basics of fine portrait work. It's easy, when starting out, to dismiss the "old way" of doing things, but I've learned over the years that having a good understanding of the styles and techniques that have withstood the tests of time is an important positive in building your own style—and your business.

▶ Advertising Photography

Do you relish creating grand tableaus complete with sets, models, and products? Perhaps you'd be happy as an advertising photographer. But wait, aren't many of the specialties discussed above advertising photography? Yes, but the category we're discussing here is focused on creating images that don't fit into the above specialties and yet cover a wide range of image types that you'll see in consumer and trade advertising. Advertising photography is a general category that covers all the lifestyle images that seem like they were captured spontaneously as well as the kind of complex studio shoots you see from companies like Absolut Vodka, with their highly retouched images, and Kohler, whose ads use models and sets to showcase their lines of bathroom fixtures. The category would also include print ads for stores like Target, Walmart, and Pottery Barn, plus ads for cars, travel, and more.

Advertising photographers are usually generalists with well-defined visual styles who are able to not only deal with all the technical issues surrounding large photographic productions but who are also comfortable taking the reins and supervising crews of professionals including models, makeup people, hairstylists, set makers, prop makers, retouchers, assistants, locations scouts, set stylists, and more. They are often called on to lead a team that will come together and help make the photographer's vision (and the advertising agency's comprehensive layout) come to life.

Shoot an advertisement with a couple on a tropical beach? Absolutely. Even if the beach is really a set in a Minneapolis studio. A couple in tuxedos having cocktails in front of the Egyptian pyramids? Of course, and the client has a choice of doing it on the real locations, having a set of pyramids stripped into a photograph of a couple, or having a trio of pyramids built in the studio. Just as the possibilities are endless, the budgets seem to be endless. But there is a catch . . .

To work at a high level in this field requires years of preparation and experience. And it's the kind of experience that can usually only be found by assisting for the people in the industry who are the current heavy hitters. It also means working in markets that are big enough to be home to advertising agencies that are routinely engaged in national and multinational advertising campaigns. In the United States, this tends to

be New York City, Chicago, Los Angeles, and perhaps Dallas or Minneapolis. And it's not just having access to the agencies, it is also about having ready access to the crews of specialists who make the shoots work at the highest level of production.

In the movie industry many films are made in secondary locations, but the bulk of the specialized crews are inevitably brought in from Los Angeles and New York City. These are the markets that have traditionally been large enough to support the full-time employment of the most gifted practitioners in each skill set. And, in advertising photography, the same kinds of people need to be known and accessible to photographers who want to work at the same high level.

Will Advertisers Take a Chance on Newcomers? If you have a fresh style that is in high demand and you can prove that you've worked successfully with a crew of experts, you will probably be given a relatively small project on which to prove yourself. If you pass the test, you will gradually be given larger and more lucrative projects. It helps if you have the referral from one of the known names in the industry.

All advertising photography projects are billed in the same fashion. The photographer charges for pre-production (which basically means getting everything scheduled, all the crew lined up and ready, props built, and locations scouted), there is a charge to shoot the actual project, all of the expenses (travel, crew, hotels, meals, rentals, access fees, etc.) are marked up and billed, and there is a separate charge for all of the various usages that the agency and the photographer have agreed upon. There are even postproduction charges which may include retouching, prop returns, archiving the files and more. Small advertising shoots might have total budgets of around $25,000, while the sky is the limit for international campaigns. It is not uncommon for multi-day, multi-image shoots to exceed a million dollars!

Jobs on the Photo Shoot. It can be confusing to read about the many different jobs that may be involved in putting together a photo shoot. Here is a list of the various positions with a job description.

Production Assistant (or PA). This is a traditional job on movie and television projects and is quickly becoming common on larger photo shoots. The PA is responsible for all the various on-set tasks that no one else has time for. They make coffee, order lunch, keep things scheduled, act as a liaison between various other crew members, take notes when necessary, and make sure the studio or set is running smoothly.

First Assistant. On multi-assistant sets, the first assistant answers directly to the photographer and acts as the crew chief for all of the other assistants. After being briefed by the photographer he will assign work to all of the other photographers and may be directly responsible for handling the cameras and finalizing the lighting on the set. Protocol dictates that the other assistants not talk directly with the photographer but work directly with the first assistant.

Second Assistant. This assistant will handle specific tasks as designated by the first assistant. These may include setting up lights and accessories, preparing props, helping to build sets, running electrical cable, or sandbagging light stands on locations. He works directly under the supervision of the first assistant. Large shoots may have several second assistants and even a cadre of third assistants.

Digital Technician (or Digital Tech). This position was created when digital cameras became mainstream in the photography process. A digital tech handles all of the back-end work as it relates to the digital cameras and files. He will assist a photographer in selecting the best camera (or camera and digital back) for a particular look and job. He will tether the camera to computers (which he controls) and will download the images to hard drives, archive copies to backup drives, help to set white balances, and convert RAW camera images to files that a final client can use to make selections and approvals. He will also act as the digital "trouble shooter" on the set or project.

Many digital techs combine their job, as described above, with the service of renting digital equipment packages to the photographer. Since photographers shoot a wide variety of projects for a wide variety of final uses, few of them actually own the high-end cam-

eras that they shoot with. This is particularly true in the largest markets. The digital tech will own a variety of camera systems and attendant lenses and will rent these and charge a rental fee that is separate from his services fees. Digital techs are expected to be well versed in many software programs including popular tethering programs like Capture One as well as the latest iterations of Photoshop, Lightroom, Nikon Capture NX, and many others.

The use of a digital tech is a "no brainer" to a busy photographer working on complex shoots because it allows the photographer to concentrate solely on visualization and creating rapport with his subjects. Additionally, since the rental fees for cameras are part of the overall expense, renting high-end, medium format digital cameras allows the photographer to select the right equipment for each job without any regard for what he might personally own. This flexibility gives the photographer the best tool for each client while preventing him from having to invest a lot of capital in rapidly depreciating assets.

Stylist. This is the person who finds appropriate props or costumes and "dresses" a set for an advertising project. A wide knowledge of various styles and an eclectic taste are plusses. This person will spend time shopping in obscure shops, tracking down props on the phone and on the Internet, and then integrating them into a set.

Makeup Artist (or MUA). The makeup artist uses his or her skills to hide flaws and highlight the positive attributes of subjects' faces. Their work makes you look better, too!

Hairstylist. Separate from the makeup artist, this professional will style a model's hair and then make sure that the hair cooperates for the duration of the shoot.

Wardrobe. The wardrobe person is responsible for making sure that any clothing used on the set or in the photograph is cleaned, sized, pressed, and ready to go on a moment's notice. She may collaborate with the stylist on acquisition of wardrobe.

Craft Service. These are the people who keep everyone on the set fed and caffeinated. That includes coffee and breakfast for the people readying the set for a shoot, lunch for all involved, dinner (if necessary), plus snacks and energy drinks to keep people moving. On very well-budgeted shoots there might even be bars wheeled in at the end of the shooting day for celebratory beers, glasses of wine, or cocktails. The craft service people create menus, prepare and serve all of the food and snacks, and clean up after everyone.

Set Builder. A set builder will generally work with a crew of carpenters or technicians in order to build custom sets for projects. These can be as simple as a faux living room or as complex as a rain forest with erupting volcanos.

Nurseryman. If you are building a rain forest on your set, you'll need someone to supply and wrangle the plants. That's this guy's job.

Producer. A producer works with the photographer to figure out how everything will come together and what kind of budget will be required. She will run the show and oversee every aspect of the shoot that is not directly under the photographer's supervision. From writing checks to the suppliers, to making plane reservations and reserving crew, to budget meetings with the clients, the producer makes everything happen.

The Rep. Many advertising photographers are too busy to do their own marketing, which requires a lot of face-to-face portfolio shows, so they develop a relationship with an independent representative who handles that part of the business. Typically your rep works with you to define your brand and then is the public face of your business in all dealings with your clients. They get a percentage of your fees for their efforts. Some swear by their reps, and when business is slow, some swear at their reps.

That's how advertising photography looks in the biggest markets with high-dollar clients, but if you are working in a smaller market with less well-heeled clients, you'll probably use fewer specialized crew members and downsize some of the more expensive aspects of your shoots.

Equipment. What's in the gear inventory at the top? It might seem crazy, but fewer and fewer of the top photographers actually own their gear. Together

Renting Your Gear to Yourself

Let's face it: keeping up with the latest gear is a major financial drag, and the real goal of running a photography business is to put more cash in your pocket. Investing in a basic studio lighting system can easily run $5,000 to $10,000, and keeping up with the megapixel race can cost you thousands more each year in camera costs. In the video production business all the gear you use to create projects is rented. The secret is that many times the video production company will own a second company that rents equipment. In this way the client foots the costs of keeping up with the competition each time they bill a project.

As I mentioned before, many photographers in the major metro markets do not have long-term leases on studio space, don't own any lights, and generally rent the camera that suits the project at hand rather than tying up their funds in depreciating inventory. If you think about it, this is a model that we could all use to create more profit and cash flow on our jobs—and there is a good rationale for it. In the old paradigm of professional photography, known as the "film days," a photographer could make a basic investment in gear and then use that gear for a decade or longer. Your only investment was routine maintenance. When improvements did come they generally arrived in the form of improved film emulsions, and every existing camera system benefitted equally.

Now you need a fast computer, lots of hard drive storage, consistent studio lighting, and upgraded cameras in order to compete. And in your market, you may not have ready access to a rental facility.

We started adding a line item to our estimates and bills for equipment rental on all advertising projects. Not a single client has so much as raised an eyebrow. A standard camera package including a Nikon D3 or D700 with a variety of lenses rents out at $150 per day, and a set of Profoto electronic flashes (a 1200 watt-second box and three heads) with a collection of softboxes, speedrings, and other accessories rents out at $100 per day. In one line item addition we've added $250 per day to our billing, which allows us to maintain better margins and put away enough extra money to allow us to make future acquisitions.

This new billing addition offsets the increased cost we all face in a market that is shifting and changing so quickly that this year's "breakthrough" equipment is next year's expensive paperweight.

If it is easier for you psychologically, you really should consider starting a totally separate company to rent out your equipment. As you find your equipment inventory growing, you might find that you've got a lucrative side business that may also benefit other photographers in your area. Often a sports or news photographer has a job that falls outside their usual area of expertise and requires studio lighting and accessories. If they can rent them from you on the days when you are not booked, you'll realize additional profit.

In the same vein, be sure to bill for all the other things you might use in a typical assignment, including seamless paper and other expendables. You should never subsidize your clients when it comes to equipment expenses!

with the advertising agency creative people, they decide on a look for each project (usually based on images in their portfolios) and rent every piece of equipment, from the cameras and lenses to the on-site computers they will tether to. The lighting will be rented and may come with its own crew. At the end of the shoot the photographer may walk off the set or out of the door of a rental studio with nothing in their hands other than a small, portable hard drive which contains all the RAW images from the shoot.

Working in smaller markets or with smaller clients will mean that you either don't have access to big rental houses or that the budgets you're working with don't support big expenditures for gear rental. In smaller markets clients will probably expect you to bring your own tools to the game. But, even in small markets, clients will understand the need to rent specialty equipment if needed.

As budgets shrink and the pace of digital development accelerates many photographers are starting to embrace a practice from the video and film worlds. Even when they own their own tools they are renting these gear "packages" to themselves by the day and billing their clients for this expense. It just makes sense to do this if you can. You are not being paid for your tools; your fee should be based on the value of your images in their intended use as well as the added value of your experience and expertise. Creating a separate

rental business, with you and your clients as the primary customers, makes good sense because it allows you to more quickly recoup the costs of new equipment and allows you to cost effectively replace worn-out gear.

▶ Corporate Photography

This is my favorite category of photography and the field in which I've been able to earn the most money, most consistently. In this niche you work directly with large corporations and supply them with all different kinds of images. Though they will usually have a large advertising agency that services their account, the agency will be tasked with creating global or national ad campaigns with large budgets. The agencies will want to hire specific photographers to match the look and feel of the concepts they create. You may or may not be what the ad agencies are looking for. They will be focused on finding a very specific look that is very much "of the moment."

Above—Though a style is everything in the realms of fashion and advertising, you never want your style to overpower the content in a CEO portrait. The whole point is to put the attention on the person, not the presentation. For a shot like this, I use a fairly straightforward lighting design that consists of two lights. One is used in a big umbrella or softbox to the subject's right, and the second is used in a small softbox to illuminate the background. A white board or reflector is used on the opposite side of the subject's face, providing fill light.

But those advertising shoots are short lived and, by their very nature, don't engender much additional work from the same client. And those ad shoots are the tip of the iceberg when it comes to the day-to-day imaging needs of major companies. They will also require a never-ending stream of executive head shots, product documentation shots, press style coverage of major announcements, and lots and lots of event photography.

Encouraging Repeat Business. Working for major corporations is so different from advertising photography that it is nothing short of amazing. An ad agency is generally looking for the current "hot photographer." They want a polished and practiced "one-trick pony" who can overlay his cutting edge style onto their client's ads. Once the style is mainstream it becomes dated and the photographer is no longer in demand.

In corporate work the opposite is true. If you get your foot in the door at a corporation (generally through the marketing services or public relations departments) and you do a good job at an acceptable rate, you will most likely be invited back again and again. The people inside a corporation are generally looking for good, consistent work that is in a widely accepted style which evolves relatively slowly. They seek repeatable results. They adore "known" resources and reward consistency. In many cases, if you are invited to do a portrait of the CEO (and if the CEO, his staff, and his family like the portrait), you will find the executives all down the hierarchy will demand that their next portrait be taken by the same photographer.

Once you've been accepted by one department, and done good work for them, your name will get passed on to the next department. The new department may be charged with getting great photographs of their products. Product photography is a discipline that's totally different from portraiture, but in the eyes of the corporate guys you are already a proven commodity, and if you say you can do a different kind of task, they will believe you until you prove otherwise. For one high-tech company in my market I provide executive portraits, product photography, complete coverage of all their events (internal and external), and even the artwork on some of their walls.

You get a client like this by building trust assignment after assignment, year after year. And, while corporate rates tend to be smaller than the day and usage rates for advertising photography, you may have gotten a hold of a client that uses you monthly for a decade or longer. All that's required of you are these three things:

1. Never promise something you can't reliably deliver!
2. Always deliver more than you promise, both in images and in service.
3. Never forget to thank your client each time they use you.

If your client needs microphotography of products using a specialized light that you've never even heard of, you'll be laying your future assignments with them on the line if you try to wing it. You'd be much smarter to help them find the right specialist. If you've built a strong relationship with the client, they will continue to support you. If you try your hand at a technique and fail, especially under a tight deadline, you will have squandered the trust you built and may never recover.

When I say you should always deliver more than you promise I mean that if a client needs a photograph delivered by noon the next day, you should aim to deliver that photograph by 8AM instead. If you see beads of sweat on their foreheads as they make their request for a noon delivery, you would be an even bigger hero if you could deliver the shot by the end of the day. Not all jobs will be a rush, but they will remember that you made their lives easier when it really counted! If you are asked to do a product shot, you should deliver what was asked for but also deliver several variations that they might like even better. If you develop a reputation within the organization as a valued team player, you will be giving yourself a tremendous amount of free word-of-mouth advertising without even trying.

And when I say "never forget to thank your client each time they use you," I am thinking of several good clients who have stuck with me for so long that they've helped me afford a nice house, a good car, and a college fund for my son. Who wouldn't want to thank business partners like that?

What does it take to be successful as a corporate photographer? You'll need to know your way around cameras and lights, but you'll also need to know your way around corporations. You'll need to know when it's okay to show up in "business casual" and when it's critical to show up in something a little more formal. If you work with assistants, you'll need to ensure that they are equally tuned in to the dress code because they are a direct representation of your business.

I had lunch recently with a friend who is a well known advertising photographer. We met up at our favorite burger joint. Since I was coming from a shoot with a major CEO I was wearing a nice sportcoat and a tie. My friend was dressed in cargo shorts, a tee shirt and a pair of sandals. He laughed at my formal dress. This is Austin, TX, after all; we pretty much invented casual. He mentioned that he had to buy a suit to attend a niece's wedding. I mentioned that I have seven suits and nearly as many different sportcoats in my closet. That's one of the requirements of shooting for corporate clients. Ad agencies are only interested in creating an image. Corporations are all about appearances. And it's always better to be a little overdressed than even one degree underdressed.

What You'll Need to Deliver. *Headshots.* You'll need to provide flattering and consistent headshots. Once you start with a certain custom backdrop you'll need to use the same basic lighting style and that backdrop for every executive headshot you photograph for that particular corporate client, whether in the studio or on location. The web designers and graphic designers want the consistency because in many cases multiples of executives will be used on the same pages. And nothing is more jarring than warring backgrounds and wildly different lighting styles juxtaposed to one another. You'll need to be able to deliver retouched files that work well as small Web images, but

you'll need to shoot them at high resolutions in case they decide to make large prints.

Product Photographs. You'll need to provide product shots that are well lit and are similar to, or better than, the competitors' images. If your corporate client makes large appliances, you'll need to learn how to best handle the challenges of lighting large objects, and you'll need to know how to correct for perspective in Photoshop or in camera. If your client makes microprocessors, you'll need to get up to speed on shooting things at high magnification, and you'll need to know how to retouch cosmetic manufacturing flaws that wouldn't normally be visible to the human eye.

When shooting products of any type you'll also need to know how to make good clipping paths, which are required for applications where backgrounds are dropped out to white. And you'll need to make sure that every step of your workflow is calibrated so your results are accurate.

Knowledge of Location Lighting. You'll need to possess a good working knowledge of location lighting because more and more marketing departments are asking for good environmental portraits in addition to head shots taken against canvas or paper backgrounds. This means being able to "take your show on the road" and still come up with pleasing and consistent results. If you need a little help, you might want to check out my book, *Minimalist Lighting: Professional Techniques for Photographers.* It's basically a primer on using small lights on location.

Architectural Photography. You'll be asked, from time to time, to take images of the client's factories, headquarters, and other buildings, so you'll want to brush up on your skills in architectural photography as well. This includes interiors and exteriors.

Event Photography. You'll need to understand how to photograph all the components of weeklong corporate events and be able to provide well-exposed, well-lit, intelligently composed images of everything from the signage at an event venue to available light shots of speakers delivering their presentations, to cocktail parties, to concerts. The event staff will want well-executed shots of the stages (the construction of

which may run hundreds of thousands of dollars), the food served, as well as shots of happy attendees lining up to register, networking in the convention spaces, and much more.

Given time and experience you'll figure out who the "heavy hitters" are, when and how to photograph them, and when (most importantly) to get the heck out of the way and blend into the background.

In my estimation the large showcase events are the most fun and the most challenging part of corporate photography. I love heading to a convention city like Orlando or Las Vegas and spending a week totally immersed in the kind of convention or showcase that shows off the best of my client's company. We hit the ground running, shoot for twelve to fourteen hours a day, edit down specific events, and constantly feed those images to our client's PR people and webmasters, and then keep everything archived and

sorted. The nice part of shooting a major show is being able to put four or five days of shooting fees and two or three days of editing fees all together in a row. A side benefit is that, as a trusted part of the company's imaging team, your client will put you up in the same (nice) hotel that their people stay in.

My wife complains that my clients have spoiled me. After having stayed at hotels like the Breakers in West Palm Beach, the Ritz-Carlton in Orlando, the Langham in Pasadena, and a Four Seasons Hotels here and there, it's tough to get excited about staying in a La Quinta or a Holiday Inn Express for family vacations.

If you make yourself indispensible to a company by dint of your knowledge of their industry, its players, and its social customs, then you'll find yourself doing a fair amount of enviable travel. Over the past few years, several of my corporate clients have taken me along to wonderful international destinations such as Rome, Paris, Lisbon, Madrid, Monte Carlo, London, and St. Petersburg, as well as really wonderful destinations in the United States and, in each case, I've been well compensated for my photographic skills and the travel.

Understanding Corporate Culture. As I've said before, the main requirements for corporate photography include the ability to do good, workman-like photography under tight deadlines and in diverse locations. Equally important is understanding the corporate culture of the company you're working with and fitting into that culture—that means dressing like them, understanding all the human resources issues required by companies, being able to eat with clients in formal settings, and knowing when to shoot and when not to shoot. Some of this you'll learn over time, but you'll definitely not be invited back if you:

- show up in cutoff shorts and a promotional t-shirt to a formal event
- volunteer your unsolicited opinion about any part of the business
- draw unnecessary attention to yourself or your photography
- evince a prima donna attitude
- cause any delays (Most high-end events are timed down to the minute.)
- violate any of the rules (A few big stumbling blocks include hitting on the interns, eating a big plate of shrimp at an executive reception, drinking on the job, telling off-color jokes, etc. Everyone in corporate environments has at least one college degree and they expect you to act like a peer.)
- fail to deliver the goods.

Equipment. What's in the corporate photographer's gear box? It's all digital now. Any of the major camera systems will work well. I use a pair of Nikon D700s, but by the time you read this they may be old news. I have three main lenses: the 14–24mm, 24–70mm, and 70–200mm f/2.8, but I routinely supplement these with the 60mm and 105mm macro lenses and a few older macro lenses that I use on a bellows close-up attachment. I bring three or four portable flashes that can be controlled by the cameras or by Nikon's SU-800 flash controller. This is my core event package and the basis of the package I use on most other jobs too.

For head shots, environmental portraits, interior architectural shots, and product shots, I add a range of electronic flashes from Profoto that include: three Profoto Compact Plus monolights, two of the Profoto Acute AB (600B) battery-powered pack-and-head systems, and several of their traditional power packs with four heads. Obviously I pick and choose the components I take to each job. I also have a collection of light stands, umbrellas, softboxes, and reflectors that I use depending on the look and effect I'm trying to get.

In addition to your office computer, you'll also need a laptop in order to archive and deliver work on location during multi-day events.

This is a category of photography where more is not always better. Many times you'll need to forego the control and power of a heavier lighting kit to provide more mobility and flexibility. A 13-inch MacBook that fits in the back pocket of my Domke bag trumps my better spec'd 15-inch MacBook Pro. Though clients might appreciate the files from a state of the art, medium format digital back with 60 megapixels, they'll quickly tell you that they don't need that kind of resolution and they don't want to deal with the giant files. Also, you wouldn't want to carry all of that weight on jobs that may move through five or ten locations in a day.

Breaking In. The best way to enter this part of the field is to assist for someone who does all of the above. Provide the photographer with the same great service you'd give a client, and when the time comes he or she may pass along a potential client whose business creates a conflict of interest for them. Never poach your boss's clients! It's in poor taste and it's tremendously bad karma.

▶ Some Axioms for Doing Business

I've been working in this business for a while, and I've discovered several axioms. Here they are in list form:

- The larger the market, the more profitable it is to specialize.
- If you specialize, ensure you are casting a wide geographic net. Make the country or the world your market. Look beyond your city and state.
- Play to your strengths. If you are a wonderful "people person" and you are delighted to make new friends, you probably won't be a happy product or still life photographer, but you might be a wonderful wedding guy. Let your strengths lead you to your specialty!
- People like to buy expertise, so make sure your marketing reflects this. If you want to be a wedding photographer and an advertising or corporate photographer, then consider investing in two different company identities with two different web sites.

Above—*This was shot on 4x5 inch sheet film for a high-tech client. The watch is a prop made from a microchip. This is the kind of shot that was a bedrock of stock sales in the 1980s and 1990s.*

- When starting out, try to immerse yourself in as many of the niches as possible to facilitate the "aha!" moment when everything becomes clear and you discover your preferred specialty.
- If you are working in a smaller market, be sure to master several related specialties. You'll want some diversification in your primary market. Just don't try to market too many "personalities" to the same decision makers.
- Time in the market can build your reputation and your clients' ability to remember your name, so be consistent and market yourself with a view to the long term.
- Charge for what you know, not what you do. If you are the best at a particular specialty, be sure

you charge accordingly. That means charging more for the things you do well, not charging by the hour for something you can do quicker and better as time goes on!

- If you are aiming for the biggest markets it pays to perfect your work in your current market and "arrive" as an expert rather than as a journeyman.
- Do what makes you happy, not what seems like the coolest part of the business. If you are truly having fun, it will be easier to make money because your enthusiasm will be contagious.

All the preconceptions in our industry get rethought decade by decade. When I started out in Austin, TX, it was critical to be able to handle all kinds of work. That "trial by fire" of diversification has been very helpful in successfully competing in the corporate photography sector. It was absolutely the wrong approach if I had wanted to pursue a career as a fashion photographer. If I started over today I'd choose one specialty that included a lot of people to people work, high fees, and relative consistency. In my market it would probably be a combination of high-end, retail portrait photography and wedding photography. In a much larger market I would try my hand at editorial and commissioned portrait work exclusively. At this point I feel so invested with my corporate clients that starting over would be too scary.

Think about this as you contemplate where you want to be in five, ten, and twenty years. Make sure that the "fun quotient" has the potential to stay high.

▶ *Where Does Stock Photography Fit In?*
Stock photography is an interesting side story to commercial photography. It's important to know how stock photography came about, how it grew and, ultimately, how it has largely disintegrated into a commodity that, for most practitioners, is no more profitable than cultivating corn.

Stock photography had its ascendency during the 1960s as a byproduct of the growing annual report market. As corporations came to regard their yearly, four-color brochures as their flagship communication

tools aimed at their stockholders and potential investors, the cost, complexity, and production value of what was once an accounting document grew by leaps and bounds. It became commonplace for publicly traded companies to send the best of the best photographers jetting across the globe to artistically record their interests and investments.

These pros shot thousands and thousands of highly creative images, showcasing life in foreign lands, diverse workforces, and breathtaking landscapes. Designers chose dozens of images to include in the reports, and the rest of the images were returned to their creators. The majority of these photographers were adamant about keeping the copyright to their images. Once their clients used the images in their annual reports, the photographers were free to sell the images to other industries who might be able to afford a healthy stock fee but not wealthy enough to afford the globe-trotting assignment costs regularly undertaken by the Fortune 500s.

At its inception, stock was not perceived as either cheap or as a commodity. Once the ball got rolling and agencies formed to service the growing secondary market, more and more photographers were anxious to share in the big fees that stock could bring. And since they owned the copyright, the images could be sold again and again as long as the rights were managed so as to prevent a use that might compete with a previous buyer's license period.

The popularity of stock among design professionals skyrocketed, and by the 1990s professionals around the world were skipping assignment photography altogether and pursuing stock as its own segment of the photographic industry. Agencies grew larger and larger and started marketing all around the globe. As costs grew the distribution of fees between the agency and the photographer started to change, with the agencies taking a larger and larger cut. As long as the total market kept expanding photographers griped but signed the contracts offered.

Stock agencies were pushing stock photographers to produce at higher and higher levels of quality. 35mm gave way to medium format film. Available light gave way to intricately lit scenes, and "production quality" became the mantra. Then something unexpected happened. The web struck the industry with the growing force of a hurricane. As bandwidth grew cheaper, more and more agencies moved their inventory of images to the web and created online marketplaces with expedited digital delivery and payment. Even though the price of providing the product went down, agencies sensed that the power in their relationships with photographers had turned. The advantage went to the entity that could aggregate the most images and distribute them to the widest audiences. Individual photographers knew they would never be able to create and implement the technology to compete with the agency, and the agencies were flush with cash from public offerings.

Then a truly revolutionary event became a "game changer." Inexpensive, high-quality digital cameras were marketed to consumers, and they've used these cameras to create billions and billions of images. At the same time, the momentum of visual advertising shifted from high-quality print to low-quality Internet display. Enterprising amateur photographers intersected with enterprising entrepreneurial agencies and prices drifted lower and lower as the volume of images used around the world exploded. Great images meant less to volume distributors than "good enough" images. Choice was substituted in many situations for creative vision. The last three years have truly been "stock photos by the pound." It is an unsustainable model.

The original stock photographers are throwing in the towel. If you are willing to do the research and shoot tens of thousands of technically perfect photographs of generic stuff each year, you may be able to make a decent living shooting stock. But you've really got to ask yourself if that's why you wanted to get into the business. Did you really want to be the micro Walmart of the photo industry, or was your original desire to make beautiful images in your own inimitable style?

If you want to proceed into the dollar stock market, here are some tips:

- Shoot what you don't see on the stock web sites. Having a distinct vision is usually an advantage.
- Don't get too fancy. Most dollar stock customers are looking for "good enough" and are not willing to pay extra for perfection.
- Do shoot everything as both horizontals and verticals to give you more selling options.
- Photograph really beautiful people, as their images tend to sell better than those of "real" people.
- Get model releases and property releases from everyone you photograph and every property owner whose property you record.
- Don't sign exclusive contracts. The more portals showing your work, the greater your prospective sales.
- Don't change your style to please a "perceived" need in the market. What you are looking at today from your competitors is already dated. You should be aiming into the next cycle. The forerunners here always profit.
- Keep production costs as low as possible.
- Get a contract from every agency and portal you deal with so that both sides know exactly what is expected from them and what protections exist.
- Remember that it is a numbers game and that the more images you have on the market, the higher your chances are at having sales.

Just remember as you sally forth with twenty thousand dollars of the latest gear, intent on making stock pay, the ultimate buyers don't know you from Adam and are just as willing to buy the right images from amateur housewives, students, laid-off IT guys, and assorted other people who have scraped up enough money to buy a Canon Rebel or a Canon G10 point-and-shoot camera. As with all widely available commodities, the market for cheap photographs is now the story of a market rushing to find its bottom.

For my time and money I think that dollar stock is a waste of time. Others disagree. There are established photographers who make additional money from their work by sending all of the outtakes to dollar stock agencies. They figure that any income from material that would just end up sitting on their hard drives makes good financial sense.

The reason I disagree has to do with a concept that I think of as "mind share." Humans can only juggle a certain number of balls (or projects) successfully at one time. Every ongoing task that you undertake requires a little part of your brain to "check in" from time to time to monitor progress. It takes up some of your mental "bandwidth." If I write a column for a web site, I find myself returning on a regular basis to see what sort of comments have been left by readers. If I buy stock in a company, there is an irresistible urge to check in and see how the stock is doing from time to time. If I'm in a relationship, it takes a certain percentage of mind share to make sure I'm doing the right stuff. This sectioning of mind share is endless and self-perpetuating, and if you add something as open ended as stock photography, with its implicit promise of financial gain, you've got to donate a significant amount of mind share to the undertaking. That leaves you with less unencumbered "juice" and creative attention to do the kind of work that makes you happy and fulfilled. It's a mean spiral.

In my world, the nice photos come from concentrated periods of focus and attention to the task of seeing clearly. Anything that distracts is a negative.

Want to make big money in stock? Don't shoot it, own the agency. While the photographers work their butts off and take financial risks, you get half or more of every single sale. It's the aggregators who have done well in this market, not the producers.

3. Learning the Kind of Photography You'd Like to Do

So you've identified the niche you'd like to pursue, and now you're looking for the best and most efficient game plan that will get you up and running in your specialty of choice. The questions become: "Do I go to photo school?" "Do I assist or apprentice?" "Can I enter the field as a self-taught photographer?"

The answers are: yes, yes, and yes. The ways in which people come to photography are as endless as the number of people in the business. But each choice comes with its own pluses and minuses.

Let's start at the most basic level. Most of the technical stuff you need to learn is readily available in books and on the web. There's no mystery about lighting that can't be quickly explained in one of the hundreds of books and millions of web sites about photography. But here's the catch: you need some sort of filtering process in order to separate the crap from the gold. You can depend on the confluence of opinion or you can just read everything you get your hands on—and then experiment.

The advantages of this approach are the limited amount of expenditures, the preservation of your unique point of view, and the simplicity of it all. But nearly everyone who takes this approach tends to overthink the basic processes. They feel (rightly or wrongly) that they are not privy to the "real" secrets of the professional. And most importantly the self-taught photographers generally doom themselves financially by not paying enough attention to the *business* of photography.

▶ Photo School

With few exceptions, photo schools (generally two-year associates' programs at junior colleges) are very good at pumping out homogenous photographers who are fairly competent at the technical requirements and have at least had contact with the idea that the business end of the profession is somewhat important. I've been invited on occasion to lecture to some photography classes at a community college here in Austin, and no matter how much "real world" information we give to students under thirty years of age, most stay in a state of denial and go merrily down the path to financial ruin. That is the nature of being young and thinking of yourself as immortal. Still, these people are learning about a wide range of topics that will give the smarter ones or the more talented ones a fighting chance at making a career in photography.

Having taught photography to university students I have a very grim regard for most fine art and photojournalism programs. In the four-year programs there is an aversion amongst faculty to even broaching the topic of business. A high percentage of the faculty go into teaching as soon as they successfully complete their MFAs, and only the tiniest percentage have ever participated in the real world of commerce. They have never had to deliver a project to a paying client under an unassailable deadline, never had to please a psychotic art director, or fight to get paid for work done months earlier. They are experts at obscurity and in the general belief in the sanctity of subjectivity.

My advice to those headed to a major university to learn photography is to detour, buy a ton of books, read them, and then take the $100,000 or so that you or your parents were going to throw at an education and buy a nice camera system, a set of lights, and the services of a few marketing professionals. Better yet, major in business as several of my colleagues did, and come into the field miles ahead of your competitors. Just don't expect to emerge from a four-year univer-

sity program prepared to do anything other than teach. Oh, and by the way, for every 3000 students who successfully graduate from a four-year undergraduate program (and remember that you typically need to go on and get an MFA in order to teach) there will be fewer than three job openings! Pretty dire.

This doesn't mean that an aspiring photographer should avoid a college/university education. I'll make a point here that many will find archaic: Get a liberal arts degree that encompasses literature, history, art, music, and a basic introduction to sciences such as psychology, sociology, and anthropology. There are two reasons why I recommend this: The first is that a well-rounded liberal arts education prepares you to think and exposes you to what has come before. A grounding in art history is priceless for an aspiring artist of any kind. Learning to write well will make your proposals more polished and cogent, and an understanding of basic economics will help you understand the underpinnings of business. The second reason you'll want to have a solid liberal arts education is that most of the people you'll be interfacing with in advertising, marketing, and the art world will come from a similar educational background, and the common touchstones of culture will make you seem more like them, and thus easier to comfortably do business with.

You can learn all the technical information you need to know about photography by reading books and working as an assistant.

▶ Assisting

When it comes right down to it, the best way to learn the profession is to assist or apprentice to a very good, very successful working photographer. If you are lucky, you'll learn through osmosis how to engineer the workflow of a good shoot, how to do or outsource the postproduction, the care and feeding of clients, how and what to bill, and how do the vital and continuous job of marketing.

Don't get me wrong. You should still read everything you can get your hands on, and every free moment should be spent working on technique and style,

but there are some intangible things that you'll only learn from on-the-job training that will be invaluable in your career.

In some European countries there are still apprenticeships wherein a person wishing to learn a trade, craft, or profession actually pays to learn from a master in the field. Those days are long gone in the United States. The closest you'll get to the valuable assistant relationship is to sign on as an assistant to a working photographer.

Assisting at the Most Basic Level. Here's the truth about assisting working commercial photographers in the digital age: You are being hired to do the repetitive grunt work of the business. You aren't being hired because you have a nice portfolio. You aren't being hired because the photographer feels a need to mentor new photographers. You aren't being hired to learn from the photographer (but if you pay attention, you can't help but learn a lot). You are being hired to make the job of photography easier and more efficient for the photographer!

The photographer rarely needs help deciding which lens to use or how to compose or expose a shot. You won't be collaborating in an "executive" sense. What you will be doing a lot of is packing camera and lighting gear, light stands, and cables into cases. You will be tasked with getting those cases from the studio to the car, and from the car to the shooting location. Once you reach a location your task will be to unpack and set up the various pieces of equipment that the photographer has indicated he would like to use.

Once the lights are set up according to the photographer's instructions and all of the props have been wrangled into place, a good assistant will step back and wait for further instructions. After the shoot is completed, the assistant will carefully pack all of the equipment back into the cases in the precise order prescribed by the photographer and will reverse the order of the steps outlined in the paragraph above until all of the gear is safely back in the studio and properly put away.

It's important to understand that the photographer is intent on the project at hand and will be plan-

ning, in his head, every step of the project before he walks in to begin the project. Until the shoot is over there is no "good" time to ask questions about photography. The appropriate time to ask questions is on the way back to the studio in the car.

Assisting Do's and Don'ts. Here is my list, garnered over twenty years, of the do's and don'ts of basic assisting for a commercial photographer:

- You are on the job to make life easier on the photographer. Your mind-set should be that of willing assistant. If that means running out for coffee, cleaning mud off extension cables, cleaning the windows on location, or holding up a reflector, you should do it without hesitation or argument. Your need to learn always takes a back seat to your photographer's needs.
- Every photographer has their own way of packing gear to go on location or for storage in the studio. Ask the photographer about their preferences and be sure that everything goes back in its place when packing.
- There is always a dress code. If you are shooting under the hot Texas sun on one of those 90 percent humidity days, it will certainly be shorts and a tee shirt. If you are shooting on a client location, your clothes need to echo those of the workers at the location. (In a corporate location an assistant might be in pressed khakis and a polo shirt with a collar; at a wedding, the same assistant would probably be dressed in black dress pants, a white button-down shirt, and a nice pair of lace-up shoes. If you are photographing hip-hop artists, you might be dressed in baggy jeans and track shoes.) The point is not to dress down, not to dress like a war correspondent if you'll be working at a medical practice, and never to embarrass your photographer.
- Be ready to "fall on a grenade" from time to time. If there is a big mess up and you know it's not your fault, it might be politically savvy to take the blame if doing so makes your photographer look good. Example: Your photographer asks you to

plug a bunch of lights into one circuit while you are setting up for an executive shoot in a factory. Just as the marketing director shows up with the impatient executive in tow the circuit breaker trips for the outlet you've plugged the lights into. The tension rises and the marketing director looks annoyed. You might provide an out for the photographer by turning to him and saying, "Sorry about that. I'll reroute some of the lights and get those breakers back on for you." Now he doesn't look like a numbskull, and if he's a good person he'll remember and reward your kindness.

- Never take your eyes off the gear while you are working in an uncontrolled location. When you are outside the studio, the photographer can't keep his eye on the camera finder and his cases of gear at the same time. It's your job to make sure that no acquisitive bystanders make off with souvenirs of his expensive gear. Both eyes on the gear, not on the attractive model. If there's no hired security, you are security.
- In the studio, keep your eyes on the lights. If the photographer's setup contains hair lights, background lights, and accent lights, you'll need to check constantly to make sure that all of the lights are firing as they should. Calmly tell the photographer if you detect a problem.
- Assisting is a very physical job. You'll be asked to corral heavy cases of gear and cart them up and down stairs, in and out of cars or trucks, and onto carts. You might also be tasked with standing near the photographer with a full camera bag over your shoulder, ready to hand him the next lens or other accessory as needed. Make sure you are in good shape to handle this kind of activity. Get lots of aerobic exercise.
- Don't look at the models or portrait subjects while they're being photographed. Here's the reason: Most models and especially inexperienced subjects are always looking for direction and reassurance. All of the direction should come from one source, the person responsible for realizing the vision of the photo shoot. That person is the photographer.

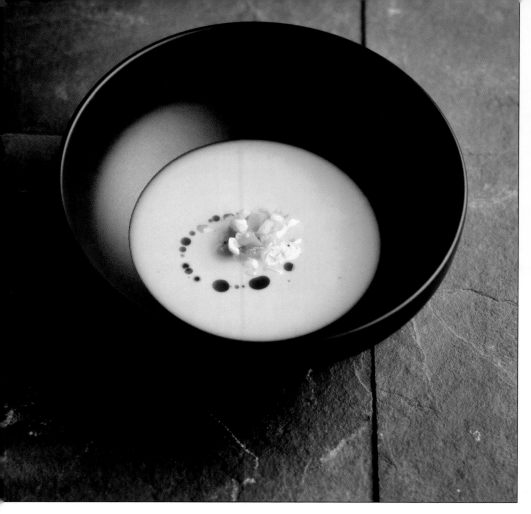

Left—Corn soup. Photographed as one of the dishes prepared as an alternate, healthy selection in a Thanksgiving dinner. The magazine, Resorts and Spas, *commissioned a shoot with seven different studio-style "hero" shots and many images of the chefs preparing the dishes. I styled the shots.* **Right**—*Photographers want to work with someone who's easy to get along with. If you grumble about going out to get coffee, you'll miss the whole point of assisting.*

If you make eye contact with the sitter then their attention is split between you and the photographer causing them to shift attention and eye contact from the camera/photographer to you and then back again. It disrupts the rapport the photographer is working hard to build. When the real shooting begins it's best to step behind a scrim and keep your eyes on the things the photographer can't to ensure that all of the lights are firing, the set is not on fire, etc.

• Don't volunteer advice or opinions unless requested. All humans are remarkably suggestible. I remember to this day a photo shoot I did in Houston, TX, over twelve years ago. My favorite assistant was unavailable so I called up a rather well-known assistant who was highly recommended by several national-level photographers. This assistant had worked all over the world for about ten years and had assisted several real photographic legends. I was setting up an environmental portrait in a boardroom and I asked him to set up the lights for me. I left the room to go and scout a second location. When I returned he had set up the lights in slightly different locations and had used different light modifiers than I would have used. He also had "just a few suggestions to make the shot better."

I started a thought process that went something like this: "Well, I've always lit these kinds of shots with a bigger softbox, and I've always placed my main light a lot farther to one side, but I know that 'Bob' has worked for so and so from New York and so and so from London so maybe he's reflecting the lighting he's learned from those masters. Maybe I'm doing this all wrong." Needless to say, my confidence was shot, and I started second guessing myself at every turn. By the time we got back to Austin, I was just hoping something would turn out on the film that my client would be able to use. Needless to say, even though

he was a hard worker and knew the nuts and bolts of photography at least as well as I did I was never keen to use him again. I want people around me in the service of my vision, not for the extension of another photographer's vision.

- Don't discuss the photographer's work with outsiders. Nothing will kill your relationship (and future referrals) with your photographer quicker than divulging the information you've learned about your photographer's business to his clients or competitors. You may be standing around a factory waiting for a shot of an assembly line worker to happen when someone asks you a question about the photographer's fee. If you blurt out, "He's really good! He's charging $2500 a day!" that person may go back and tell everyone he works with on the assembly line, including the employee who your photographer just spent ten minutes convincing to be in the shot for a token $10 modeling fee. All of a sudden, the worker might not feel so well disposed about modeling for someone who charges more in a day than he might take home in a month.

If you want to learn all about your photographer's best practices, as well as the little nuts and bolts that hold the business together, he'll need to trust you to safeguard his confidences. It's in your best interest to have a mutually trustworthy relationship.

- Never show up late. Never. Call if it is unavoidable. Better yet, show up early.
- Get a good night's sleep. The photographer is paying you for a certain level of performance. It's not fair to them if you've been out drinking and dancing all night long and you stumble in for an early morning call exhausted and hung over.

Getting the Most Out of the Relationship. If your long-term goal is to become a successful photographer and you've been lucky enough to start working with a good, established shooter, you'll want to make the most out of your experiences with him or her. Acknowledging that half the job description is taking care of the equipment, you'll need to make sure that you know how (and when) to operate all of the gear your photographer uses. Ask your photographer to show you how he packs his cameras and lighting equipment and how everything works. If the equipment is new to you, it might be a good idea to make a list of the gear you'll be shepherding and then go online and study the owner's manuals.

I guarantee that your photographer would much rather take an hour or so to run you through the process than take a chance that you'll inadvertently destroy an expensive piece of gear in the middle of an important assignment.

Here are a few things that have gone wrong for me when I assumed that a new assistant was experienced in handling gear:

My all-time favorite was the day we needed to bleed off power from a big electronic strobe pack. We had already turned all the dials to minimum, but we really needed just a little "puff" of light to make the shot work. I asked my new assistant to plug in an extra head to cut the power by half. (Plugging in a second head divides the power between the two heads on my small Profoto strobe pack, effectively cutting the output in half.) I was busy behind the dark cloth of a view camera and wasn't really paying attention to my assistant.

He pulled a flash head out of the case, turned off the pack, plugged in the new head, and then turned everything back on again. I shot for a few minutes until I smelled something burning or melting. I looked around the room in a panic until my eyes hit the second flash head—the one sitting over to one side, smoking, with the protective plastic cover still on.

It hadn't taken long for the 250-watt modeling light, trapped under a plastic protective cover, to melt the plastic and also destroy the wiring and the flash tube.

On another day, I asked a new assistant if they were "up to speed" with view camera operation. They said yes. I asked them to put a Polaroid back on the studio Sinar while I made some lighting adjustments on the set. The next thing I heard was the crunch of a break-

Spotlight: Wyatt McSpadden

I met Wyatt McSpadden many years ago, and after taking one look at his portfolio I was ready to hang it up and get a real job. Most photographers I know get influenced, bent, controlled or off track as a result of intended or unintended pressure from clients. Wyatt's vision is Wyatt's vision, and somehow he's been able to hold on to the thing that makes his work special despite any external influence. We should emulate that if we want a style we truly own. The images below and on the facing page are three of my favorite McSpadden photos.

Left—*Wyatt McSpadden. If someone woke me up in the middle of the night, put a gun to my head, and demanded to know the best photographer I'd ever personally met, my gestalt reaction would be to scream out, "Wyatt McSpadden." Everyone should know a few photographers who are profoundly better at the craft. It keeps reminding you that there's always more to learn, always more to do. Wyatt has done a book on Texas BBQ that totally transcends the subject matter. All film, no lights. Absolutely amazing.*

Above left—*Mary Jane Johnson, photographed for Texas Monthly magazine. ©2008 Wyatt McSpadden.* *Above right*—*Portrait of a serial killer for Texas Monthly magazine. ©2008 Wyatt McSpadden.* *Facing page*—*Texas BBQ cook for the book,* Texas BBQ *by Wyatt McSpadden. ©2008 Wyatt McSpadden.*

ing ground glass. That was one of the few items we didn't keep a backup for in the studio. The camera was out of commission for nearly a week during a very busy season.

I've lost count of the number of creative ways assistants have snapped or bent rods for our softboxes. The inclination is to use a little more force if something is not working rather than asking for guidance.

So much for stories. The moral of the stories is, ask questions. Better still, be sure to ask questions before you get to a high pressure location. Take the time to learn the gear back at the photographer's office where there is ample time to learn about the equipment step by step. Once you are working in a high-pressure location with a harried photographer who is shooting under a tight deadline, any question that requires a long answer will probably be answered by the photographer ripping the equipment out of your hands and doing the task himself.

If you are smart, take notes, and follow up with a little research on the web, you should be able to learn the rudiments (and safety rules) for all of your photographer's gear. You'll want to remember this process because, with luck, you'll need to train your own assistant one day.

Most of the stuff you need to know to operate gear is covered in the owner's manuals. The real reason to work as an assistant is so you can get a ringside seat to observe the intangible parts of being a successful photographer.

When you are on a set with a photographer and a client, you should observe the way your boss handles input and requests from the client, how he gets a great expression from a model or portrait subject, and how he handles problems under pressure. Note the way he deals with a client asking for a change on the set. This is where theory meets reality, and though there are as many different styles of interaction as there are photographers, there will be basic qualities that come through. Is he unflappable when a piece of equipment decides to take "early retirement"? Is he able to tune out distractions while he's shooting? Is he able to delegate well to you and other subcontractors on the set?

Does he make the client feel like a collaborator rather than a nuisance? Can he make good decisions on the fly? How does he do it?

Early in my career I had the good fortune to assist a nationally known editorial shooter (who has since turned into an advertising photographer with an international following) named Will Van Overbeek. We traveled through south Texas shooting for a lifestyle magazine called *Domain*.

I had recently left my job as the creative director of an ad agency and was returning to a photographic career I had left seven years earlier. I had a decent level of competence with the gear Will was using and, like most new photographers, I assumed that the clever use of the equipment was the real secret to getting "the shot." Our multi-day trip proved to me just how misguided I was. The secret to Will's successful portraits was his ability to arrive with an idea in his head and to bring the subject around to his vision no matter how many roadblocks were put in his way. He didn't compromise his vision to make the job easier to execute, and he didn't let the subject dictate the aesthetics of the photographs. He didn't butt heads with people; rather, he masterfully deflected their attempts to control the session. The camera and lights were always secondary to the rapport he worked hard to establish with the subject. Will cut his teeth as an editorial photographer and even on a large advertising shoot for a multinational client the gear is a distant second to the human connection and a clear, unassailable vision of "what the picture should look like."

When I returned home I was amazed at how strongly this short trip changed my perception of commercial photography.

Much later in my career I had a studio in a large building in downtown Austin that was home to four other photographers and a host of other creative people. One of the photographers who had a studio there was Wyatt McSpadden. Even though I had been working with good clients for over a decade I could see from the outset that Wyatt's work had a dimension that was levels beyond mine. His lighting was superb in that it created a mood or a look without ever

drawing attention to itself. I once saw a photo he had done of a murderer on death row, and I sat and stared at it for the better part of a quarter hour trying to understand how he had crammed so much feeling and nuance into a two-dimensional magazine page.

Then late one afternoon Wyatt dropped by my studio with a request. His regular assistant had gotten sick, and he desperately needed someone to help out with a shoot the next day in Dallas, TX. He had been assigned to photograph Colleen Barrett, who at the time was the second-in-command at Southwest Airlines. Even though I felt like I was an established professional photographer in my own right I jumped at the chance to learn from a master like Wyatt.

We packed up a jumbled assemblage of battle-scarred Bronica SQ medium format film cameras, film backs, and lenses into several camera bags. We packed several huge Norman electronic flash systems that appeared to have been used in a number of war zones and an assortment of crooked light stands. Somehow we were able to get all the stuff past the Skycaps and we headed to Southwest Airlines headquarters.

The folks in the PR department had already decided where we were going to shoot and how the shoot would go. I watched Wyatt suggest (with a wave of his hand like a Jedi master using the Force) that we all just look around the building and see if there wouldn't be a better spot for the shot. The PR folks backed down and followed Wyatt all over the building. He finally found a big executive conference room that was just right for his shot and requested it. He was told that it would be impossible to schedule that room on such short notice. Ten minutes later we were loading gear into that same room.

He directed me to set up a large softbox and to load as many film backs as I could find because once we got started he didn't want to stop and interrupt the flow.

The image we got of Ms. Barrett was astounding. I learned to push for the vision and to move obstacles out of the way without becoming objectionable. I learned that knowing exactly where to put a light is much more important than which light you use and

that having the right vision and following it through is the difference between a photographic "order taker" and an artist.

When I walked into the job I did so with a bit of attitude; after all, I owned a very complete and very shiny Hasselblad system at the time, and Wyatt was "making do" with a battered Bronica system. I was using the latest Profoto electronic flashes from Sweden, and Wyatt was using Norman lights that had all the appeal (to me at the time) of corroded car batteries. I entered the job looking for little tricks and techniques that would help me be a better photographer and I left, much humbled, with my first glimmer of an important understanding: Wyatt's integrity of vision and his skills with people transcended all equipment. Like a tenth-degree black belt in photography, he had learned all of the technique long ago and had made its application subliminal. This left the path clear for him to react and create instead of consciously mapping his every move with all the interruptions and dissipation of passion that conscious thought entails.

The whole point of these stories is that very little of what makes Will and Wyatt's photographs successful has anything to do with what gear they use and everything to do with their unobstructed vision and their ability to bend people to collaborating with them to realize that vision. Learning this is the highest reward of assisting, and it's something that can only really be absorbed and understood by osmosis, by time spent observing a master at work.

Learning the Middle Ground. There is one area in which learning the nuts and bolts of the profession can really pay off, and that is in the area of business practices. Not every photographer will be willing to share every shred of information with you, but if you are trustworthy and useful as an assistant, it's likely that your photographer will share the very valuable concepts that differentiate his business practices from the less adept.

Here's what you want to learn:

1. How to charge for photo assignments and usage of images.

2. How to bid a job successfully without giving up the kitchen sink.
3. How to find and market to clients.
4. How to control cost in order to maximize profit.

You can read about each of these parts of doing business, but there's little substitute for seeing the principles put into action by someone with experience. The best way to get the information you need is to ask direct questions at the appropriate times. Ask about the nuts and bolts of bidding a job after your photographer has clinched the deal, not while he's hard at work fleshing out the initial bid. When you are traveling or have other "down time" together, ask your photographer how he might approach hypothetical bids. Watch for your photographer's "organic" methods for reducing cost. It could be the process of eliminating unnecessary expenses such as first-class travel, delaying the purchase of nonessential equipment, and outsourcing time-intensive operations (for example, retouching could be better and more quickly done by a retouching artist, freeing up the photographer to pay attention to important "profit drivers" such as arranging portfolio shows with prospective clients).

Here are the basic hints for getting the most out of your time assisting:

- Keep your eyes open and learn as much as you can by osmosis. Just soak up the knowledge, but don't expect your photographer to act as an unpaid teacher for your benefit.
- Ask specific questions, but only at times that are comfortable and convenient for the photographer.
- Always act with total commitment and honesty. Work for your photographer the way you'd like an assistant to work for you. It's good training for everything else in life.
- Try assisting a range of photographers who work in a diverse number of styles and with diverse subject matter. This may help you sort out just the kind of photographer you'd like to be.
- I keep a notebook with me all the time, and when I light stuff or have ideas about photography, I pull out the notebook and write down all of the details of the shoot. That way I don't forget how I did a project. I recommend to assistants that they keep a notebook to jot down the stuff they learn on the job for later review. It's a good habit to get into.

The Other Side of the Coin. If you are already working and have no inclination to work as an assistant, then it's time you really paid attention to how to get the best work and the highest efficiency out of using an assistant on assignments. Here's how I handle it:

- When I'm working in my (admittedly small) studio, I find that my biggest need is to have my assistant follow along behind me and clean up the trail of used and then discarded equipment that seems to accumulate in small piles. Left unattended the piles grow and make it hard for me to find the basic things I need to do my job. Where's my meter? Where did I put that lens? Why can't I walk across the floor without crushing valuable props? I'm a sloppy worker so I want an assistant who's a detail-oriented person. The first thing I do with a new assistant is to show them (in detail) where all the equipment lives, how I like the cords wrapped, and when it's important to get stuff put away so it doesn't get inadvertently destroyed.
- Sit down with your assistant first thing in the morning (we usually do this at our neighborhood coffeehouse) and go over the day's work assignments in detail. Tell your assistant exactly what you expect at each part of the assignment. I usually make a list the night before and give them a copy. It might read: "Pack the xxxxx lights (see packing list) with stands and cables. We'll need a makeup kit, a laptop with batteries and chargers, and a special light modifier. Remember to bring a posing stool! I've packed the cameras, but make sure the case gets on the truck. At 9:00AM we set up a gray seamless xxxxx on location. We use a xxxxx flash head in a small softbox as a back-

ground light, centered on a lowboy stand. We'll need a large softbox with a xxxxx flash head set up to the left of the camera and a pop-up white reflector on the right as fill. At 10:00AM we break down and move to the second location. This is an environmental. We'll need two lights with standard reflectors, covered with ½ green gels to balance for the fluorescents." The list goes on, hour by hour, and reflects what I expect from the assistant at every point during the day. We also have an equipment checklist we work with for every shoot. It tells the assistant what I want loaded in the truck and provides any special instructions. Over time a detailed list becomes less necessary as we learn what to expect from each other.

- During our coffee meeting we go over what we're going to shoot, what style I'll be trying to create, a little bit of background about our client, and any special ground rules (e.g., the client is a staunch Republican/Democrat, do not talk about politics). When we are both on the same page my assistant and I can work as a team instead of me constantly having to tell him or her what I want done. The preplanning meeting is also a good time to talk about any changes in equipment I've made or any experiments I want to try.

 Many times I'll ask my assistant to remind me of something I might forget in the excitement of a shoot such as, "Don't forget to shoot an array of verticals and horizontals."

- I expect my assistant to keep an eye on me and anticipate what I might need instead of chatting up the cute model. I expect the assistant to be discreet and not bring up any subject that might interject tension or dissension into the shoot. That also means never discussing or criticizing other photographers and/or their work.

 If I buy new equipment that I want the assistant to learn to use, I'll hire them for a half day and pay them to come to the studio and learn how to assemble, handle, use, and disassemble the new products. We often do mini workshops showing the assistants how to set up lights for a white back-

ground, how to meter more accurately with hand-held meters, how to save files, and much more. I would rather have them exude the expertise that comes from good training than to learn on the job and make embarrassing mistakes in front of paying clients.

If you hire smart, talented assistants, you will be able to learn from them if you keep your ears open. I'm fifty-three years old as of this writing, and I'm always grateful to my assistants who share new music with me, as they tend to be much more tuned in than I am to the cutting edge of music culture. My music collection now includes bands like Radiohead, Shiny Toy Guns, and Daft Punk—bands I would have never found on my own.

I had one great assistant who helped me raise my rates and my presentation to a new level. The same assistant was also very fashionable and eventually got into the habit of critiquing my wardrobe and haircuts. While it sounds funny, she was right on the mark more often than not, much to my advantage.

The bottom line, though, is that my assistants are there to make the physical job easier for me so that I can spend more time thinking about creative work. They haul the gear. They do the setup stuff. (I fine tune.) They put everything back in its place at the end of the day. And they will go and fetch coffee for me (although it's just fair to pay for theirs as well).

The Friction Zone. Most problems between photographers and assistants happen when issues about financial compensation get muddled. You'll want to agree before you work together just what each of you expect when it comes to money. Here's how we've handled it:

- Agree on compensation in your first meeting, not on the way to your first job.
- Decide whether you consider your assistants to be independent contractors or actual employees of your business, and get your paperwork in order.

Working Kit

Assistants should carry a working kit in a waist bag. It should include the tools you need them to have for your kind of photography. For the kind of work I do (portraits for advertising and corporate public relations) I like for my assistants to carry clothespins to clip poorly tailored jackets and shirts; gaffer's tape to anchor wayward ties and lapels; a few safety pins; a compact with translucent face powder; a Gerber multi-tool (a tool that's a combination of pliers, knife, and screwdrivers) to tighten up screws on light stands and background stands, cut seamless background paper, and more; chewing gum and mints; lens cleaning cloths; and maybe an extra flash meter. The kit goes wherever the assistant goes and provides a quick fix for the kind of small problems that occur on set and on location.

You may ask your assistants to carry slightly different tools, but they should have the necessities right at hand. You'll know what to put in the waist pack once you've got a number of shoots under your belt. They can be shoot savers.

Above—Have your assistants put together waist pouches with simple tools and extras. They will always be ready in a pinch.

For years, photographers who worked sporadically and used a revolving selection of assistants considered all of their assistants independent contractors. Recent IRS rulings are changing that structure, and their definitions may determine whether or not you are required to treat assistants as temporary employees with the requirement of withholding taxes and Social Security/Medicare contributions. You will also be smart to cover these employees with a worker's compensation insurance policy. All of this must be figured out and agreed to before your assistant starts work with you.

- Understand that you (not your client) are hiring the assistant; therefore, it's your responsibility to pay them regardless of whatever arrangements you've made with your client. This means you'll need to have working capital or will need to get expense advances from your clients because you will have to pay your assistant whether you get paid or not! Payment of an assistant is never contingent on when or if you're getting paid for the assignment. Agree on what constitutes a day's work and when overtime kicks in.

- Pay in a timely manner. A quick survey of fellow photographers in my region leads me to believe that the majority of them pay on the day of the shoot for a single-day assignment and at the end of each week for a multiple-day assignment. If you'll be shooting out of the studio for several weeks, you'll need to pay the assistant upon your return. With a solid advance from your client safely nestled in your bank account there is no good reason not to pay your assistant promptly.

- Have them sign a basic nondisclosure agreement. This form legally prevents them from discussing your trade secrets and proprietary information. You'll probably never enforce it, but having your assistants sign this agreement reinforces to them that you value their discretion and consider it part of the bargain you are making.

Common Sense Stuff. Don't ever make romantic advances toward your assistants. It's tacky and it gets around the industry gossip circuit at the speed of light. Just because the economy might be a bit slow right now and people are anxious to work on just about any project doesn't mean it will always be like this. In a robust economy it can be tough to find qualified assistants who aren't all booked up. They want to work with people they like and trust. If you have a sleazy

reputation, you may find your sources of assistants all dried up, and that can be a real hardship.

When working on location, most photographers cover their assistant's cost of meals during the job (and meals generally mean at least half an hour to stop all work and enjoy good food). When we work in town we have lists of conveniently located restaurants we can hit that serve healthy food. We would only hit a fast food joint under duress or dire need. I also pay for coffee and snacks.

Never put your assistant in harm's way. That means not asking them to stand on the top step of a ladder, not having them handle ungrounded electrical equipment, not carrying too heavy a load, and not standing in the middle of a wading pool with a battery pack/inverter combination like an AlienBees Vagabond. Provide hardhats and hearing protection when necessary. Even if you've had them sign forms swearing that they are independent contractors and they've signed waiver after waiver, you'll find that these paper "hedges" are not nearly as bulletproof as you might imagine when you are defending a lawsuit for negligence, or worse. No commercial photograph is worth injuring someone over. And no commercial photograph is worth dying for.

Have a plan that makes good use of your assistant's time on every shoot. Just having someone along as entourage can actually be detrimental to the creative process. Be clear about why you need and want to have an assistant along for the ride, and then use them intelligently.

Consider that it might be more important to use an assistant for the parts of the business in the studio that you aren't too excited about. I'll be frank. I hate cleaning up and organizing my office and studio. I'd much rather have an assistant do that than have an assistant along with me while I'm trying to establish a nice rapport with an available light portrait subject. I'd much rather turn over the tasks of burning archive DVDs, making web galleries, and addressing marketing materials than have someone along on a landscape shoot to assist me with the overwhelming task of changing a CompactFlash card (sarcasm intended).

If you've been assisting, there should come a point when you know it's time to strike out on your own and get your business in gear. You'll know you're ready when you can handle the gear in your sleep, you know the nuts and bolts of accounting and contracts from every angle, and when you start to think you could do the job better than your photographer. You'll wake up one day and know you're ready. Give your photographer lots of notification. Ending a photographer/assistant relationship on a good note will position both of you for more success.

▶ *Professional Organizations*

The least productive way to do anything is to ignore everyone who's gone before you and set out on the dusty path of reinventing the wheel. Why learn everything the hard way when there are organizations out there that can provide you with valuable information about starting and running a photo business? If you are serious about making money in a photography business, then run, don't walk, toward one of two professional organizations: the American Society of Media Photographers or Professional Photographers of America.

The American Society of Media Photographers (ASMP). The ASMP exists to help professional photographers help each other. The national office is located in Philadelphia, PA, and has been around for over fifty years. The organization started out as a sort of union for photographers who worked in editorial photography but has grown to include any kind of photography created for publication. This encompasses all kinds of editorial photography as well as corporate, advertising, and public relations photography. There are several levels of membership. Just about everyone is eligible for "associate" membership. This level will get you access to the local chapter meetings, access to all of the relevant business materials such as model releases, sample agreement forms, and more. The "general member" level requires that you show tear sheets or other proof that you publish regularly and that the majority of your income is derived from photography for publication. Part of the requirements

Above—*A Texas farmer's market. Many editorial assignments give you a good excuse just to walk around with a camera, shooting whatever catches your eye. Fresh produce is a wonderful subject. It's also fabulous stock.*

for this level of membership is sponsorship from a current general member. General members are the only level of member eligible to vote in the society's referendums and the elections of board members.

The benefits of ASMP membership are many. They include getting updates about the state of the industry; getting great discounts from car rental companies, computer companies, insurance companies, and many other suppliers; allows access to local and national ASMP programs that can be both educational and inspiring; and meeting peers, suppliers, and support people in your geographic area.

Though the forms, the knowledge base, and the opportunity to meet other commercial photographers in your area can be very helpful to all photographers, the ASMP works best for photographers who provide images for businesses.

Professional Photographers of America (PPA). If you've chosen wedding photography, portrait photography, or any other part of the business that is more focused on the retail (direct to client) sector of the industry, there is an organization that will be a better fit: PPA. This organization is much larger and more polished than the ASMP, and its mission is to support members who run businesses that offer more direct retail services. This organization works more like a guild and seeks to educate and certify its members through workshops, print competitions, and business seminars. Each level of achievement, called a certification, earns a new rank that members can append to their name. While these certifications have little to do with ensuring anything stylistic, they do infer that the recipient has a certain level of technical expertise and that they have pledged to follow certain prescribed ethics in their businesses.

The intersection between these two organizations is their vigorous defense of the existing copyright laws as well as their tireless efforts to protect the livelihood of their members. The PPA offers a bigger range of discounted insurance and business products. The ASMP is more focused on lobbying and legislative issues.

No matter which organization you choose to join, you will have access to tremendous amounts of business information and workflow strategies for business and the protection of your rights. The cost of membership is tax deductible and the time, sweat, and tears you save by taking advantage of your membership is priceless.

Finally, the Internet and books are both excellent sources of information about every aspect of the photography business. See the resources section at the end of this book for more information.

The dirty little secret of photography is that just having tremendous photographic talent doesn't guarantee financial success. For every successful photography business run by a photographer with a modicum of talent, there are hundreds of failed businesses that had been run by amazingly gifted photographers who almost pathologically resisted learning about the nuts and bolts, accounting and paperwork, and details of the business. The biggest blind spot for most of these artists is, without a doubt, marketing.

Whether it comes from the fear of being rejected, the belief that their work is so incredible the world should be beating a path to their door (or sending a purchase order to their e-mail account), or from some

Left—Our first TV spot "deserved" a postcard, which was also an invitation to a celebration. Never underestimate the power of good parties. The social linking that goes on is priceless to cementing your image as a desirable contact in your field. *Right*—Photographers should consider spending more time marketing than they do shooting. When we complete any job with "fun potential" we produce a postcard and have one mailed off to those in our core target audience.

COME TOAST OUR TV PREMIER

MARTIN BURKE IS FULLY COMMITTED

A NEW CULINARY COMEDY BY BECKY MODE

PHOTO BY KIRK R. TUCK

Left—A show of images from a trip to Rome makes a great joint venture with a cool new restaurant. They provide the food, we provide the art and a crowd. **Right**—*A follow-up postcard for the Rome show.*

powerful aversion to the whole idea of marketing, these people have sabotaged their own success.

There are three legs on the "tripod of marketing success": the quality of your work, the effectiveness of your business model, and the power and reach of your marketing. There are no shortcuts. If your marketing is great but your images are mediocre, you may get people to try you once, but they won't be back. If your images are great but no one knows your name or how to contact you, then you have failed. If you've constructed a business model that tries to sell a product no one wants or needs, then all the marketing and inspiration won't save you from financial dissolution.

▶ Effective Marketing Requires Six Steps

Step 1. Your first marketing task is to decide who your target market will be. Ask yourself what kind of photography you want to do and determine the level at which you feel you can enter the market. If you want to photograph for corporations, you could identify local, regional, and national companies that you'd like to work for, then find the right person(s) at each of these companies to introduce yourself and your work to. Rather than try and engage the widest market (a strategy that works well only for companies with deep

pockets and a product or service that appeals to a very wide variety of consumers), you'll do best to narrow down the companies to the ones that use the kind of photography you offer. To start out it makes sense for you to select companies headquartered near you. So your list might include one hundred companies that are natural matches for the kind of work you want to produce, have the budget to be able to hire you, and are located within an hour's drive.

If you are a wedding or portrait photographer, the process will be the same up to a point. You will need to identify the kind of bride you want to work for and and how to reach her.

Step 2. Your second task is to brand yourself. Branding is the process of building up a public face for your business. Every time the public sees your logo, your business forms, your ads, the way you package yourself, and how you present yourself on your web site, they are seeing your brand. And just as McDonald's works hard to ensure that the way the public sees them is very specific and positive, you'll need to create and preserve your brand if you want to get the most out of your marketing.

Start the whole branding process by digging down and really getting clear on exactly how you'd like your

company to be perceived. Work with a really good designer to have a logo, paper system, and ad materials designed. Once you've established a look you'll need to be consistent. From web site to presentation folder, always use colors from the same color family. Stick with the type style your designer has chosen. Never bounce around from style to style.

Here's why you want to create a brand and resist changing it for as long as possible: Consumers need to see your ads or your targeted marketing pieces seven to twelve times before it even begins to dawn on them that you exist. Your brand becomes a symbol or shorthand for what your company stands for.

In creating your brand it's important to choose an identity that fits you. People can tell when the brand and the company don't match up. When it comes to design, simpler is better. From your business card to your coffee cup, your message to the potential client should be consistent so that each "impression" is tallied in your column. Good branding is about getting your prospective clients to see you not as the best solution but as the only solution to their problem!

Step 3. Your third task is to find out what buyers are looking for and how they can be reached. Once you have a list of companies you'd like to work with, you'll have to figure out who coordinates buying photography at each company. You can be fairly certain that most large companies will have a marketing department, and that's the best place to start. You are looking for a name, a contact telephone number, an address, and an e-mail address.

Suppose you specialize in photographing executives and other prominent business leaders. You may decide you'd like to expand your customers to include attorneys. You'll find all the major law firms in your market listed in the telephone directory. You'll want to make calls to find the appropriate person in each firm. It may be one of the partners, but it may be the office manager. If you are cordial and polite, you'll find that the receptionist will be willing to let you know who you need to work with. Be sure you get the spelling of their name correct. Getting a marketing piece with your name misspelled creates a negative impression.

Step 4. Get the word out. Your initial foray might include a postcard mailer with a great sample shot that is relevant to this market (e.g., an interesting and well-done portrait of someone who looks like an attorney). The postcard is your first impression. A week or so later you might follow up with a more involved mailer complete with samples, good descriptions of the features and benefits your photography services provide, and perhaps an offer to get them to try you. A week after this mailer goes out you might want to follow up with a phone call to make sure that your potential client received the materials you sent. You can then try to schedule an appointment to show your portfolio and talk about their company's photography needs. (*Note:* We'll take a look at the most commonly used marketing tools later in this chapter.)

Step 5. Make very clear who you are, what you have to sell, how to buy your product, and how to get in touch with you.

Step 6. Repeat steps one through five over and over again.

Completing the above steps sounds easy, and given an unlimited budget it probably would be. But marketing is difficult because the targets keep moving and advertising "weapons" keep evolving and making older solutions obsolete.

▶ *Mass Marketing versus Targeted Marketing*

If you do still life, fashion, architecture, corporate, or just about any other specialty within the realm of commercial photography, you can try the shotgun approach and advertise in a traditional, wide-reaching media like a daily newspaper. The problem with this approach is that you are essentially paying lots of money to reach people who have no interest in or can't afford your product. While a small group of people within the general audience will be prospective customers, it just doesn't make sense to spend enormous amounts of money when this small group can be identified and reached much more efficiently.

You'll also find that using mass marketing to reach a small segment of your audience will waste plenty of your time. The busy people you wanted to reach may

ment in newspaper ads. Here's the comparison: The total cost of a good quarter-page newspaper ad in your market could run from $1600 to $8000. The total out out-of-pocket cost for your mailers to the targeted law firms will probably be much less than $500, and you will have made three cumulative impressions directly on the decision makers by the time you're done.

Here's a strategy for targeted marketing:

- Identify the people you'd like to reach. Determine the kind of photography the demographic is likely to need and buy from you.
- Design customized marketing pieces that speak directly to each of the markets you identify. Send images of lawyers to lawyers, images of doctors and medical "lifestyle" to medical practices, cool product shots to manufacturers, etc.
- Create a campaign that introduces your business and leaves the door open for additional impressions. A subset of your active marketing should always include a push of your best passive marketing.
- Get in front of the people with the money and inclination to hire you! The person-to-person sales call is the single most effective way to get work.

▶ Marketing Tools

Internet Marketing. *Your Web Site.* Your web site is most people's first introduction to you and your work. Whether you build your own site or have one designed for you, be sure that your site's front page immediately speaks to what you do and what your brand is all about, and viewers should be able to easily navigate through the site to view portfolios of the kind of images you'd like to do in the future.

The site should load quickly and have a logical order to follow. Buyers who have never met you before are much more interested in your actual work than in a blog that shares your personal life. If you blog on your site, be sure that it is cogent to your

not read all of the local paper. If they are like the executives I know, they read the *Wall Street Journal* and then the local headlines and business news. If your ad runs in the sports section or the "lifestyle" section, your target audience may not even see your ad. But there are plenty of people in the general market who have time on their hands and read the entire paper. The result may be a flood of calls from totally unqualified buyers who will waste hours of your time calling to find out what your "package price" is for portraits of their kids, dogs, families, etc. These shoppers will be comparing you to the studios at J. C. Penney's, Sears, and other discount providers. The time you spend fielding these calls is lost opportunity. And you will have paid dearly for it.

Using a targeted marketing approach is a more effective, efficient use of your efforts and money. Though the approach is more involved than running an ad in the Sunday paper, the results can be much more focused. And, while you may invest more time in this approach, you will find the cost savings to be an order of magnitude lower than an inefficient invest-

prospective clients' businesses and not just technical articles aimed at other photographers.

I personally hate a lot of gimmicks and flash implementations. I won't tolerate music, and I hate having to search for contact info.

The art buyers I've spoken to most want to get to the meat of the site so they can qualify you as a photographer of interest or someone to screen out of all future business. There's never a stack of "maybes." The quicker the art buyers can get to your portfolios and review them, the better. The fewer visual gimmicks, the fewer points they will subconsciously critique. You don't want to be eliminated from consideration for using a goofy font and an icky color.

The bottom line: your web site is your online portfolio. Make it clean and direct. Tell the client what they need to know. Make it easy to get through. Put your best foot forward.

Two pages from my web site are shown on the right. It's a work in progress; I'm always adding and subtracting work from it.

Tip: I think you should design your own site. If people like your work on their initial visit, they will bookmark your site and visit it from time to time as assignments requiring photography come across their desks. Doing your own web design means you can make changes frequently without cost so the site remains fluid and beckons prospective clients to revisit your site. Refreshing the images on the site frequently shows the viewer that you are a serious contender with lots of work. People want to do work with busy people. There is safety in the virtual pack.

I use a program from Apple Computer called iWeb. It's a template-driven program that requires no prior knowledge of programming or the writing of

Top—*The front page or splash page of your site should immediately engage the viewer. Photos should dominate the page, and type should be succinct and to the point. The navigation bar across the top is self-explanatory and simple.* **Bottom**—*Once you select a portfolio from my portfolio page, you have the option of playing the images in a slide show or seeing a running banner of shots above a selected shot. This portfolio is all black & white portraits. I specialize in photographing people, so I try to make that the foundation of the site. One site, one message.*

html. It's basically a "fill in the blanks" deal with lots of potential to customize. If you have a folder full of right-sized images, getting a web site up and running with iWeb could take as little as one evening's work. Programs like these put all of the potential of web marketing right in your hands.

If you are courting corporate clients or advertising agencies, you'd be wise not to include nude images or political images as part of your image mix. Here's why: Even if an art buyer loves your personal work and your nude work, part of their job when you are being considered for projects is to send the link to your site to their clients and managers. The clients and upper management may be much more conservative than young art buyers at agencies and may be turned off by work that is too avant garde. Earlier in my career I did a poster for Zachary Scott Theater to promote their production of the play *Angels in America*. The poster had a beautiful photo of a nude man (very tastefully presented with no frontal nudity) with angel wings. The poster won advertising awards. I put the image on my site in one of the portfolios.

I got a phone call from one of my favorite advertising agency clients and this art buyer (who was a big fan of the play, etc.) asked me to please take the image off the site temporarily as she needed to send a link to my site to one of the agency's biggest clients as part of a pitch. She was worried that this client (a big discount store headquartered in a Midwestern city) would be offended by the image and it might cost me the opportunity to be involved. Lesson learned. My site is an ad for a business, not an art gallery. Different rules apply.

Search Engine Optimization (SEO). Search Engine Optimization means that there are a number of ways to design your site, and to add copy and links to your site, that will elevate its rank in a Google, Yahoo, or other search. The problem with SEO is that it's a moving target. People find out what things move a site up the ladder in a search, and within weeks all the web designers implement the same changes, insert the same keywords, and everybody is back where they started. A detailed discussion of SEO is beyond the scope of this book but well worth looking into if an appreciable percentage of your clients come to you from web searches.

Paid Per Click Ads. Another device that many photographers are using to drive numbers of people to their web sites are ads that come up in the right or left side of a search by a given search engine. An example of this is Google Adwords. You pay Google a set amount and they guarantee a certain quantity of right-side ads that pop up when people do searches that contain keywords you choose. Again, this works well for people who have a wide range of products and services that are desirable to a large demographic. It works progressively less well when the product or service is more specialized.

E-Mail. Sending out e-mail marketing isn't exactly like sending physical mailers. Most clients get dozens (or hundreds) of e-mail solicitations every day. There's no way they can deal with so many unsolicited e-mails and still have time to do their routine work. Most e-mailed promotions end up in a spam folder, and the ones that get through tend to get lost in the shuffle. Very few art buyers bother to archive unsolicited e-mails meaning that the message you worked hard to create existed for mere seconds before being relegated to the electronic waste basket of the universe. That's the deal with unsolicited (spam) e-mails.

Some of your clients and prospective clients may welcome your e-mails. You can set up a guest book on your web site where interested viewers can leave their e-mail addresses.

You can also do well with e-mail referrals. Our strategy in using e-mails is to stay in touch with clients, people we've met and exchanged business cards with, people who have sent inquires about our business via e-mail, people who have visited our site and signed a guest book, and friends and family. The purpose of our e-mail messages is to: (1) Remind the audience that I still exist and that I continue to offer photography services. (2) To show off new work and let my audience know that I am constantly working (and practicing) on fun projects that may have relevance to their future projects. The times we've experimented

Cover of Kirk's newest book.

My publisher just announced that my second book on professional photography will be published on April 1st of 2009. The book is a companion to my first book, Minimalist Lighting: Professional Techniques for Lighting on Location. The first book has been a technical book bestseller since its publication last May.

I am currently finishing up a third book for Amherst Media that will be about the ins and outs of commercial photography.

I guess the point of this e-mail is to say, if you need someone to photograph a person or product for you and then sit down and write a bit about how the photo was done, I might be your guy.

Thanks for all of your support!

Kirk Tuck

www.kirktuck.com

With all the bad news swirling around the market it's sometimes hard to remember that great projects are happening every day.
At left is the cover of this year's annual report for the Kipp Austin School.
It's a great educational initiative that is changing young lives in Austin.

Photography: Kirk Tuck
Creative Direction/Design: Gretchen Hicks
Agency: Sherry Matthews Advocacy

Top—*If you're going to use an e-mail promo, it's good to have real news to share with the folks on your list. This e-mail is an announcement of a publication date. It tells my clients that I'm an expert in my field.* **Bottom**—*Completing an annual report project, with design by a "name" advertising agency, is a good topic for a self-promotional e-mail.*

with large e-mail "blast" marketing have generally been disappointing, with many people writing to demand that we remove them from our list. The responses from a "blind" list of a thousand recipients are never as good as the results we routinely get from a list of two hundred and fifty "documented" recipients.

Two psychological problems with e-mail blasts are that they are perceived as having little intrinsic value by most recipients (outside your network) because they know that you don't have any real "skin" in the game. You've spent nothing to do the blast, and all clients know this. Secondly, you might be tempted to follow the economic "path of least resistance" and start sending out more and more frequent e-mails while disregarding other pathways. Eventually e-mails that arrive too frequently, even from qualified senders, will become a nuisance and be relegated to the spam folder.

Tips: Your e-mail should have a concise subject line that is closely aligned to the content. People like to know what they're receiving. Your e-mail should contain a headline with the gist of your message, a cool image or two (really small file sizes! Don't clog the mailbox!) and a link to the rest of your promotion that resides on your server or site. This allows the recipient to get as little or as much information as they require. Sending an e-mail that's over 250K as a self-promotion is just plain rude and will probably be the tipping point in whether or not you get invited back to that mailbox. If there is a link to click, the client won't have a stuffed mailbox and will be able to dig into the meat of your message. This also gives you the opportunity to scale your message progressively.

Keep exchanging business cards during the work and social functions you attend to get new, qualified e-mail addresses, and be sure to put friends and family in the mix. The more they know and understand about your business, the more referrals they can make.

Digital Newsletters. The one-page digital newsletter, pregnant with links, is the corollary of the printed newsletter. Today I received forty-five online "newsletters" from my credit card companies, retailers whose businesses I frequent, airlines I've flown, and camera companies. I wasn't in the mood or the market for any of the services, so I clicked through them and sent them to the trash. I didn't relegate them to the junk or spam folders because these messages are from merchants or enterprises that I either agreed to receive e-mails from or sought out information from. And that's the best way to use your digital news-

Left and right—*I hate the idea of sending out nothing but solicitations! As part of our marketing we throw a Christmas party each year at a local theater. We send invitations like the ones shown here to a select group of people. No selling takes place at the parties, we're just having fun. But the event gets more popular every year. Next year we are considering having two parties to handle the demand!*

Top—*I love postcards that are not a hard sell.* **Bottom**—*We love traditional paper postcards because they are quick and easy, and don't end up in spam folders.*

water
people

KIRK R. TUCK
photography
512/328-8881

letters. Use them to keep your repeat clients, friends, and noncompeting associates in the loop.

Direct Mail. In the Internet age photographers would love to believe that traditional media no longer matters, but that's just not true. The more concise your market is, the easier and more efficiently it can be reached by tools like direct mail. If you have two hundred and fifty corporate buyers to reach with one message, direct mail might be just the ticket. If you have a thousand people you'd like to reach with some sort of offer, you'll probably have much better results with direct mail than just about any other form of advertising.

Postcards. In the early days if you said "direct mail" to a photographer, the first thing they thought was "postcards." Postcards are still very popular. As more people migrate their advertising to the web the flow of postcards has slowed down, and that makes them more attractive. Perhaps art buyers take you more seriously if they know you took the trouble to create and print a piece and cared enough to spend an additional forty-four cents to mail it!

There are a number of companies offering five hundred 5x8-inch postcards for as little as $99. Turnaround times are quick, and most companies offer online templates that make quick card design easy.

Tip: Just as important as the image you select for the mailer is the need to make your name big and your web address prominent. A famous New York advertising photographer once said of his own postcards, "I don't really care about the image, just make sure my name is printed big enough so the art buyer can see it in the trash can!" Every mailer needs all of your contact information. You never know when you might get lucky and have your card hit the desk of an art buyer who has just gotten the perfect project for you. On a more serious note, good design is critical, but a great image is even more critical. If you don't have something stunning to send, reconsider your mailing.

We're always predisposed to think of postcards as a "mail only" tool, but I'm more apt to think of it as a multipurpose tool. Of course I send out the bulk of the cards I order, but I always hold onto a stash for

Top left and right—The two post-cards above are my favorite kind: free! I did the images for these two promotional postcards, and the client printed tens of thousands. They were more than happy to provide me with several hundred to send out to my local mailing list. It's a marketing win-win. I keep my photographs in front of my clients. My client gets free postage for their advertising to my selected list! *Bottom*—The very well-designed and exquisitely printed Kipp School Annual Report was a wonderful piece to put in front of my design and agency clients.

other uses. I include a postcard in every job delivery package that we send out of the studio with a messenger service, and I keep a stack of cards in the car to give out to people I meet who are curious about my business. I use the cards as "leave behinds" to give art directors and art buyers after I've shown them my portfolio. I use them as thank-you cards and reminder cards. You should try to get as much mileage as you can from each piece of collateral you produce.

Printed Samples. Direct mail can be so much more diverse than just a four-color postcard. Some of our most effective mailed promotions have been samples

from client projects. We recently did an annual report for a charter school here in Austin, TX, with wonderful monochrome images of their kids. A bonus was the high quality design by a well-regarded agency and printing at a premium press facility. We negotiated to get one hundred of the annual reports and sent them out, with a cover letter, to our top one hundred prospective clients. The response was incredible. The experience reminded me that the quality of the offering is as important as the quality of your mailing list!

Newsletters. I know several photographers who were true believers in printed, mailed newsletters. The newsletter in the mailbox has several benefits: it's rare

for retail customers to have competing newsletters in their mailboxes, the printed newsletters are highly portable, and people may read them and then pass them along to friends who might also be interested in the information or the offer. But in the end, except for highly targeted audiences, the cost of printing and postage seems to outweigh the perceived benefits.

Books. Another direct mail strategy is to use the small books you can create using Apple's iPhoto or Aperture programs. These little twenty page books measure $3\frac{1}{2}$ x $2\frac{5}{8}$ inches and are absolutely adorable. I use them for very small mailings to highly targeted groups of clients. Recently we did an assignment for a high-tech company. We were on location in a great resort in West Palm Beach, FL. I knew most of us would never be back if we had to travel on our own budgets, so I spent some of my down time taking images of the most beautiful aspects of the resort. I stuck the photos into one of the little books and had eighteen copies printed. They fit in a #10 envelope and struck the perfect note of continuing marketing with a client of twenty years. A week after the mailing I got thank-you phone calls or e-mails from every single recipient. The allure of sending something like a small, personalized book is specifically because it is personalized or unique.

Consider that art buyers in major agencies receive dozens, in some cases hundreds, of postcard mailers a day. Nearly all are the same size. Many imitate the latest popular styles. Sending a unique package with one-of-a-kind images is the best way to break through the clutter and be remembered.

My strategy with direct mail is to stay connected with existing clients and introduce myself to lists of new prospective clients. I understand that consistency is very important, so I try to maintain both a design ethic and a schedule for mailing that works. I want existing clients to see something from my company that

Top and bottom right—*Several online printers offer a range of book sizes. I've made a number of small books ($3\frac{1}{2}$ x $2\frac{5}{8}$ inches) using Apple's service and they've turned out well. Clients love them because the product is different than what usually comes in the mail.*

says "success" at least once per quarter. Direct mail is different from e-mail blasts in that it actually sticks around.

Sourcebooks. In the 1980s and 1990s sourcebooks were all the rage. These "fatties" were books with hundreds and hundreds of pages of photographers' work. With names like *The Black Book, The Workbook,* and *The Showcase,* the pages in these nationally distributed, hardback books started around $5000 for a single year's insertion and topped out near $12,000. Before the advent of Internet market-

around austin summer 2008
www.kirktuck.com

ing and photographer's web sites, these were incredibly popular marketing resources, and getting just the right selection of images into a book could mean a very lucrative payoff. A successful ad would move art buyers to call in a photographer's portfolio and position him to potentially do some of the best paid jobs in the world.

With the near-universal adaptation of broadband Internet access, the sourcebooks have largely gone the way of daily newspapers, with ever declining revenues and fewer published pages. Now art buyers cruise "portals" on the web. These are virtual sourcebooks that are collection of sites (paid for by photographer subscriptions) that try to duplicate the reach and exclusivity that was once the provence of sourcebooks.

When the physical sourcebooks were in their ascendency, they were valuable collections because they brought together images from many of the best photographers into one small collection of books. There were never more than four or five trusted and well-used books at the top tier in any given year, and all of the books were sent directly to tightly researched lists of top agency buyers and art directors. Though the web portals have somewhat duplicated the formats online there are now hundreds and hundreds of sites offering the same basic services to buyers without any real mechanism to filter them down. This has made art buyers' jobs more difficult instead of less, and it's now harder for individual photographers to stand out from the crowd.

One interesting aspect of the old sourcebooks is that they were published just once a year. Every once in a while a single photographer would come up with a look that shifted the paradigm of a whole segment of the business. This happened when a photographer named Aaron Jones devised a method of light painting that was revolutionary. His spread in several of the sourcebooks caused his phone to ring off the hook, and the publication cycle of the sourcebooks ensured that his signature look stayed undiluted for the better part of the year. Oh, there were legions of copycats, but none of them could rush their work into the sourcebooks for 365 days after Jones splashed onto

the scene. Nowadays, the latest look is broadcast across the web in days.

Should you buy a page in one of the remaining sourcebooks? Probably not. Like newspapers the audience for the books is aging, and the cost of publishing the books will soon make them irrelevant. Should you shell out a lot of cash to participate in one of the portals that dots the Internet? Well, in the old days, you could get basic information like the number of books being published, the demographics of the free distribution list, and more. In a roundabout way, you could cobble together a "cost per thousand" exposures estimate, and you knew that there were few other ways to hit the target market for the same costs. Advertising portals on the web have been at it for over ten years and still don't have a universally accepted measure of how wide their reach is. There's no real way to calculate the return for your expenditure, and there are so many options available to art buyers that the value is highly diluted.

If I were hell-bent on advertising on Portfolios.com or another one of the online virtual sourcebooks, I would probably call ten or fifteen photographers in noncompeting markets who currently use the ads and ask them about their experiences before pulling one of my credit cards out of my pocket. There are better ways to drill down to the buyers.

Several photographers who are general members of the ASMP report getting great results from "Find a Photographer," which is an online portfolio hosted on the www.asmp.org web site. Included as part of every general member's annual fee, this online resource lets the general member upload six images at no charge and enters them in a highly searchable directory. Since the ASMP has high name recognition among photo buyers and art directors, there is a benefit derived from the association. Buyers generally understand that ASMP general members are experienced professionals who must be sponsored and pass a portfolio review. This assures buyers that the photographers on "Find a Photographer" have a certain level of competence. Anything that can lower the resistance to contacting a photographer is a plus.

Face to Face Meetings. This is the mother of all marketing. No matter what combination of marketing materials you choose or what part of the business you're in, the most powerful single marketing approach you can undertake is to sit across the table from a potential buyer and show them your work.

Three or four years ago there was a raging discussion among photographers. The gist of it was, "The printed portfolio is dead. All that matters is the quality of your web site!" It's just not true. Art buyers have learned the hard way that the low-resolution images on the web can hide many flaws that would have never remained hidden during a portfolio review. (There are exceptions to every rule: many magazines assigning work at a distance, for instance, will rely on photographers' web sites to make their hiring choices.)

When marketing to prospective clients in my own region, my strategy is to use my web site—in concert with my other marketing materials—to get my foot in the door. But my ultimate goal is to sit down in front of a prospective client, open my portfolio, show them a dazzling array of images, and get to know them. Though the Web has improved by leaps and bounds, there's no way to compare small, low-res images on a screen to the effect of big, beautiful, detailed prints that can be examined in great detail. And there's no better way to convince other humans that they will enjoy being around you and can trust you with a large chunk of their budget than to sit down with them and converse.

Here's the step-by-step guide to showing your portfolio to an ad agency art director:

- Once you've called and successfully made an appointment to show your book, send the art director a (snail mail) note confirming the date and time and thanking them.
- Double check your portfolio and replace any prints that are not perfect, page protectors that are worn, etc. Make sure you have an appropriate "leave behind" piece.
- Dress to match the agency. It's always better to be a little overdressed (proof that they could put you

Mailing Lists

Whether you choose to do postcards, e-mail campaigns, cold calls, or some combination of all of these marketing tools, a large part of your success depends on the quality of your mailing list. In the unimaginably distant days before the web most photographers painstakingly built their own mailing list, name by name. We'd sit in front of our computers with a stack of business cards we were lucky enough to cadge from art directors and other kinds of clients, and we'd enter all of the cogent information into our glacially slow and unstable computers. Then we'd pick up the phone and cold call.

It's a whole different ball game today. Now you can rent or buy lists with amazing amounts of specificity from a number of vendors, and the names hit your inbox seconds after your credit card numbers are entered. I've had dealings with FreshLists, Adbase, and Agency Access, but there are literally thousands of others. My favorite is probably FreshLists because they update often and let you use the list over and over again for a one-time payment. You only pay again if you want to buy the update for your lists. The lists are generally broken down by category like this: Art Buyers National, Magazines National, Art Directors Texas, Art Directors New York, etc.

Get bids from several competitors and be sure to get them to explain exactly how you can use the lists and for how long. In this day and age I would advise against going with a firm that sells you the names on a one-time basis by sending you physical mailing labels. That is *so* last century.

The people at FreshLists provide lists that break down buyers by specialties within their category, give a physical address, a phone number and an e-mail address, all of which makes following up and building some sort of relationship with the art buyers easier.

in front of a conservative client) than even microscopically underdressed. Shoes matter.

- Arrive a bit early. Being late can create a bad first impression that's difficult to overcome.
- Once you are sitting in the conference room or office and you've made small talk, proffer the portfolio and sit back. Let your images do the talking and let the prospective client set the pace. They can turn the pages without your help, and if they

Left—*I carry my main portfolios in this Tenba shipping case. It protects the material during transport, keeps me from trying to take too much stuff, and is easy to carry.* **Right**—*Inside are three black books that each measure 11x14 inches. Sometimes I take only one, other times I take all three; it depends on the client. Each book contains twenty prints.*

Left—*I try to start with funny, quirky photos that communicate my ability to pull things out of actors and portrait subjects.* **Center**—*The "guts" of my first pitch is usually my black & white portrait work, which is a style I use in most of my marketing efforts and echoes the images that are framed and hung around the studio. Most people know that black & white prints require extra effort to perfect.* **Right**—*My third book is all commercial portraits on location and lets the buyer know that I am comfortable arriving just about anywhere ready to make a great portrait of just about anyone.*

need information about an image, they will certainly ask you.

- Once they've completed their journey through your material, ask about their work.
- When you sense the meeting is over, hand out your "leave behinds" and thank them for their time and interest.
- If you feel the meeting went well, it is appropriate to ask if there are other art directors/art buyers who might be interested in your work. A referral is a great way to get your foot in the door and past the universal impediment we call "voice mail."
- As soon as you get back to your office take the time to write a nice thank-you message on a greeting card that shows off one of your most popular images. Be sure to do this before you do anything else.
- Repeat this with every potential client you can find.

This strategy works in every single specialty of commercial photography. It's no different than sitting down with a prospective bride and groom or the owner of a small business who needs a few images for a holiday promotion.

Professional Associations. In most major cities there is an Ad Club affiliate. These clubs are where ad agency people, freelance designers, video production company staff, and all the associated vendors for the business come together.

A Real, Live, Non-Virtual, Printed Portfolio!

I stated earlier that the actual non-digital portfolio is not dead. A photographer friend of mine sent his off to an art director in Chicago, via FedEx, a few weeks ago as part of a request for bids for an international company's annual report project. His constant campaign of postcards over the years had attracted and kept the interest of the art director. His web site helped the art director convince her team to "call in" my friend's portfolio. The beautifully printed work in his portfolio is what closed the deal.

So, what's in a portfolio and how do you put one together? A good portfolio is the result of good planning, careful selection, and great presentation. According to twenty-year graphic design veteran Belinda Yarritu, the "book" (shop talk for portfolio) should have a stylistic consistency. That means an art director should have the sense, when looking at your work, that it all came from the same photographer. The book should definitely not contain a mix of styles. Yarritu also emphasized that you should limit the number of images you show. She indicated that she'd rather see fifteen to twenty great pieces than thirty to forty pieces of variable quality. You will inevitably be judged by the weakest piece in your book!

Before I interviewed Belinda and a few other designers, I believed that they would think that portfolios of odd sizes, shapes, and presentations would be a nuisance. Instead, Belinda assured me that anything goes as long as it's tastefully done and easy enough to get in the door—that includes portfolios with hand-painted covers and portfolios wrapped in handmade Japanese paper, complete with pressed flowers and ribbons made from shredded wedding dresses. Her point was that you will always get extra points for creative packaging, but only if it's done well. My best advice? Find an honest art director to help you make selections for your portfolio. Have them edit your images, and don't be heartbroken if some of your own favorites don't make the final cut. You favorite work is not always your best work. You just have to suck it up and get over it.

Find a really nice case to present your work in and keep it clean and in good shape. Make sure every print is pristine and perfect. If your book has plastic page protectors, be sure to replace them the minute they get a scratch or abrasion. This is the media weapon you'll use to seal the deal in any high dollar job.

We photographers get used to thinking about our physical portfolios as something precious that we just trot out for serious meetings—and rightly so considering the cost and time we've invested in the book. But such a powerful weapon should be leveraged all the time so you might want to do what several fashion shooters in my town do: create a 5x7 inch portfolio at the same time you create your "serious business" portfolio. Get a nice little black leather binder for the 5x7 inch prints and carry that mini-portfolio with you everywhere. You'll be amazed how much fun it is. You could be at lunch with a friend when you get introduced to someone. When they ask you, "What do you do?" you can smile and hand them the portfolio. If you're having lunch with the right people, you'll be amazed at how many doors the little book can open.

The real pros have more than one serious portfolio. You'll want one for agencies that have a "drop off" policy (you leave your portfolio at the reception desk and the art staff reviews it in at their leisure and then lets you know when it's ready to be picked up). You'll want another one in the office for those face-to-face meetings you are sure to have, and then you'll want several more with different images so that you have good reason to go back to an art buyer you've already met in order to show more work.

Finally, the portfolio should be an organic entity. You should plan on changing out the images in the portfolio frequently during the course of the year so that the images are always fresh and inspired. The best way to accomplish this is not to wait until December 31 and then scramble through all the work you've done over the course of the year, trying to remember what image came from where. Instead, as you edit a good shoot, identify the files that you really like and copy them to a "portfolio" folder. Every week or so take a few hours to retouch and finish out all the images in the folder and send them along to your print house (or print them on your inkjet printer). This way you'll constantly have a growing stack of recent work just waiting to be edited into the portfolio at a moment's notice. If you spread the printing out over time you'll barely notice the costs.

Left—I love nontraditional books, and so do designers and art directors. This is a portfolio I show when I'm competing for jobs that are all about intimate portraits. It's a nonstandard size. **Top right**—*The inside of this portfolio has translucent fly sheets over each page which gives the impression that the images are more valuable. One image per spread.* **Bottom right**—*While I want to show different looks and different lighting, it's important that the presentation and printing style be uniform. The singularity of vision is a selling point.*

Rather than show up at another dull meeting to discuss usage rights and optical theory with your photography buddies, you might consider heading to one of the monthly happy hours that seems to be a standard and standing event for most ad clubs. If you have a buddy who is in the business, go with them and ask them for a few introductions. My strategy is to come with a pocket full of business cards and enough cash to buy a beer or two for new art directors I might meet.

One photographer in our town joined our professional advertising association and eventually worked his way up to be president. He now knows every major advertising person in the area on a first name basis, and they've seen him work, and volunteer, with good results. The art buyers know his business practices are rock solid and that he can deliver what he promises. Do I need to mention that we don't see him very often at the photographer happy hours? Or that he's always busy with prime work? His thinking was clearly outside the box and it landed his career squarely in the box.

Additional Avenues. Though the bulk of the text in this chapter might lead you to believe that marketing is a compartmentalized subset of your business, but nothing could be further from the truth. Marketing your photography should become an organic process that reaches into most areas of your life. And good marketing can take any number of forms.

Magazines. Part of your career plan could and should include photographing for well-designed magazines. Just having your images in any magazine is not necessarily a good thing. As in all parts of life you are judged by the company you keep. Having a series of beautiful shots in a well-produced magazine adds credibility to your work and lets potential buyers know that others see the value of including your images. Though the editorial rates in magazines doesn't come close to matching the rates you should expect for your commercial work, the trade-off is good exposure. I work for a number of magazines, but one of my favorites is a local lifestyle/architecture/design magazine called *Tribeza*. I love their square format, and they use images very well.

Though I can't always track work directly from publication in a local magazine like *Tribeza*, I do know that I'm getting good impressions among an affluent and educated demographic because lots of friends comment about the images frequently.

Be sure to get paid for your work in magazines. They are published for profit and you should be paid for helping to make them a success!

Shows of Your Work. We've got a zillion Starbucks across the United States. Find the one closest to the biggest ad agency in your town and ask them if you can do a show of your work. If you do portraits, find the most popular coffeehouse in the area you've targeted and have a show there. Anywhere you can show a beautifully matted and framed image, along with your name and contact info, you will garner additional impressions and may find new clients. My local coffee shop rotates art shows on their walls once a month. I try to get on their calendar once a year. Keep in mind that you don't need to think in terms of exclusives; you can have shows at a number of venues all across your city. Once you've got a show scheduled, you have an excuse to write a press release.

Press Releases. Every time your business passes a milestone, has a show, signs a big account, publishes a book, or donates to charity in a big way, you should take the opportunity to promote yourself. When we hang a show, we send out a press release to the local papers telling them the "who, what, when, and where." The papers don't always write about our stuff, but when they do it makes a big splash. Our main local paper hits nearly half a million people, and even though our target demographic is probably in the hundreds, the constant mention of our business name adds to our total impressions. Every press release should go out with a sample photo from your show, a news photo from your project, or something visual to anchor the article. Public relations releases stand a much better chance of being picked up when they are accompanied by photos.

Write an Article. If you have an expertise in some aspect of photography, writing an article can be a career booster. I once wrote an article for *Studio Pho-*

tography magazine about photographing a CEO with small, battery-operated lights, and the next thing I knew I was writing about the subject for a book publisher. I got reprints of the magazine article to send out to my regular clients because the CEO in question was the head of the first or second largest computer company in the world. When potential clients received the mailer with the magazine reprint, it immediately said two things about my business: (1) This guy takes really good photographs of executives (my bedrock marketing mantra) and, (2) This computer company trusts this photographer to take portraits of their most important executive.

But few people would have known about the photo session if I hadn't written the article. You might not consider yourself much of a writer, but you probably know someone who is. See if they would like to collaborate on articles about your business.

Writing for photography magazines and web sites could be the tip of the iceberg for a really motivated writer/photographer. You might consider approaching your local paper about writing a weekly photography column about digital photography for amateurs. You'll quickly become the community expert, and people will see your name frequently.

Chances to market are everywhere. If you are a runner, team up with a silk screen company and have a number of t-shirts printed up with your logo and your tagline or selling statement on the front and back of your shirt. Austin is a big running town, and on a typical Saturday or Sunday run (or walk) around the four-mile path that wraps around our downtown lake you'll probably pass or be passed by three or four hundred runners in an hour's time.

I speak about running a small business in front of three hundred students in a finance for nonfinance majors class once or twice a year at the McCombs

School of Business at the University of Texas at Austin. I don't expect that most students will be in the market for my services, but the other people who speak on the panel have turned out to be. They include architects, other small business owners, lawyers, etc. And who knows how many of the students will graduate and go on to careers in fields where they may have input into the hiring of photographers?

Write a Book. Writing this book represents a wonderful marketing opportunity because it gives me a jumbo sized brochure with lots of my photographs to hand out to my clients. This reinforces their decision to hire me and gives them materials to reference when we talk about pricing and when they refer me to other clients.

Host a Gathering. Back in 2001, when the economy was falling apart, I traded a local theater some good photography work for a full house of seats at a funny, upbeat holiday play (*Santaland Diaries,* by David Sedaris). I invited one hundred and fifty friends and clients to the play. I served wine, champagne, beer, and appetizers. After the play we served coffee and fun holiday cookies and pastries. The response, in

Right—*You might not start your career shooting annual reports for IBM, but you have to start somewhere, and a good way to pad your portfolio is to offer your services at a discount to a nonprofit organization or charity that you believe in. You'll be getting nice pieces for your portfolio while providing a real service for your community.*

KIPP: Austin College Prep Annual Report 2005/2006

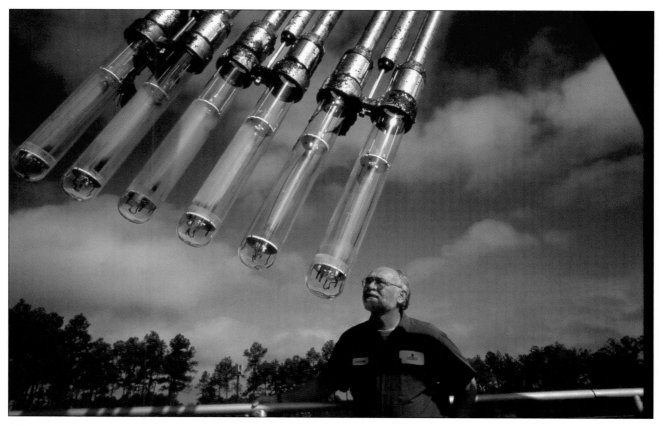

Above—*Industrial photography is fun photography. One of my favorite annual reports was done for Southwest Water Company of Los Angeles. They build and run water treatment and waste water treatment facilities across the United States. This image shows UV lamps raised for cleaning. The UV from the lamps kills bacteria.*

the middle of a bad economic period, was off the charts. No selling took place. No marketing, other than the fun of the play and the joyous mood of the crowd, was undertaken. But we bonded over good feelings, good food, and great theater. I've made this a holiday tradition, and people start calling in August to make sure they are on the guest list for December. It's not traditional marketing, and I certainly wouldn't depend on it for the main thrust of my promotions, but it is a nice way of saying "thank you for your support" at the end of the year. The theater wins because they get great photographs and they have one hundred and fifty relatively affluent people trying out their product. Many become season ticket holders.

The Referral. A good referral from an existing client to someone else in their field is the most powerful form of marketing. The second best reason to continually market to clients you already do work for

is the likelihood that they will think highly enough of your standards and your artistic vision to refer others to you without reservation. (The best reason to continually market to existing clients is that it's the most cost effective solution to growing your business. They've already tested you and found the product and service to be good. You continue to market to them to cement their loyalty and to keep your brand in front of them.)

If you have a very good relationship with your client, it can be appropriate to ask them if there is someone they can refer you to. It never hurts to ask, but make sure the relationship is there before you do.

Take a Lunch Break. My last marketing tip: Lunch 'em or lose them! If you are considering advertising, corporate photography, or business-to-business photography where repeat business is critical, you might consider tightening your bond with your clients even

more. Once you've done business with a client and you feel that you are on the same wavelength, consider having lunch with them from time to time and just chatting about what's new in the industry or in their lives. Ask them about their projects and sit back to listen.

Anthropologists have known for years that people bond over food, and lunch is a good opportunity to bond. If your table manners are good and you have even a modest gift for conversation, you may find that you are able to build an even better working relationship with your client. This serves many purposes but seems to be an effective way to neutralize competition and build a bit of customer loyalty. I try to book two or three client lunches per month. We always go somewhere fun, and I never directly sell my business during a casual lunch. If I want to show a portfolio, I make an appointment to see the client at their office. Lunch or coffee is always "no strings attached."

▶ Designing Your Marketing Pieces

I keep telling you to do all of this marketing, but I haven't really told you what to put in your marketing pieces. It's obvious that you will want to show examples of your best work, but there's always the question of where to start and how to extend your brand by putting out new stuff.

Photographers have two ways to deal with the "what to show?" question. If you are just starting out, you might not have a backlog of cool looking jobs to choose from (and let's face it, if you are working in a second-tier market, you may not have frequent chances to really do extraordinary work in your day-to-day business. If this sounds like you, then consider the benefits of doing shoots just for yourself that push the limits and showcase the unique vision you'd like people to associate with your brand. The mantra of creative coaches is always, "Don't show what you've done, show what you'd like to do." Clients can be very literal, and if they don't see a photograph in a new style, they are not able to make the mental leap that you will be able to deliver a new style. If you want to sell it, you must show it.

Every time I give a lecture to college students I get a bunch of question about the imagined "Catch-22" of commercial photography: "How can I get the jobs I want if I've never done those kinds of jobs before?" The students will go on to say, "It's not fair because I know I can do that kind of work!" The obvious answer is that the students should immediately set up and shoot the kind of work they think they would like to do and then put it in their portfolios. That's one of the secrets of this business: You are just as good as your book. The photographer with ten or twenty years of experience may have better name recognition than you, but if you produce a new and exciting style for your portfolio, and get it in front of the right photography customer, then all of a sudden you are on even footing. Long story short, if you think the lack of an image(s) is all that's holding you back, there's really nothing stopping you from creating that image and sticking it in your book. Nothing.

If you've worked long and hard to build up your business, then your marketing pieces can come from real success stories. I find that many of my best pieces are done for pro bono clients, who value a creative approach. In situations where you are donating your services you can collaborate and set parameters for how you'd like to shoot a project. Once the project is printed or launched, you have a compelling success story that's a perfect excuse to send out marketing materials to your potential and existing clients. At this juncture I've got a backlog of beautifully printed annual reports for a number of charities that I can use to market my portrait style, and they will become my strongest campaigns.

▶ Summary

There's a lot to learn about effective advertising and marketing, and there are many books that do a good job covering the ins and outs of this art/science. I've recommended these in the resources section.

You may have noticed that I like making lists. To close this chapter, I've provided a list of the top ten things you need to know about using advertising to drive your business forward:

1. You build your "brand" over time. You do it by being consistent in your messages to the public—your company's "look and feel"—and the way you personally represent the business. Consistency lets potential buyers create a mental image of what it is your company does. Don't start out "paisley" and end up "pinstripe" or vice versa.

2. All advertising impressions are cumulative. Those who study the pseudoscience of advertising have figured out a formula that goes something like this: Consumers need to see your ad a minimum of seven to ten times for your brand to start to register in their consciousness. They need to see your ad ten to fifteen times to take your business seriously and to add you to the resources they think of when they consider your business category. They'll need to have seen your marketing messages at least fifteen times before they try your service or product. This is just as true of retail portraiture as it is advertising.

3. There are two kinds of advertising: Ads that build your brand image and ads that issue a call for action. Basically, that means that one type of ad makes your business look cool and desirable, and the other type of ad states a compelling reason to use your services or buy your products. Think of the first one like an ad from Nike with no type and a great photo of a beautiful person running in Nike shoes. Think of the second ad as one that shows the product close up, gives you important details about the product (foot protection, lightweight, etc.) and gives you a reason to get up off the couch and go to a store to try on the product (e.g., a limited time sale or a coupon). You'll need to consider both kinds of advertising if you are running a retail business. You'll rely on the first kind (branding) if you market to art buyers or corporate marketing departments. But sometimes even corporate advertising guys can run a sale of sorts.

4. You need to create a unique selling proposition. This is basically a blend of style, pricing, presentation, and special skills that makes you different from every other photographer in your field. Suppose you want to specialize in food photography. Wouldn't it be more appealing to potential buyers if they knew you had once been a Cordon Bleu chef in a prestigious restaurant? If you are a product photographer, wouldn't it be nice to let buyers know that your studio has 4000 square feet of usable space and that you have an enormous collection of very good props? If you are pitching a company that makes computer chips, wouldn't it be great if you could let them know that you've got a microscope/camera rig that can image things down to one millimeter in diameter full frame in your camera? Any special training, special gear, special insight, or special working methodologies offer you excellent opportunities to differentiate yourself from your competitors.

5. You cannot solely depend on word of mouth (unless your work is a lot better than anything else in your market niche); you must market on some level to stay in business. If you've chosen a very specific specialty and are very good at it, your marketing may require nothing more than a web site and a sales call to the potential users in your market. If your work is on par with your competitors (and let's be frank, not every photographer can be the best in the business), you'll need to show as many potential clients as possible the differentiators that you think will tip the balance in your favor.

6. Unless your photographic career came fully equipped with a trust fund or you've recently won the lottery, you won't be able to advertise in every media and reach every potential client. You'll need to do your research and drill down to the clients who offer the most promise of wanting and being able to hire you. This may mean starting local and identifying a market that you have an affinity for. I like to work for corporations, so I've built my business by identifying all of the major manufacturers in my region as potential clients. When I realized that this was too big a list I refined it by seeking out the corporations that

specialized in an area I was interested in: high technology. This gave me a reasonable number of leads to start with but not a number that was so overwhelming that I would never be able to afford the expense or time to intelligently service them all. Think of your business as a series of concentric ripples in a pond. The first ring (your first campaign) is your hometown. The second ring includes the neighboring cities. The third ring is your state. The fourth ring is your region. The fifth ring is your country, and every additional ring reaches farther around the globe. You need to start somewhere, but you need to dream of what you'd like to accomplish down the road.

7. Planning is crucial. Without a plan you can follow, your marketing will be chaotic and inefficient. You want to plan your marketing to constantly build on what you've already done. You've heard it a thousand times, "Those who fail to plan plan to fail!" No plan is like taking a trip across the country without a map (or a GPS navigator); you will get lost, you will run out of gas. You will show up late. You don't need to stick to every fine point of your plan; you can change it as you go along, but you need one to keep you on the general track.

8. It's important—no, it's critical—to do your marketing when you are very busy with paying jobs. Marketing takes time to produce results. The messages we send out right now will start to show results months from now. And by then, if your business is already tanking, it's too late. Sit down today and start planning. Figure out a practical budget. Put gear acquisitions on hold. Plan step one, two, three. Then pull the trigger.

9. Never put all your eggs in one basket. Imagine spending months putting together the ultimate direct mail piece and spending your entire year's marketing budget on the printing, acquiring a mailing list, and postage. Imagine you mailed it out in your hometown of Houston the week Hurricane Ike struck. Most of your target market evacuated the city. Houses and businesses flooded (and so did their mailboxes). Many of your beautiful mailers were destroyed. Other recipients were too overwhelmed to act on your offer or message. There were few chances to follow up. And now your budget for the year is shot. Even if every piece had been successfully delivered, you would have only made one impression on each recipient, far short of the seven to ten impressions it would take to show up on the buyer's radar.

10. The single biggest mistake I see among fellow photographers is the urge to delay marketing until they have "just the right image" for a promotion. Sadly, the perfect image doesn't exist, and even if it did, it would constitute a moving target. At some point you must set a schedule and work with what you have in hand. As a former creative director at an ad agency, I saw an interesting phenomenon: some photographers jumped right into the process with the images they had at hand. The images might not have been perfect, but every time they made a portfolio show appointment they extended their network of potential buyers, practiced their sales talk, and (most importantly) became more comfortable with the process as a result of good and continuing feedback from the art buyers with whom they met. Another group of photographers endlessly procrastinated. They were waiting for the results of a "dream" assignment that never came. The chance to put a perfect image into their portfolios. By the time desperation drove them out of their dark caves and into the conference rooms of advertising agencies the braver souls had already beaten them to the prize. And that prize was the mind share of the art buyers. Haste may make waste, but procrastination in marketing makes business failure.

5. Ethics and Standards

It's easy to gain market share if you give your work away. It's easy to destroy a competitor by lying and slandering him. You can make a quick buck by selling a proprietary shot to your client's competitor. You can keep more money if you cheat on your taxes, but it's not right. Here are the standards of the industry and a good life: Right action, right speech, right thoughts. Then you will never have to apologize, sweat an audit, go to jail, get sued, etc.

▶ Never Give Your Work Away

As a photographer, you'll be asked to give your work away. Not-for-profit groups and unscrupulous for-profit ones may say something like, "We'd like to try you out on a free job. If things work out, we have lots of work we can give you at your regular rates." The pitch from ad agencies, magazines, and regular businesses usually falls along the lines of "how great your work will look in our publication," or, "what a great portfolio piece this particular image will be," or, my favorite, "you'll get incredible exposure."

The problem is that these people have made a life-long practice of manipulating photographers into giving them free work, and they're not about to change for you. There will rarely be any more work coming your way, and if there is, you'll likely be offered just as much as you were on your first job—nothing!

I once made the mistake of working for free for the local chapter of the United Way. The art director had used (and paid for) a nice shot of mine on a magazine cover at a previous job. He made the pitch for me to help him with his pro bono project because it was going to be a sure "award winner." The work went okay, but at the end of the project the promise to pay for film and processing was forgotten. Then I found out that (against our signed agreement) they were offering my work for free to a major donor who was one of my biggest for-profit clients—a client which, at the time, was making billions of dollars of profit every quarter. The award-winning piece ended up being printed in black & white as a newsletter and wasn't even a piece I could send to my mother.

The art director was embarrassed, but most of the shenanigans were out of his control. He moved on to a better job elsewhere. The very next year his replacement called and offered the same "incredible deal." This time I was prepared. I asked her about a budget to pay my fee. "Oh, we don't have any budget—we were hoping you'd do this pro bono" (as if asking for free work in Latin makes it better). I asked her if she was working for free. She was not. I asked her if her organization provided her with healthcare and a 401k. They did. I asked her if she could afford to work for free. She could not. "Neither can I," I said, and we both moved on.

The lure of "great exposure" is always strong for photographers who are just starting out, but it's a trap and it takes away time and energy you must use to get jobs from people who will pay you money and will give you interesting work.

That being said there is a moral imperative for assisting nonprofit organizations that are important to you. There are charitable organizations here in Austin that I will do pro bono work for at the drop of a hat: a community clinic that is a last resort for Austin's at-risk population, a secular charter school that is transforming kids' lives, and a community theater that does really good art and offers opportunities to diverse communities. In the case of the theater I do benefit with an ample supply of free tickets to wonderful

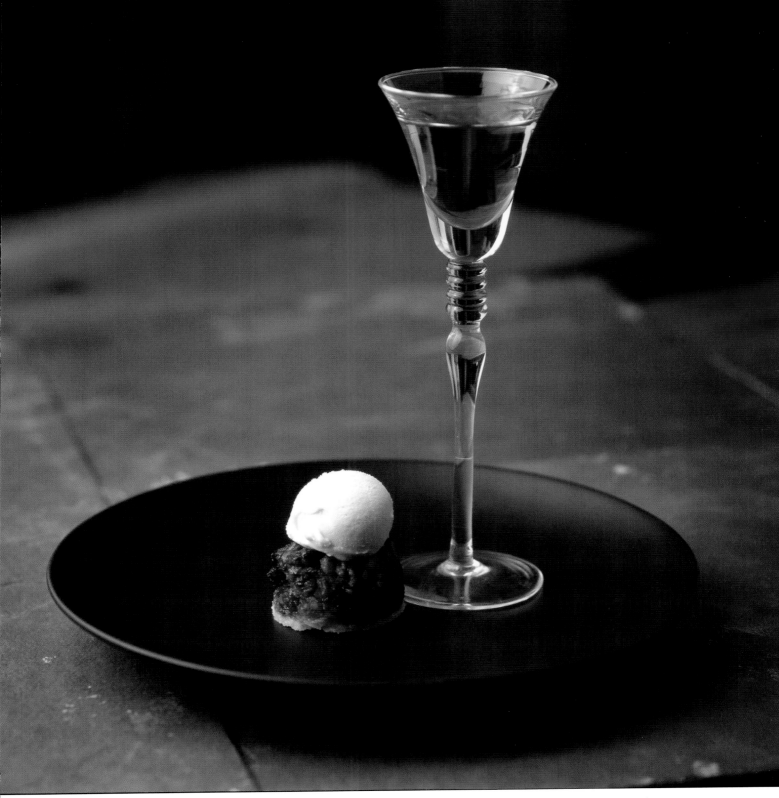

Above—Dessert wine and pecan pie with ice cream. On assignment for Spas and Resorts *magazine. I try to keep my lighting simple and my food images cleanly designed. I brought the slate tiles along on an impulse. Finding the right background can make or break an image.*

shows. If I can't use the tickets I always have clients who love what the theater does as well.

▶ The Karma (Instant and Otherwise) of Disparaging Other Photographers

"Right action, right speech, right thoughts." These words are a guiding precept of Buddhist teaching. And they mean just what they say. If you disparage your competitors, you will look venal and petty in the eyes of your client. If you trash them in front of the wrong person, the insults will always get back to the injured party and you will have started a cycle of bad feelings that will bring both of you down. Moms had this right from the beginning: if you don't have anything nice to say, just don't say anything!

If you succeed in thoroughly trashing one of your competitors, the likely course of action the person listening to you will take is to hire a third photographer and carefully avoid both the trasher and the trashee in the future.

Taking the right action means doing the things you know are right and never cutting corners. Never promise a delivery time if you know you're not going to make it. Never pad expenses. Never lie to a client or an assistant. If you always proceed by taking the right action, you'll never have to apologize or be prosecuted for your actions. A perfect example is the pervasive ability of many people to justify stealing software or, for that matter, music. While it's true that Photoshop is expensive, it is one of the many tools you'll need to have if you want to be a successful photographer. It is very clear that Adobe sells their Photoshop software with the agreement that it only be used on up to two computers which are owned by the same user/purchaser. To give out the software to another photographer or to accept a licensing password to use a copy of Photoshop that you didn't legally purchase is a federal crime, it's not just sharing. You are stealing someone's very labor-intensive intellectual property.

I've heard different justifications for stealing software, but the most common is, "I just can't afford it right now." Photoshop is cheaper (by a long shot) than the cameras we use to do our business, but I've never seen anyone make an argument that it's okay to break into a camera store and steal a camera to use. The right course of action is to use a cheaper program to do your work until you build up your business enough to cover the cost of a legal copy of Photoshop. It always seems easier to steal from a large, faceless corporation, but it is no more correct, ethical, or moral.

The third leg of a good existence is "right thoughts." Psychologists will tell you that harboring negative thoughts about your competitors, clients, and life in general has a negative cumulative effect. Your success will take longer, be shallower, and less enjoyable, and you'll likely leave a landscape littered with people who don't want to spend time with you and don't want to hire you again. If you are a negative person, you have two choices: change your occupation to one that doesn't require your willing cooperation with other people or change your thoughts. If this seems goofy or "new agey" I would ask you to reconsider your prejudices and at least think about being cognizant of your own negativity and its effect on others. You may find that life becomes easier when you look for the positive around you and stop dwelling on negative aspects. It will also make your photography better and put more energy in your efforts to be creative.

Though the above might seem "touchy-feely," just about every professional society has a code of good old fashioned ethics that it expects its member to abide by and practice. I find that the whole ball of wax can be distilled down to a list a five things:

1. Deal honestly with clients. Be mindful of their best interests and protect their personal/business information.
2. Deal honestly with other photographers and work to protect your mutual interests.
3. Deal honestly with assistants and other subcontractors. Help them to succeed and you will help yourself succeed.
4. Be true to your own beliefs. Don't take a job if the product you'll be promoting or the cause you'll be spotlighting is in opposition to your personal beliefs. Accepting the job may bring you

money, but the lack of satisfaction will make you bitter.

5. Leave your campground cleaner than it was when you arrived. I mean this in regards to the overall market. If you charge too little, you will ruin the market for future photographers who deserve to earn a fair living. If you are rude and contentious with clients or models, you build the (incorrect) expectation that all photographers are pond scum and make the next photographer's job more difficult. Move the whole industry forward and upward whenever you have the opportunity.

Doing the right thing consistently will keep you from getting sued. Maybe you're one of those people who think the ethical rules only apply to the other guy. Well maybe you should follow the rules for your own self-interest. In the United States, just about anything is actionable on some legal level, and the minute you misrepresent yourself and your abilities, or fudge a nondisclosure agreement, you could get your butt sued off. Better to just follow the ASMP or PPA ethics than to see how close to the line you can get and still be in business.

▶ Nondisclosure Agreements

Many clients developing proprietary products and processes will insist that you sign a nondisclosure agreement before doing any work for their companies. Be very careful when you sign the agreement, because it is a legally binding contractual agreement that basically states that you are given access to their people, products, and processes in exchange for your promise not to discuss them with anyone. These agreements are a standard part of doing business with most modern corporations, and they take them very seriously.

Once or twice I've been working in a corporate environment with a new client who hasn't proffered a nondisclosure agreement. They will start to discuss financial news or product launches, and I will immediately stop them and let them know that I've not yet signed an agreement. This lets them know that I take their business and their confidences seriously.

When a client requires me to sign a nondisclosure agreement, I become responsible for the actions of my subcontractors. In those situations I require them to sign an agreement so that if there is a breech of information somewhere along the line I can show "due diligence."

I was asked a few years back to photograph the first large-scale, multi-core processor wafer from one of the world's top technology companies for the cover of an industry magazine. After signing a nondisclosure agreement for both the magazine and the manufacturer, I was escorted into a high security lab and was asked to set up in a room with monitored security and a "human minder." I did the shot on site, and we loaded the files onto a computer (also on site) provided by the company. I selected the final image and did the necessary retouching. The manufacturer checked the image and then sent it to the magazine. They physically embargoed the images until publication, whereupon they returned the original files to me on disc. They took the whole issue of privacy *very* seriously.

▶ Taxes

Doing the right thing also extends to the way you report your finances to your state and federal government. Keeping a clear and honest paper trail is the best way to avoid an audit. If an audit is inevitable, clean and precise bookkeeping will reduce the pain by several orders of magnitude.

We can go on and on with examples and guidelines, but here's my main set of rules: (1) If it feels wrong, it probably is wrong. (2) If you have to consult an attorney to see "where the edge is" in a business practice, then you're probably on the wrong track. (3) If you have to trick someone into an agreement or you're hoping they won't read your "small print" on a contract, you're already stepping over the line.

Just remember the mantra, "Right thoughts, right speech, right actions," and you'll do fine.

Above—*Mexican cookies. The ability to write as well as photograph pays dividends that aren't always obvious. A lifestyle magazine came to me in a panic. Their original food writer had unexpectedly dropped out of a project and left the magazine with no bakery story even though it was part of their online promotion for an upcoming issue. I was given a long weekend to select, photograph, and write a two-thousand-word article about three different bakeries. Being the writer, I was able to pick bakeries based on two important qualifications: I had to really like the bakery, and it had to be an interesting shoot. Writers always get to pick the venue. The photographer usually comes in after the article is well into the editing process. Nikon D2X camera and an 18–200mm lens with vibration reduction. Ambient light.*

6. Setting Up Your Fledgling Business

When I say "setting up your business," it sounds daunting and exhausting. However, a lot of setting up a business is just common sense. After you've decided what kind of work you want to do and who you think your market will be the next steps are pretty straightforward. Here are the basics:

▶ Your Business's Name

Every business has a name. There are books written about naming corporations, and there are some advertising agencies that charge incredible amounts of money to name businesses. As I see it, you have two choices: you can use your own name (or some variation thereof), as in Kirk Tuck Photography, or come up with a name you like that separates you from the business, like Studio Parabola, Wild Wing Images, or something along those lines. If your plan is to grow the business by adding other photographers under one corporate banner, the "made-up" name makes a certain amount of sense, as one day you might be able to sell the business to someone else.

I always saw my business as a one-photographer operation, and most of my work is for ad agencies and corporations. I realized my clients would all realize that they would be dealing with me as a person and it would just be easier to use my name. I would suggest you use the words "photography" or "imaging" somewhere in the name so even a casual observer has a good clue about what your business does.

Once you decide on a name, you'll need to go to your county clerk and do a search for the name to make sure that someone else isn't already using it in your area. Then you'll need to pay a small, one-time fee to register the name. What you'll be doing is registering a DBA (doing business as) that tells everyone who the owner of this new business is. Armed with a DBA, the next step is to get a commercial checking account and a sales tax certificate.

▶ Collecting Sales Tax

If you're a commercial photographer, you'll be doing work for lots of different business entities, and in most cases (with the exception of resellers who give you "resale certificates"), you'll need to collect state and local sales taxes for just about every sale you make. You'll need to get serious about keeping a paper trail; if you don't, you'll answer to a higher authority—the state comptroller—and nothing good can happen to you once you get on their bad side.

To be very clear, sales tax is not money out of your own pocket. The state and local governments set the tax rate and you are adding this tax to the total you charge your clients. You are acting as a collector for the state. It's not your money! If you need to set good boundaries, consider putting the taxes you collect in a separate bank account so you're not tempted to spend the tax money you've collected.

▶ Becoming a Business Entity

Now you've got a name and a resale tax certificate. You've got one more hurdle to jump over before you go out and conquer the world of photography: You'll need to decide what kind of business entity you really are. The choices include sole proprietor, partnership, limited liability partnership (LLC), corporation, or S-corporation. I'm sure the lawyers have cooked up a few more that aren't on my radar.

The two big differentiators between the sole proprietor category and the other entities are the staffing of the business and the way the accounting is handled.

A sole proprietor owns the business and *is* the business. As a sole proprietor, everything the business does is both your personal and professional responsibility. This means if someone sues your business, they are also suing you. Most of the other business entities make the business separate from you personally and attempt to insulate you personally from actions taken by your business.

The sole proprietorship has the easiest accounting requirements. At the end of the year you file an IRS 1040 tax return with a Schedule C, which shows what you spent, what you took in, and what your profit or loss is. Corporations must pay taxes in a different way, must create articles of incorporation, and must have officers. While you may be able to reduce your personal taxes with a corporation or one of the other business entities, you will have more procedural paperwork.

When it comes to accounting I prefer the simplest and most direct path imaginable. For me, it means running my business as a sole proprietor. Everyone's needs are different. Get a professional to help you decide what your business needs and how it meshes with your personal style.

That's about as deep as I'll go. After all, this is a photography book and not a tome on tax law. Please talk to your accountant (and if you don't already have one, now's the time to find one) and get his or her help on deciding which entity is right for you. As I understand it, it's easier to go from being a sole proprietor to a corporation than the other way around.

Note: Some states require you to get a business license to do any kind of commerce. Your tax assessor's office can make you aware of what's needed in your locale. If a license is required, do yourself a favor and don't do business without one; the penalties may be greater than your profits.

▶ Accounting

No matter the type of business entity you choose, you'll want your accounting to be easy and as automatic as you can make it. I use a program called QuickBooks, which is a template-driven general ac-

counting program. Every month I go through all the invoices I've sent to my clients and enter them into the program. I also enter all the receipts for the products and services I buy for the business. When clients pay their bills I enter their payments into the appropriate windows in the program. Since I enter the state taxes along with the invoice totals, the program can kick out a monthly report that tells me exactly what my gross and taxable sales were and how much money I need to send to the state for sales tax.

I can get reports from the program telling me, month by month, what my profits or losses are and who owes me money. At the end of each fiscal year (which for me follows the calendar year) I can output a very detailed report of everything I've spent money on that is either deductible or depreciable and of all the money I've taken in and I can hand this to my account in order to prepare my federal income tax form.

You'll want to find a good program that you feel comfortable using—and works well for your accountant—and use it from the outset. If you don't know how much money is owed you and how much money you owe, you won't be able to budget or to even get a handle on how much it cost you to be in business. Understanding the cost of doing business is the first step in being able to estimate and bid jobs with an eye to long-term profit.

▶ Getting Right with the IRS

It's inevitable. If you make money, you will need to pay federal income taxes. And since you are in this for yourself you'll also need to cover your Social Security and Medicare obligations.

When your business is up and running you'll get to the point where you'll be able to judge, month by month and quarter by quarter, how much money you've taken in and how much you'll need to put aside for estimated tax payments. When you are getting your business off the ground the whole process will seem a lot more mysterious. Here's my suggestion: Start using an accounting program like QuickBooks from day one. Estimate your profit or loss every month. Take 25 percent of your net profit each month

Above—*One of the most visible projects I do each year is the season brochure for Zachary Scott Theater. The concept is always very creative, the models are real actors, and the art direction is superb. This brochure used "different hats" as a creative hook and would juxtapose photos of the actors in different hats.*

and bank it. When you do your end of year accounting you'll have enough saved up to get you pretty close to the amount you'll need to pay.

You'll be in for a bit of a shock if you've previously worked as an employee for another business because you will be paying not only your income tax but both halves of your medicare and social security obligations (employers typically pay half of this amount for you!). In a good year, running a profitable business, you could find yourself paying 36 percent in income tax and an additional 16 or 17 percent in FICA.

Because it is beyond the scope of this book to talk about investing and strategies to reduce your tax burden, you will want to work with a financial consultant or trusted accountant to understand how much of your income you'll be able to put into tax-deferred retirement accounts and what sort of purchases of property or equipment you can make to reduce your taxable income. It's a hoary cliché by now, but you've got to start retirement planning when you are young and not wait until "time's winged chariot is drawing near" to start socking money away.

My only real tax advice is, don't get behind. Pay what you know you need to pay when you have it in your hands instead of buying gear or advertising or anything else. Once you get behind you'll be in interest and penalty hell, and it might be impossible to ever catch up. Just remember, interest is your best friend if you have savings and your mortal enemy when you have debt. Pay now, or pay more later.

Once you've started the business you'll need to make payments to the IRS quarterly. They'll even send you the envelopes. I keep saying to myself, "Taxes are the price we pay to live in a civilized society." It doesn't help.

There are a few states in the U.S. that don't have a state income tax. Texas is one of them. Alaska is another. In many other states, perhaps the one in which you live, you will be obligated to pay a state tax. If so, everything I mentioned above about the IRS and your federal taxes applies to your state taxes too.

Disclaimer: Don't take advice from me about tax law. I'm just a photographer. You need to see a real tax professional if you want (and need) the most ac-

curate advice about your tax obligations. You wouldn't expect me to do brain surgery, would you?

▶ Ensure that You Are Well Insured

This is almost as painful as the section on taxes and there's really no way I can candy coat the amount of money you'll have to spend to cover yourself and do this right. However, I've found out first hand just how valuable the right insurance coverage can be, and I was happy to have a good policy. So let's start with the big stuff and work our way down the list.

Health Insurance. Sure, you're as healthy as a horse right now and you're feeling pretty bulletproof, but what happens when the light turns green and you proceed into the intersection of life just in time to be "T-boned" by the proverbial accident from out of nowhere? I've got a photographer friend who was in great shape, exercised regularly, weighed just about exactly what those optimistic insurance charts wanted him to, and had cholesterol levels that most people only achieve through fasting and statin drug therapy. One day after a spirited run he had some pressure in his chest that got worse and worse, and finally his wife convinced him to go to the emergency room. The diagnosis from the emergency room doctor was a massive heart attack. He was rushed into the ICU, and they kept him there for over a week.

As bad as the heart attack was, the bill from the hospital was worse. The total for his stay was over $60,000! Had he needed surgery it would have been closer to $100,000. Here's the only good part of the story: he had major medical insurance, which covered all but about $7,000 of the bills. His conscientious maintenance of his health insurance policy saved him $53,000 in one episode. Major medical bills are the leading cause of bankruptcy in the United States, and no one ever thinks something will happen to them.

If you are lucky, you have a spouse who works for a big company or a state agency and will be able to get on their policy. If you're not lucky, you'll have to buy an individual policy for you and your family (if applicable). It's a rare photographer who can afford a comprehensive health insurance policy, so you'll probably do the kind of calculus that we all end up doing, trying to figure out how much of a deductible you can afford to pay out of pocket versus how much you'll save on monthly premiums. The sweet spot is somewhere between $2500 and $5000 for a yearly deductible. That's how much you'll have to pay out of pocket in an emergency before your insurance policy kicks in.

I have a friend in the human resources department of a big company and he recommends that photographers look into HSAs (Health Savings Accounts). Instead of spending all of your money on premiums, you stick a certain amount in an HSA account, tax deferred, and then you can draw on that amount every year for any valid medical or dental issue or check up and maintenance. You'll need to see which carriers offer HSAs in your state and carefully read over and compare policies.

In years past just about every major insurance company was thought to be rock solid. Since the Fall of 2008, I would caution you to carefully research the financial health of any insurance provider you are considering, because nothing is worse than paying premiums for years only to have your insurer go out of business just around your time of need.

My advice is not to skip health insurance. The options for the uninsured in this country can be very bleak and ultimately more expensive. If you live in France, Sweden, etc., you can ignore that advice.

General Business Insurance. This sector of the insurance market looks downright sensible and fair compared to health insurance. What you need to look for is a policy from a major insurer that covers both your property losses and especially your liability (that means they pay you for equipment that is stolen or destroyed, and they'll also pay if someone sues you for an accident on your premises or as a result of doing your business).

You'll find that more and more corporations are requiring that vendors who come onto their property to do business prove that they are carrying one or two million dollars of liability insurance. They often will ask for a certificate of insurance and won't hire you if you can't produce one. And all it really takes is some-

Above—*Fresh fruit tartlets photographed at Swetish Hill Bakery for an article on bakeries for* Tribeza *magazine.*

one tripping over one of your extension cords and hurting themselves to ruin you financially. One of my major clients instituted a policy of requiring proof of liability insurance after one of my competitors blew up an electronic strobe pack in a critical part of their factory and shut down a million-dollar-a-day process for 48 hours. All the smoke and particulates had to be cleaned out before the area was operational again.

When you start shopping for your policy this is probably the minimum coverage you'll want: Liability insurance for about $2 million, a dollar amount that will cover replacement cost (not depreciated value!) of your camera gear, office machines (computers), and important papers. You'll want a company that is responsive because you might need them to produce certificates of insurance on short notice.

When you read the statistics on how many American businesses get sued, and the amount that plaintiffs get, you'll not even put up your "open for business" sign before you have a policy in place.

Some new photographers try to cut corners by depending on their homeowner's or renter's policies to cover losses of equipment only to find out that nearly every policy has a disclaimer for any gear used professionally. Cover yourself. You'll thank yourself the first time you need to use it.

Auto Insurance. It goes without saying that if you're driving, you need auto insurance. The only wrinkle I think you'll need to look at is to make sure your policy will cover you if you have an accident while using your car for work or business. Some policies (especially from less expensive, regional providers) have exclusions that will leave you sad and poor if you have an accident while on your way to a commercial job. Ask questions and read the fine print.

Disability Insurance. This is the one that most people miss or decide to put off when the business is young and money is tight. It's a gamble. I started carrying a policy right after I bought my first house because I wanted to make sure that some major accident wouldn't leave me unable to work and unable to generate the cash flow I would need to have to survive and recoup. A typical disability policy will not pay your full income (I'm sure you can get one that would, but it would be unimaginably expensive) but will pay somewhere in the 60 to 70 percent range. You can decide when you want your disability insurance to kick in. You can choose thirty, sixty, or ninety days, or up to six months. The longer the waiting period, the less expensive the coverage. This, and your large medical insurance deductible, are two very powerful incentives to keep a "rainy day" fund in your bank account at least equal to your living expenses for the grace period of your liability insurance, plus the full amount of your medical deductible.

As you get older, buying a disability policy gets more and more expensive for the same coverage. Only you can decide the right point at which to buy a policy. It is one part your comfort with risk, one part your assessment of your earning power, and one part luck. This is one of the areas where having a trusted friend in the insurance business can pay off.

So now we've got you set up with health, auto, disability, and general business insurance. What about life insurance?

Life Insurance. If you are a fatalist and you have no dependents, I would say you could safely roll the dice and see what happens. If I were a bachelor with no close family, I wouldn't bother buying life insurance, but as the father of a thirteen-year-old who is college bound, and as the husband of a devoted and patient wife, I feel better knowing that the combination of a few life insurance policies will cushion the blow should I depart prematurely.

Back in the early 1990s I got talked into buying a "whole life" insurance policy. My more financially astute friends took me to task for buying an "expensive" policy. They said, "Buy a term life insurance policy with a much lower premium and invest the difference in the stock market." Interestingly enough the whole life policy has accrued at least 7 percent a year in cash value and, to date, has beaten any of the mutual funds I've chosen over the last decade. I do have a term life policy as well.

If you are healthy, a nonsmoker, and at your ideal weight, you'll be able to qualify for a good policy of either type with fairly low premiums. Buying a policy while you are still young will keep your premiums lower. But beyond these meager facts I won't venture, because the sad truth is that once you are dead the contents of this book will be inconsequential.

The bottom line on insurance is this: your clients will insist on some kinds of insurance, like a general liability policy, in order to work on their property. The major hotels in our area are now asking wedding photographers for certificates of insurance. If you drive, not having car insurance is a violation of the law. But, in truth, all the other insurance options are totally up to you. You choose your coverage based on how much risk you want to assume. It's always a gamble, and what I've learned as a photographer is that the odds favor the house and Murphy's Law is always in play.

7. Pricing What You Sell and License

This chapter appears near the end of the book because I wanted you to wade through all the things that would cost you money to be in business first. People who are entering any business for the first time tend to see things in overly optimistic ways. New photographers look at established photographer's fees and think, "These guys are billing more in a day than I used to make in a month in my old job," without taking into consideration the cost of doing business.

▶ The Cost of Doing Business

The cost of doing business is the biggest determining factor of what you should charge for your services. So, here's the drill: You need to sit down and methodically write down all the expenses you will incur to be in business. This includes your studio rental cost, the yearly depreciated cost of equipment acquisitions, all of your insurances, the cost of workshops and training programs, the cost of books you buy, the fees you pay to your accountant and attorney, the costs of advertising (including your high-speed Internet connection and fees paid to your ISP and web site host), postage, ASMP or PPA professional memberships, utilities, and mileage on your car. Everything you spend in order to run your business is your cost of doing business.

Add that all up. Now decide how much money you'd like to make above and beyond the cost of doing business and add that to your equation. Now figure out how much you need to put in your retirement account every year and put that into the equation. I think you'll be shocked at how much money you'll need to make to live as well as you'd like to.

Now take a calendar and start figuring out how many actual shooting days you have in a given year. Based on experience I'll say that if you run an efficient operation you'll find that two-thirds of your time will be spent marketing, pitching, billing, and working on other paperwork. After you subtract holidays and the collateral damage to your work calendar caused by "bridge days" to the holidays, I think you'll find that you'll have approximately one hundred shooting days a year—*if* the economy is good and the stars all align.

If your total cost of doing business is $60,000, you'll need to work one hundred days at $600 a day just to break even. That doesn't include your salary and income taxes. So you'll need to add more income to the $600 figure if you want to do things like make a house payment or buy a cup of coffee. Let's say you would like to take home (after all your business expenses) about $60,000 each year. You'll have to charge twice as much to make this happen. To make $60,000 over 100 days, you'll need to bring in $1200 each day. But in order to grow your business, keep up with inflation, and be ready to make big changes that will be driven by changing markets, you will need to make a profit on top of your basic "salary."

▶ Pricing Theory

Most commercial photographers who understand the dynamics of the market charge a "creation fee" or "assignment fee"—a minimum charge to do a job—and then they add usage fees to incorporate a reasonable profit. The usage fees are based on the value of the image and the size of the market. A small local use of a relatively generic image garners a relatively small usage fee. Worldwide use in all media garners a much, much larger fee. All usage fees are based on the scope of the use and the time period in which it will be used. Images that are "one of a kind" and impossible to duplicate will demand a higher fee. Images that are top-

Facing page—A rustic cabin in the Texas hill country. This property was moved to a private ranch and lovingly restored to a museum quality by its owner. Photographed for Early American Life *magazine, using Norman studio flash equipment and a 4x5-inch film camera.* **Above***—A new house built and furnished in an authentic 1800s Texas ranch style. Photographed on the outskirts of Houston, TX, for* Early American Life *magazine.*

ical, appeal to a large audience and are exclusive yield even bigger fees. There are programs like FotoQuote from Cradoc Software that will walk you through the process of coming up with an appropriate fee for just about any usage. The figures that FotoQuote generates are generic and require you to make allowances depending on your market and the unique circumstances of your photograph. It is great to have a starting point.

This basic pricing theory, based on your cost of doing business, works equally well for people in the wedding business as it gives you a true measure of what is involved in each wedding and how much

money each wedding has to generate in order to cover your cost of doing business and your anticipated profit.

In order for this model to work you must bill for each usage. You must be very clear about just what it is your clients are paying for. They must understand your billing model for it to work. Otherwise, you'll find them pushing you back to a basic "What's your day rate?" model with no additional fees.

The argument usually goes, "We don't know what different uses we'll have for these pictures. Can't you just charge me one fee to cover everything I might need?" You could, but it would have to be a really big

fee to cover all the anticipated uses. When they move you back to the hourly or daily-fee-only model, they've won a big part of the battle because now the client can compare you with other fee-only photographers and all of you basically become a commodity that can be selected based on price.

We've been moving as far away as we can in my business from the "day rate" model because it really only works well for clients. If you are offering a day of your time for a fixed price it invites clients to cram as many image opportunities as they can into one day. This approach really becomes a nightmare when you sit down to handle the postproduction aspects of preparing your images. And, while you may struggle technically in the early years of your business, making it easier for you and the client to justify the day rate only idea, you will get more and more proficient and you should be rewarded for your increasing skills, not penalized for them.

What do I mean by that? Well, imagine you got a job shooting microchip dies. These are weird, tiny, highly reflective things to shoot, and you need to get incredible detail from shots that are taken at high magnification. When I first started shooting them it took me a whole day of experimenting to get just the right shot. Based on the enormous amount of time I spent on the project I charged $1500. When I shoot new stuff I keep good notes. The next time I got a microchip die job it only took six hours. The client, based on the first job, still budgeted $1500. Each chip die is different and takes some trial and error but, on average, it now takes me about three hours, from setup to tear down. I still charge $1500 for each chip I shoot. That's the value it has to the client and that incorporates all the years of learning that led up to being able to figure out the process in the first place.

We are not manufacturing concerns, we make art. Just because I've figured out the process doesn't mean that my business will follow Moore's Law and get 50 percent faster and 50 percent cheaper every eighteen months. That's because our tools and processes don't change. There are no "economies of scale" being put into place to drive our costs down, nor is there a mass market into which we can deliver these highly specialized images.

The benefit to the client in working with me is the assurance that the job will be completed with a high probability of success in a fixed time frame. That is always worth X dollars to them. The benefit of pricing by the image for me comes when the client has four or five similar products and gives them to me all at once. I'll typically be able to complete all four images in one day for a total of 4xX in billing ($6000 rather than one "day rate" of $1500). I am able to profit from my acquired "intellectual property" while delivering a service that my client values.

The same applies to just about everything you do in commercial photography. In the old film days of photographing a CEO for a major project we invested a lot of time in the setup and testing of our shots. Cumulatively my crew and I might spend the better part of a day setting up, testing, doing the actual shoot, and then doing post-processing. We charged a creation fee that covered our costs and a usage fee based on the worldwide use of the image.

I am a better photographer twenty years later. I have a better rapport with CEOs by dint of my age and experience—and I should be able to charge for that. Even though digital cameras make the nuts and bolts part of the project quicker and easier, and even though I've gotten much more efficient and certain in my lighting and can now do the same work in half the time I could before, I am constantly aware that the typical market for the resulting image is now so global and so much more pervasive. Hundreds (millions?) of times more people experience images today versus the days before the Internet. I should be compensated for the value the corporations derive from the image instead of being tied to an hourly measure, and so should you. The pricing model I suggest allows you to grow your profits as your proficiency grows. Why would you want to do it any other way?

The Day Rate versus Fee Based Work. I know I'm belaboring this point, but I want to give a real-world example that every photographer will understand. This is the kind of assignment that now

comprises the bread and butter work for most commercial photographers regardless of their market size.

Bob Smith (client) calls and says, "I need to have ten of my executives photographed individually for our web site and our marketing brochure. What do you charge?"

The day rate photographer breaks it down like this: "My day rate is $1600 and my assistant charges $200. The makeup person charges $450 and $250 for post-processing. The total is $2500."

The client says, "Well that's a little higher than we wanted to go, but could we add a few more people to that and still do the job in a day?" (Remember, every extra person requires more post-processing on the back end of the job.)

The day rate photographer knows that he can handle a lot more than ten people in the course of a full eight-hour day, so he agrees in order to keep the job. On the day of the shoot the client hands him a list with twenty-six people on it. The photographer and his crew work a long, hard day and add hours to the post-processing work.

Here's a much more profitable way to bid and produce the same job. Our fee based photographer is asked to bid and he says, "We charge a standard $250 sitting fee for each person and that includes all of our costs. That's turnkey." (Ten people at $250 each = $2500.)

The client accepts his bid. Note that it is exactly the same total as the day rate photographer's original bid.

If the job proceeds according to the original parameters presented by the client, the photographer and his crew breeze through an unhurried day and do exactly as much postproduction as they originally anticipated.

If the client comes back to the photographer after the initial acceptance of the bid and asks to "add a few more people to the shoot" the photographer gladly agrees. That's because each additional head represents $250 more dollars in his pocket. If all twenty-six people troop through, the photographer will be able to bill $6500 for his investment of time. That's quite an incentive to fine-tune one's method of charging for photographs.

It also gives the "per person" fee based photographer a lot more negotiation leeway. If the client comes back and pushes on budget, there's more wiggle room to offer a "quantity" discount. Even if he were to drop his fee by $50 per person, he would still be billing $5200. If the day rate photographer is pushed on price by the client, the only thing he can do is devalue his price for the day, which sets an ugly precedent for all future dealings with this particular client.

I wish I'd known all of this when I started my career because, I must admit, I left a lot of money on the table. You have the opportunity to start your business with the right pricing model from the very beginning. Do yourself a favor: don't throw away this opportunity!

Clients have now grown up with the stock photography model. They pay by the shot, not by the time it took to make the shot. Exploit this model for greater profitability.

If your business involves retail sales to the public, you'll need to work the same math to understand how much to charge for each session and how much to charge for each print you output and deliver.

▶ Bids and Estimates

The first thing you have to do is get clear about the difference between a bid and an estimate. Some clients and photographers use the terms interchangeably, but they do have two different legal meanings. A bid is a fixed price for a fixed assignment. The art buyer gives you all of the parameters for a shoot and you generate a price that you think will make you a profit. If the assignment changes, you'll need to go back and modify your bid, but if you just plain screwed up and bid too little, you have to live with it and get smarter the next time.

An estimate really means that you are giving the art buyer your best guess, but both of you understand that it could be off by, perhaps, 10 percent in either direction. You might estimate that the job will take four hours, but a traffic jam or uncooperative weather

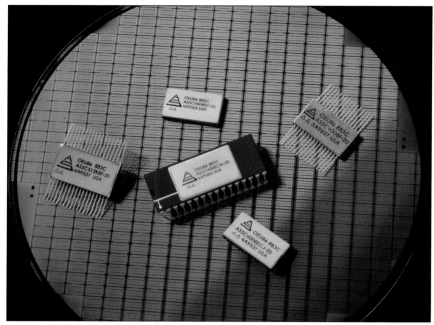

might delay your progress. That's okay within the scope of an estimate. If your costs or fees are going to make the job cost over 10 percent more than what you originally estimated, it's considered industry practice to go back to your client and let them know. Generally clients on really tight budgets with very defined needs favor the fixed bid. Shoots that depend on weather, the vague schedules of executives, or the cooperation of puppies and small children beg to be estimated. Otherwise you could lose your shirt.

Corporate Bids and Estimates. Here are the nuts and bolts of a bid or estimate for a corporate shoot: Let's assume you are being hired to take a number of photographs of a key executive for a computer company that sells products and services worldwide. The images will all be taken on one afternoon in one location that is controlled by the client. No ad agency is involved, and you will be contracting with and being paid by the computer company.

In all probability you will be contacted via e-mail having been referred to this requester by someone at company XXXXX that has worked with you and can vet your personality and professional competence. The e-mail will be vague. It will say something like:

Client: "You were recommended by Rebecca Smith. I have an executive that needs to have his pic-

ture taken. How soon can we get on your schedule, and what's the cost?"

At this juncture you need to marshal your thoughts and start thinking about best case scenarios. Don't immediately assume that this person is looking for a cheap headshot against some seamless backdrop paper (though they probably want that too). Before you give them any figures, be sure to ask for more details.

Your Response: "Thanks for getting in touch. Are you looking for a range of environmental portraits or just a headshot? Here is a link to a web gallery of images we did for another exec at XXXXX. Is this what you are looking for?"

The web gallery shows an executive photographed traditionally against a backdrop but also has five or six really fun environmental portrait treatments that incorporate the business's well-designed interior. There are portraits in front of a big rack of server computers, in front of a long row of flat screen displays, and other variations.

Client: "Yes. That's exactly what we want to do with Mr. Jones. When can we get on your schedule? What's the cost, and what do you need from me?"

In order to do the job right, I need to have access to a conference room so I can prelight a standard corporate headshot. A second opportunity will be a shot across a conference room table. I want one hour to scout for locations in the briefing center we'll be using, and I need two hours to prelight as many of the locations as I can. I want the executive to block out two hours of "no cell phone, no distractions" time in order to make the shoot work. I'll need a makeup person and an assistant to help move lights and equipment. We'll provide a web gallery so the client can

choose the right look from each setup. Then we'll provide high res, color corrected and retouched files for each selected image. Finally I'll contract to charge them for a usage license that covers public relations use for a period of two years. I write all this down in a very nice way and explain each step. I reference which days I am available, then I provide a proposed budget, which might look something like this:

Photographic fee: $1800
Two-year international public relations only usage license: $500
Assistant: $250
Makeup person: $450
Postproduction and finishing on eight images: $400

Project total: $3,400 plus applicable sales tax

This estimate is based on payment via credit card upon submission of our web gallery.

I would send the figures back over to the client with terms and conditions that we talked about above appended.

Every estimate and every invoice should have some language that gives you leverage in the event a client doesn't pay on time. Here's what we say in our terms and conditions on every estimate and invoice:

All invoiced amounts are due and payable upon receipt. Any invoice unpaid after 10 (ten) days shall be considered past due and subject to late fees of up to 1.5 percent of the balance per month. All arbitration and litigation to occur in Austin, Travis County, TX. We are licensing usage rights to reproduce images one time in consumer magazines, trade publications, on trade show, or other collateral materials such as brochures or direct mail pieces including, but not limited to, your company's web site. Specific usage rights are conveyed in the project description above. Our estimate and our invoice specify the usage rights that will be granted upon pay-

ment of the balance due and supersede any and all verbal agreements. We transfer no rights to use or publish until this invoice is paid in full. All images are registered.

The second line from the last is the one that sets the tone.

The terms and conditions is the opening dialogue, and it represents my best-case scenario. If we've hit the ceiling on the client's available budget, this e-mail will prompt a discussion. The client might want to reduce the total budget, in which case I would want to cut something from the project. The old adage is never to cut price without cutting some part of what the client will receive. We might agree on doing just three different environmental shots and changing the photographic and licensing fee by some amount. But unless your first estimate is seriously out of line most client resistance tends to be token. You can usually tell the difference between a client whose back is up against a budget wall and a client who's trying to make sure they've received your best price.

Client: "This looks fine. Can we schedule this for the 25th? Mr. Jones can be available from 2 till 4PM."

At this point I finalize the budget, terms, and conditions and put them all in a letter of agreement, which is basically our contract, and send it over via e-mail with a request that they print out the e-mail, sign it, and send it back to me. If I've worked with the company before and feel comfortable with the client, I'm happy if they agree to the terms by replying to my e-mail in a straightforward way like stating, "We are good with this agreement," and then give me the signed letter of agreement when we show up for the shoot.

While the professional photography organizations (ASMP and PPA) can provide you with contract forms the size of mortgage contracts, the dirty little secret of the business is that once you've worked well with a client, most jobs are agreed to, basically contracted, via e-mail exchanges. I'm no lawyer, but as long as you've got all the parts of your agreement in place and the client indicates in writing that they agree to your terms

I think you've got a contract that shows intent by both parties. And that's 90 percent of any legal battle.

At this point, we're done with the bidding and estimating and will move on to the shoot.

▶ Getting Paid

The shoot is over and the client has e-mailed you telling you that the assignment was a success and everyone is happy. Good. Now strike while the iron is hot. Get paid while everyone is still feeling that warm and fuzzy buzz of success.

Here's my process to get paid promptly: You did put your terms and conditions for payment into your letter of agreement, right? Good. As soon as you deliver the job, write up your invoice. Doing it as soon as you get home from the job is very helpful because you'll remember everything you need to bill. In the example above I told the client that I would bill them as soon as I presented a web gallery of images and that payment, via credit card, would be due at that point. They've already seen the work and know that it is at least satisfactory. As soon as the gallery goes live I send them a PDF copy of the invoice via e-mail and also drop a hard copy in the mail. I wait twenty-four hours and then call and ask the client if they got the invoice. If they answer yes, I ask, "Is this a good time to get a credit card number from you?"

Once I have the information I need I process the credit card right away and send a receipt to them via regular mail. The money is deposited in my bank account in three working days. In today's financial climate, do you really want to wait around and see if that credit card is still good a couple of weeks from now?

If you don't accept credit cards, you'll likely get locked into a thirty-day billing cycle. This is a "last century" standard but it still reigns at a number of companies. I won't work for any company that states a longer (than thirty days) billing cycle, because I don't think it's profitable for me, or ethical in general. You'll have to decide for yourself where that particular value proposition lies.

Getting paid by check is another option. It should go like this: put up your web gallery or deliver the im-

ages by whatever means you promised. Immediately e-mail a PDF copy of your invoice and include a note in the e-mail restating your mutual agreement to be paid within X number of days. Also send a hard copy via mail. When twenty-four to forty-eight hours have passed, call your client and ask them if they have received your invoice. Tell them you wanted to double check and make sure that there is no other information they need in order to process your payment on time. (Typically a corporation will require a W-9 form, which gives them your tax number, and without this form on file they will not pay your invoice. They won't let you know about this until your invoice has already passed thirty days and you've called to try and troubleshoot the transaction. Once you've sent them the form the clock starts over again and you might be looking at another thirty days before a check is cut.) Be smart and ask them if you need to send over a W-9 or provide any other documentation during your first follow-up call after sending the invoice.

A week before the thirty days is up call and ask to speak to the company's accounts payable department. Ask them what the status of your payment is. If everything is on track, they'll quickly tell you that the check will be cut on such and such a day and mailed on such and such a day. Thank them and then pray it's true.

If you call accounts payable and your invoice is a total mystery to them, it's time to get back in touch with your client to find out what went wrong and how you two can work together to fix it.

This all sounds a bit cynical, but experience has shown me that the longer it takes to get paid, the more inefficient the whole accounting process becomes, and the greater risk there is that something will go wrong.

It's hard to believe this when you are just starting out, but the client does not hold all the power in your relationship. When a client chooses you as their photographer they are doing it because they see a certain value proposition. As long as you aren't the cheapest guy in the business they are usually hiring you because they like what they've seen of your work and believe that your work can help sell their product or bolster

their image. They have every right to tell you how they like to do business, but you have every right to tell them how you need to do business. If they like your product, they do have the flexibility to pay you in any number of ways. Most of the time all you need to do is ask—and push a little bit.

I don't believe in providing credit to major corporations, and the corporate unravelings of the last year have shown that you can't even be sure which large companies are really credit worthy. The quicker you get paid, the more secure your business is.

▶ The Special Case that Drives Freelancers Crazy

The best work in the business is the stuff that ad agencies assign. Here's why. Corporations will assign day-to-day work that moves product out the door or has to do with event documentation or public relations, but when they need to pull out all of the stops and do really cool branding advertising they always default to their advertising agency of record. After all, the agency most likely developed the concept for the whole campaign and bought all of the media space and time, so it is only fitting that they implement the creative production. If the client was responsible for producing the creative product instead of the agency, then the client wouldn't have a clear path to blame the agency when things go horribly wrong. No matter how lame the concept or tragically misguided the media strategy, the agency could always blame the actual production. By putting the whole ball of wax in the agency's purview, they've got a ready scapegoat if and when the campaign fails and plunges the stockholders into despair.

The bottom line is that the agencies have big money riding on the success of their work and have an interest in hiring gifted people to bring the work to fruition. Since most of the work is for branding they have a license to be more creative than the work that's done in PR or brand management. This makes for juicy portfolio pieces, and that's why so many good photographers are knocking on agency art buyers' doors.

Here's the downside: Most agencies are notoriously slow at paying their bills—like 90 to 120 days

slow—and it's been that way for many years. The reasons are many. Some are just inefficient in their billing and will wait until all of a campaign is complete before billing their client. Their client is trying to hold onto the money for as long as possible to help their own cash flow. You are at the very bottom of the trickle down. (Not all agencies are bad, however. I work with several in my own town that pay like clockwork. But I've come across a large number over the years that like to hold on to their money.)

If you want to do business with these agencies, there are a few strategies that you should be using. The first is to get introduced to the unit business manager for the account you'll be working on. Having a name to reference is always good. Always ask for an advance to cover your out of pocket expenses like travel or subcontractors. Make prompt payment part of your negotiation tool kit. If the client wants you to lower your cost on some part of your bid, you might consider a cost reduction if they agree to prompt payment.

Go into agency jobs with your eyes open. Don't take on an assignment that plunges you into debt if you are counting on the agency's prompt payment. Sometimes the lure of a great job will overwhelm your accounting sensibility; that's okay as long as you've done the math and you can survive on your own funds until the agency gets around to paying you.

Let's look at the worst-case scenario: You've done a great job, you and the art director really hit it off, the work is in publication, it's been three months since you billed and no one in accounts payable will take your call. What do you do now?

First, let's lean on that great relationship with the art director. Ask the person you worked with to roll up their sleeves and help you navigate the corporate maze. Always adopt the attitude that the screw-up is really just a mistake and you are certain that everyone involved wants to do the right thing. The next step is to start moving up the ladder and finding out who is in charge of the accounts payable department. Send them a registered letter restating your agreement and letting them know that, according to your agreement

Top—*Kara was photographed for the cover of a book on photography. Using professional models and makeup people makes a huge difference in the quality of your final image. This portrait was lit with one light: a softbox from Kara's right.* **Bottom**—*Merlin Tuttle, founder of the Bat Conservancy. Mr. Tuttle is a leading expert on bats and the photography of bats. I photographed him for the cover of* Texas Life *magazine. A portable flash in a softbox provided the main light in this twilight exposure.*

(which states that no usage rights are transferred until the invoice is payed in full), they are now in violation of the federal copyright law. Keep it all friendly, but if there is no movement, it may be time for you to accept that you'll need outside help. If you have an attorney who can help you with your business this would be the time to enlist their help by having them send a "demand" letter.

Psychologically prepare yourself for the loss of at least some of your money. You are already losing the "opportunity" of your money as time ticks by, but now you will have to share part of your money (if you recover it) with whomever you enlist to help you recover it. At some point three things will happen: You will finally get a check in the mail (and resolve never to work for these people again!), you will get a notice from some legal group letting you know that their client (and your client) is insolvent, bankrupt, gone and that you have joined a long list of "unsecured creditors" who may or may not get even a tiny percentage of what they are owed after the secured creditors (the banks and the government) work over the carcass, or they may decide to string you along right up until the minute you're ready show up at the courthouse to bring suit and then hand you a check.

In my experience with big companies (especially those with cash flow problems), the squeaky wheel always gets the grease. If you never push for payment, you will always be at the back of the line. You may think the third option I discussed above is rare and cynical. No one would put their company's reputation in jeopardy over a payment to a creditor, right?—especially if they intended to pay the bill at the end.

Well, I was having trouble getting a number of my invoices paid by one of the biggest technology com-

panies in the world back in the late 1990s. As luck would have it, I got booked (against my own best advice) to photograph one more executive for this company. The exec they needed to have photographed just happened to be the CFO (the chief financial officer) for the entire corporation. When we finished up the shoot and we'd gotten some good shots in the can I figured I had nothing to lose, so I asked him point blank, "Why am I having such a hard time getting paid by your company?" Without missing a beat he smiled a malevolent little smile and replied, "My job is to keep your money in our accounts for as long as possible." Then he turned and walked off.

The next day I stopped everything I had in progress with that company. I had angry marketing people calling me left and right. They needed images of executives for conventions, prints of the CEO for press tours, and product photographs for press releases. I stuck to my guns and told them I could do nothing until all of my unpaid invoices were resolved. They trotted out a corporate credit card and took care of tens of thousands of dollars of invoices that day. I thought I'd never be invited back to work for them again, but they never blinked. From that day on I've asked for a credit card every time they call.

▶ You Set the Rules

To end this section I want to emphasize to you that your clients aren't in command of the relationship with you unless you let them assume control. You have a basic obligation to your own bottom line to understand how to best do business to ensure a long-term, steady stream of profitability. You can't do that if your clients' demands are unreasonable. You can't do that if you let your clients set rules that are destructive for your business.

As a one- or two-person shop you have to operate all the non–revenue generating aspects of business as efficiently as possible. It's inefficient to spend your precious time calling and writing to your clients to find out what's happening with a late payment. It siphons off time that should be spent marketing and shooting.

A very wise businessman once told me, "The key to success is not which clients you get but which clients you fire!"

At first I thought of covering this in the marketing section, but after writing so many things about the business side of things I thought it would make more sense here. I've written about some of the pitfalls of doing business with large corporations and advertising agencies and talked about some nightmare clients. Hopefully these kinds of situations will be rare. In my twenty years as a photographer I think I've only been totally stiffed six or seven times, and thankfully the dollar amounts weren't extreme.

Most clients are genuinely nice people who have upstanding ethics and want to work in an atmosphere of cooperation and collaboration. Many clients become lifelong friends. So, if you are lucky enough to have mostly great clients, don't spend all your time with the 10 percent who represent "squeaky wheels" —the demanding ones who make being a professional tiring and frustrating—instead, focus on continually thanking the good ones. Send a written thank-you note at the completion of every job or project. Send a thank-you note, fun print, or small gift every time someone gives you a nice recommendation. Send a note of thanks for better than prompt payment. Make sure the squeaky wheels are not the only ones who get their share of grease. Reward the ones who make your working life fun!

▶ Writing a Contract

A contract is a written agreement between buyer and seller that carefully spells out what is being created, how it will be used, what the costs will be, which party is responsible for what, how the product will be paid for, and when the payment is due. It covers stuff that *might* happen and how that stuff will be dealt with as well.

If you are looking for some good sample contracts, you should pick up a copy of the ASMP book, *Professional Business Practices in Photography*. I find it to be a very valuable resource when it comes to writing contracts, as it is very detailed and the concepts behind

the contracts have been put to the test over the years by some of the country's top photographers.

Every contract starts out by defining who the parties are and then moves on to defining the scope of the work to be done. The "who, what, when, where, and for how much" is the easy part. The hard part is making sure that you've included terms and conditions that protect your interests as well as those of your client.

Here's a list of things I think should be in your contracts. Be sure to run your paperwork by an attorney to make sure you have covered everything in accordance with your local laws.

- **Definition.** In this section you are describing the project in detail including who's going to be there and what steps will be taken for approvals.
- **Rights.** What usage rights does the client get and how long can they use the images? These two factors form the basis for usage fees. This section defines what the client will end up with, how it will be delivered, and how the client and photographer will protect each other's rights in regards to the use of the images.
- **Return and removal of images.** This section lays out the obligations of the client to actively observe the time limit stated in the contract for the use of the images and acknowledges the client's understanding that the images will be removed so that the photographer effectively regains unfettered use of the images in other venus. This is a vital step if you are planning to resell the images as stock.
- **Loss or damage.** This relates to actual film. In the old days it was vital to get original film back from clients if you were going to be able to safeguard it and relicense usage fees. Now most delivery is done electronically, and this part of a contract isn't as vital as it once was. If you are delivering actual film to a client, you'll need to agree on a value for each frame and outline who is responsible for loss or damage to the film.
- **Photo credits.** If you are working for magazines and other publications, your work should always be credited. Be sure your contract covers this. Why accept the lower rates that magazines pay if you don't get the exposure you've been promised?
- **Indemnification.** If someone sues your client over the ad, photo, or joint product of your photography and their design, who is ultimately held responsible?
- **Terms of payment.** Make sure you and your client know exactly what you'll be paid, when you'll be paid, and what remedies you will be able to pursue in the event of nonpayment.
- **Licensing usage rights.** Most friction occurs when photographers and clients misunderstand exactly what is being paid for. You must be clear about exactly what usage rights the client is buying and for what duration.
- **Acts of God.** There should always be a clause or section in your contract that deals with disruptions or inability to perform because of things like hurricanes, revolutions, and other little annoyances. Spell these out to your client. Decide in advance how you will handle these issues so that when they come up (and they will) you are ready.
- **Signatures and dates.**

If you are looking for an ironclad agreement form or contract, you can't do much better than the one given as an example in the ASMP book. The bottom line is this: the greater the amount of money and risk involved, the more detail you'll need in your contracts.

8. Financial Strategies for Running Your Business

Books about running a commercial photography business tend to focus on all the fun advice like which cameras to buy and how to pull in world-class clients, but they either ignore or presume basic financial intelligence! The bottom line in any business is that most failures are a result of three financial missteps that include undercapitalization, erratic or insufficient cash flow, and overwhelming debt burden.

▶ Undercapitalization

Running out of money is the biggest hurdle for photographers starting out. You have to be able to last long enough to build up a base of clients and start getting income. If you start a business with $10,000 in the bank and you rent a $2500 a month studio, buy the latest camera system with lenses for $5000, and a set of lights for $2500, you've rolled through all of your cash reserves before you've even opened the doors for business. If you don't immediately start booking clients and billing them, you've already failed. The money is gone, and the chances of going from 0 to 100 miles an hour in this business are about the same as winning the lottery.

If you are starting from scratch, you might just make it with a $50,000 operating fund for the first year, but I'm here to tell you that unless you have some very convincing and liquid collateral you certainly won't get that kind of money as a loan from any bank. Even if you did have the money saved up from a previous life—say as an computer programmer—you'd be better advised to keep that money in the bank and "bootstrap" your business.

Bootstrapping is the method of building your photography empire totally out of the cash flow that your business generates. This means starting with the equipment you already have in hand and only adding to inventory when you've done enough work to cover your expenses with some left over for future investment back into the business. Most prudent businesses finance their day-to-day operations from their cash flow—and the smaller the business, the more prudent this model is.

Borrow or rent expensive equipment for the rare jobs that can't be done with the equipment you have at hand. Stay with your existing career until you've built up a solid clientele. But make sure you've got money in the bank to pay your rent, buy food, and survive. No small business starts out with every piece of gear and resource they would like. The process of growing the business organically and socking away money for a rainy day is a bedrock of smart business practice.

▶ Clogged Cash Flow

This is a killer for businesses of every size. In order to do work, you have to spend money. Models and assistants must be paid. You've got to budget for advertising and regular business expenses. Everything comes to a screeching halt if you can't get paid. Some of the biggest names in the field have been there. They've produced $100,000 shoots with travel, models, hotel charges, and all the other pre- and postproduction expenses that come from putting together a shoot. And they paid for it out of their operating accounts confident that the check would come from the client before everything became due. But then the check didn't come until months later. Multiply that scenario by a factor of three or four and you can understand how the lack of cash coming in, even if it is owed to you, brings your business to a standstill. And once you've

got a reputation for not paying your bills the business falls off quickly.

No matter which part of the commercial photography business you are in, here are the rules for keeping the cash flowing: (1) Don't bite off more than you can afford to chew. Don't commit to a job that comes with a big price tag if you don't have the wherewithal to produce it. In the end you will destroy the job or the cost will destroy you. (2) Don't work for people who don't or can't pay their bills on time. If someone won't write you an advance check, they're not a serious client. (3) Don't spend all your hard-earned cash on new equipment and toys or extravagant expenses until you've fully funded your retirement account for the year and put aside enough ready savings to bankroll your business for one full year. Make sure that prompt payment, with substantial remedies, is part of every contract you write.

▶ More Debt than Assets

It feels so good until you need to stop. Debt is like heroin addiction, and the effects on your business can be just as bad. So many photographers luck into a big job or have a great quarter and think that the money will keep flowing in at the same rate in the future. So they go out and drop big money on the lighting system of their dreams or a state-of-the-art medium format camera system . . . and it feels so good when they are buying it. The problem is that most photographers don't have all the cash in their hands at any one time, so they put the big purchase on a credit card and have every intention to pay it off quickly. But one thing after another comes up, and pretty soon they've amassed tens of thousands of credit card debt. You don't worry about it as long as times are good. You think you've got it under control. And if the economy kept up the same rate of acceleration all the time you might be able to handle it.

But inevitably the economy takes a nose dive, you run into a big medical expense, something expensive breaks, and the cash goes to meet the most immediate need rather than toward servicing the debt. Soon you find that during the lean times you are in over your head and you can't meet all of your obligations. Maybe you miss a payment or two and suddenly find that the fine print on that credit card statement stuffer calls for you to pay 23.95 percent plus prime on your balance. Eventually that debt service will destroy your business because you'll lose so many opportunities and investments, and most of your profit will go just to pay interest.

Here are the rules to live by if you don't want to see your business crater from debt overload: (1) Even if you can convince yourself that a new piece of gear is vital to the business, you can't afford it unless you have the cash to pay for it. (2) Any out of pocket expenses for photo shoots must be covered by your client in the form of an advance. Don't incur model fees or assistant fees until you have someone else's money in your account to cover the expense. (3) Don't live beyond your means. That means bringing your lunch to work instead of heading to a nice restaurant, and making the stuff you have last until you can afford to buy more.

I've got a friend who is a camera junkie and he buys the latest Canon SLR every time one comes out. He's got the newest 21 megapixel body. It cost him $8000, and he put the expense on a credit card with a 14 percent interest rate. I've seen his work. He mainly does model head shots, and I think the work he did with his 6 megapixel camera is just as good.

I hope one day he gets out from under his debt load, but it seems like he is sinking faster than ever. Remember that people are paying you for your eye, your point of view, and what you know, not for how much bling you have hanging around your neck.

A Case Study. I wanted to add this to give you an idea of how a shoot gets started, produced, and finished up. I'm going to use an actual project that we did for Zachary Scott Theater and their ad agency, Clutch Creative, as an example, but we'll price it like a more conventional job instead of a job for a nonprofit organization.

Day One. I get a phone call from Jason, the agency's creative director, asking if I'd like to bid on a job. Could I come over and look at comps? (Com-

prehensive layouts: The blueprints for ad materials.)

We met and discussed the concept. We would have seven different talents, each of whom would represent one play that the theater would be putting on in the upcoming season. The creative team wanted to show two sides of every character, and they wanted to do it by having a half page of one mood overlaying a full page showing the talent in another mood. This meant that the talent would have to keep their hands and their bodies in the same position for each shot even though they would have to be photographed once, leave the set, change costumes, redo makeup, and then come back to do the second shot.

We figured that we would have two days to cast talent, one day of testing and preproduction, and one day of shooting. After the client chose the images they wanted to work with, my share of postproduction would be to do RAW conversions of the digital files and try to make perfect color and density matches for each pair of images. The agency would be responsible for retouching and dropping in different backgrounds.

I went back to the studio to figure out an estimate. I called the creative director with a tight estimate, and he gave me his approval over the phone. I prepared a standard contract and e-mailed it over to him for his signature.

Days Two and Three. The second and third day were spent casting the talent and working with the costume shop at the theater to make sure the costumes would fit and work well. While one art director and the theater staff took care of the costumes, the creative director, my assistant, and I worked in the studio to figure out a lighting design that would work for all seven image pairs. Next, we did some test shots and some combinations of images in Photoshop to prove the idea would work.

Day Four. The shooting day. We would have models arriving every hour to go into makeup and costuming. My assistant and I were in the studio at 6AM to pack all the stuff we'd need for the project—several Profoto strobe generators, several large softboxes, backgrounds, and plenty of camera gear. We arrived at the theater to set up a little before 8AM.

Setup was done and tested by 9AM, and we took a break for coffee as the first talent finished getting dressed and having makeup applied. We would shoot the entire day with the camera tethered to the computer so we could constantly check to make sure that bodies fit into the right boundaries and matched up to previous shots. I used a sheet of clear plastic over a laptop screen, and we were able to use a china marker to mark outlines. This kept us in the live areas that worked best.

A production assistant brought meals and snacks so we could work through the day with very little downtime. Talent came on strict schedules, and the artistic director and marketing director for the theater were both on the premises to give approvals when necessary.

The shoot went exactly as planned and we generated around 1400 images. Unlike still life, great expressions are the goal for a people shoot, and those are fleeting and elusive. I needed to shoot a lot of frames to get the ones I really wanted.

At the end of a very long day my assistant and I broke down the lights and hauled everything back to the studio. It was past 10PM when we had everything stowed away, but I sat down and downloaded every CompactFlash card to my main computer and then copied the resulting folder onto a second external hard drive.

Day Five. Back into the studio to do global color corrections to the files and then make web galleries for each talent's character. We put the web galleries on a disc and had a courier deliver them to the agency.

Day Six. The client selected variations for every actor, so it took the better part of the day to do color corrections, RAW conversions, and basic retouching.

This project was done for a local nonprofit organization, but if we pretend it was done for a global company that would use the resulting brochure internationally, here's how the cost would break down:

Advertising creative fee: $3000
International usage for two years: $5000
Two days of postproduction @ $1500 each: $3000

LOVE TRIANGLES HAVE SHARP EDGES

AIDA

April 21 - June 19, 2005
Music by Elton John, Lyrics by Tim Rice
Book by Linda Woolverton, Robert Falls and Henry Hwang
Suggested by The Opera

Elton John's follow-up to *The Lion King* is the story of a beloved, enchanting princess forced to trade her royal crown for a slave's kerchief. Verdi's classic tale re-imagined by Disney tells the star-crossed plight of Aida, a captured Nubian princess; Amneris, an Egyptian royal, and Radames, the brave soldier they both love. Already a hit on Broadway, this musical features fabulous Nile-inspired fashions from head to asp, and an exhilarating Tony® and Grammy® winning score that will have you rockin' like an Egyptian. There's intrigue among the pyramids for the whole family in this timeless story of endless love.

CHARGE SEASON TICKETS BY PHONE (512) 476-0541, EXT. 1

SOUL OF THE NILE

Starring Kia Fulton (*Crowns*) as Aida, ZACH's production of AIDA is no stuffy opera or ancient history lesson. The costume and scenic designs incorporate a contemporary, neo-soul, hip-hop vibe closer to Outkast and Beyoncé, than Marc Anthony and Cleopatra. Notable Austin-based fashion designers are being asked to contribute outrageous Egyptian-inspired couture for Amneris' Act One catwalk show, guaranteed to rival Elton's over-the-top Captain Fantastic concert days. I'm too sexy for my sphinx.

Already a hit on Broadway, this musical features fabulous Nile-inspired fashions from head to asp, and an exhilarating Tony® and Grammy® winning score that will have you rockin' like an Egyptian. There's intrigue among the pyramids for the whole family in this timeless story of endless love.

CHARGE SEASON TICKETS BY PHONE (512) 476-0541, EXT. 1

AMAZING GRACE

CROWNS

September 30 - November 14, 2004
By Regina Taylor
Directed by Dave Steakley

It's true what they say - the secret to heavenly bliss is all about possessing the right "hattitude." Based on the book *Crowns: Portraits of Black Women in Church Hats* by Michael Cunningham and Craig Marberry, *Crowns* is a jubilant celebration of survival, laughter and the uplifting power of a stylish chapeau. Sporting hats of extraordinary confectionary delights, this powerful circle of African-American women hold their heads high as they help each other through the losses and victories of life. You will thrill to this joyous new play with traditional gospel music, riveting storytelling and soaring hymns. "A powerful lesson in dignity and a soul-stirring, hip-swaying spectacle!" - *The Atlanta Journal-Constitution*

CHARGE SEASON TICKETS BY PHONE (512) 476-0541, EXT. 1

HEAVENLY VOICES

Starring some of the best gospel singers in Austin - Judy Arnold (*Beehive*), Jacqui Cross (*Dreamgirls*), Janis Stinson (*Smokey Joe's Café*), and Timothy Curry (*Gospel At Colonus*)—ZACH's production of *Crowns* will have you shouting "Hallelujah!" Master milliners Michael McDonald and Leslie Bonnell are creating over 40 custom hats for this production. The costumes and scenic designs are all white, so that the majestic array of hat colors will rise to heavenly heights. Please adorn your head with a hat of your own choosing when you attend the performance!

with traditional gospel music, riveting storytelling and soaring hymns. "A powerful lesson in dignity and a soul-stirring, hip-swaying spectacle!" - *The Atlanta Journal-Constitution*

CHARGE SEASON TICKETS BY PHONE (512) 476-0541, EXT. 1

I'M READY FOR MY CLOSE UP

BLOWN SIDEWAYS THROUGH LIFE

January 13 - March 6, 2005
By Claudia Shear
Directed by Dave Steakley

In this hilarious tour-de-résumé, Claudia Shear (playwright of ZACH's comedy hit *Dirty Blonde*) shows us what it's like to juggle multiple hats - often all at the same time. As the poster child for Austin's slacker culture, Shear eats her way through 100 minimum wage jobs, from artist's nude model and escort service receptionist to multiple waitressing and Wall Street proofreader gigs, all the while dreaming of becoming a great Shakespearean actress on the Great White Way. Barbara Chisholm (last seen in ZACH's *House Arrest*) stars in this hysterical true-life account of the underling's underling, giving us an insightful look at the inner lives of those who serve us and keep our dirty laundry under their hats.

CHARGE SEASON TICKETS BY PHONE (512) 476-0541, EXT. 1

MAXIMUM FUN MINIMUM WAGE

Comedic actress Barbara Chisholm is already known around Austin as a woman who wears multiple hats. You probably know her from her stellar performances in ZACH productions like *House Arrest*, *The Pavilion*, and *Abundance*. Or maybe you read her food and restaurant column reviews in the *Austin Chronicle*, where she is also the Community Listings Editor. Oh, and then there's the hat she wears as a mom and wife. Throughout the year she teaches drama classes for her daughter Rosalind's private school, and can usually be seen taking on one of the Bard's great roles alongside her husband Robert Faires. And twice a year you'll find her shakin' it like a Polaroid picture at the Continental Club's Elvis celebrations.

great Shakespearean actress on the Great White Way. Barbara Chisholm (last seen in ZACH's *House Arrest*) stars in this hysterical true-life account of the underling's underling, giving us an insightful look at the inner lives of those who serve us and keep our dirty laundry under their hats.

CHARGE SEASON TICKETS BY PHONE (512) 476-0541, EXT. 1

HAT'S A GOOD THING

OMNIUM-GATHERUM

September 16 - November 6, 2004
By Theresa Rebeck and Alexandra Gersten-Vassilaros
Directed by Dave Steakley

You don't just buy a chef's toque - you have to earn it. In this very funny and provocative new play, our perky, perfectionist hostess Suzie (who bears more than a passing resemblance to a famous convicted multimedia domestic diva) assembles her dream dinner party, and delivers a few hat tricks along the way. From the amuse bouche to the delectable assortment of miniature desserts, Suzi's guests (a blockbuster novelist, a feminist vegan, an African-American peacenik, an Arab political expert, a Cambridge educated journalist, and a NYC firefighter) engage in a non-stop volley of furious opinions and lively, contentious debate. *Omnium-Gatherum* is a hilarious place on the edge of reality and is the most entertaining play yet written to wrestle with the meaning of life after 9/11. (Audience talkbacks are conducted after every performance.)

CHARGE SEASON TICKETS BY PHONE (512) 476-0541, EXT. 1

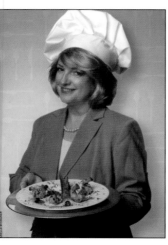

ENTERTAINING IS A REAL BATTLE

"The debates here are incredibly stimulating, because of the live-ness of theatre, and because they're presented by lively, smartly sketched characters. The cerebral distance disintegrates in a flash of primal emotion. The characters are forced to confront 9/11 again in a very immediate way. It's a visceral moment that wouldn't have the impact it does on a movie or television screen. Director Dave Steakley negotiates the show's radically different tones and sensitive subject with great skill, leading us from theatre that is captivating around a hairpin turn to theatre that is compelling." –*Austin Chronicle*

NYU firefighter) engage in a non-stop volley of furious opinions and lively, contentious debate. *Omnium-Gatherum* is a hilarious place on the edge of reality and is the most entertaining play yet written to wrestle with the meaning of life after 9/11. (Audience talkbacks are conducted after every performance.)

CHARGE SEASON TICKETS BY PHONE (512) 476-0541, EXT. 1

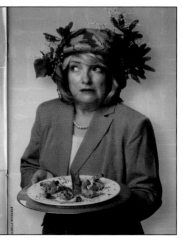

Three days of assistance: $600
One day production assistant: $150
Craft service for one extended day: $600
Two days of makeup artist: $1200
Equipment package rental: $600

Total for our services: $13,550
(This total doesn't include the hairstylists, talent, costuming, and props required, nor does it cover the cost of casting or the work done by the advertising agency.)

Some samples are shown on the facing page.

▶ Predictions

The market is changing rapidly and irreversibly. What worked ten years ago doesn't work now. Most of the barriers to entry have fallen. So what can you expect in the next five to ten years? First, your camera won't matter. I say this because everything is moving from print, which required high quality and high resolution, to the web and to HDTV monitors. The highest resolution in these media is around 2000 pixels. There is no need for more pixels, that picture information will just get thrown away. This will also tear down another barrier for people wanting to get into the market. You'll be able to do business with a point-and-shoot camera. And guess what? These media can take advantage of movement. If I were a client I would choose an ever changing, kinetic display over a single still frame every day.

Second, the recession of 2008 and 2009 has decimated most pricing structures. Getting back to livable pricing will take a lot of effort and may not be achievable in every market segment. This might mean that a career in photography is only practical if you can spread a very wide net. I see the future photographers offering multiple services including web site design, video content production, and writing, in addition to photography. There will still be niches for the very best in the industry to charge high rates, but the niches have grown smaller.

Finally, with the web we will see more and more competition from what we used to see as Third World nations. Buyers will be able to source images from everywhere. They already are.

How do you compete? Your marketing must be better and smarter than your competitors'. Your product must be more alluring and desirable. The market will no longer tolerate lousy service or personality defects. Your presentation and sales pitches must be honed to a new level, and you must be smarter in how you invest in your business and yourself. If you are used to doing projects the same way, over and over again, you may be setting yourself up for failure. The new strategy is constant education and constant renewal. Anything less is failure.

Epilogue

Photography is a tough business, but you can make it even tougher on yourself by coming into the industry with flawed assumptions. It is not inevitable that the market will collapse and fees will fall. Photographers worked through the Great Depression, and they will keep working as long as clients require images to sell their goods and services, and for as long as moms and dads want photographs of their families that make them look much better than the photos that they can take themselves.

There will always be someone who will work cheaper than everyone else, but you don't need to play their game. Your goal is to find the real value of the work to your client and charge accordingly. Your goal is to never charge only by the hour. Charge for what you know, not for what you do. Your goal is to continue to raise the quality of your product, your vision, and your service so that you can continue to raise your fees and make the kind of income you deserve.

You must come to grips with the reality that the gear, the cameras, the lights, and the carbon fiber tripods you use don't make nearly as much difference in the quality of your work as your ability to use these tools. If you want to be master of your craft, the only way to do it is to spend 10,000 hours practicing. A true master can pick up any current piece of equipment and make art. A beginner can hold the world's greatest camera in their hands and make nothing worth looking at. Once you free yourself from the "buying spiral," you'll be able to focus on the important aspects of photography which include—but are not limited to—rapport, impassioned seeing, and a determined and very individual point of view.

In a sense, professional photography is a cult of personality. Your work matters, but so do your personality and attitude. You could be a technical genius, but if you can't use empathy and insight to put a portrait subject at ease, you will fail. Your attitude is part of what you are selling.

You can approach this career in many ways, and the free market system allows you to make lots of mistakes. You can price yourself out of business at both ends of the spectrum. You can waste money you need on things you don't need. And as a self-employed person, your only safety net is your ability to learn quickly from your own mistakes.

Finally, you are only as good as you are smart, and you must understand that what made you smart last year might not work this year. To be successful, then, you must be committed to constantly evolving and learning, but at the same time being true to your own vision.

You alone will be responsible for your success or failure.

Good luck! It's wild out there.

Resources

▶ **Books**

There are several books which I believe every working photographer should own. They are filled with detailed and technical business information. What I presented in this book is a good start, but no one should expect to find all the secrets to running a six-figure-plus business in one thin volume. Here are the books that I find priceless. Some sections may prove to be a little dry, and I'm certainly not suggesting you should read them as you would a novel. Rather, they are reference books like dictionaries and should be approached as such.

Professional Business Practices in Photography (7th ed.) by ASMP. If you are looking for a model release example or contract sample that will keep you out of any court, this is your book.

The War of Art by Steven Pressfield. This is my favorite book for photographers because it is all about dealing with resistance to getting stuff done, breaking down creative blocks, and providing a philosophical framework for achieving your goals. There are no pictures, just lots of great thoughts.

Real World Color Management by Bruce Fraser, Chris Murphy, and Fred Bunting. If you are selling your photos to magazines, advertising agents, and other high-end users, correct color is a must for business success.

Matters of Light and Depth by Ross Lowell. This is the perfect book about lighting because it is not step by step. Rather than giving you a fish (i.e., lighting diagrams), Lowell teaches you to fish by teaching you the ideas behind good lighting.

Photography: Focus on Profit by Tom Zimberoff. Zimberoff does a great and encyclopedic job at explaining the nuts and bolts on a macro scale. The four hundred plus pages of information will prevent you from reinventing water and will flesh out the information we've touched upon here.

Photoshop Restoration and Retouching by Katrin Eismann. This is the best-written overview about general retouching concepts for photographers. It is mostly aimed at retouching portraits—and that's how it should be, since people comprise (by far) the highest percentage of subjects for paid photography.

Skin: The Complete Guide to Digitally Lighting, Photographing, and Retouching Faces and Bodies by Lee Varis. Wow. If you want to make more money photographing people, the knowledge you'll gain in this book will differentiate you from nonreaders by a considerable amount. And it is knowledge you'll need to compete at the top end of the business. The book includes many examples and much theory.

Best Business Practices for Photographers by John Harrington. This is similar to the Zimberoff book, but it's a slightly different take and several years more current. Harrington knows his subject well and is a fluid writer.

Pricing Photography: The Complete Guide to Assignment & Stock Prices by Michal Heron and David MacTavish. This is a pricing guide, and it's very useful as a starting point to estimating and bidding, giving low, average, and high prices for tons of photography categories. Though it was written in 2002, the economy hasn't experienced enough inflation to outdate the information. It's a valuable guide.

Numerous books covering various genres of photography are published by Amherst Media, and some of those titles are featured at the end of my book. All books are good. If you learn one good tip or technique, then the book is worth its cover price!

▶ *Magazines*

National Geographic. Take a look every month at photographs that were taken, and printed, at the highest level of quality on the market. Even if you just look at the way they get the ink on the paper, you will learn what it means to produce at a high level. And it's pretty interesting stuff.

Photo District News. This is the industry's trade publication in the truest sense. The magazine highlights trends, industry news, photographer profiles, esoteric equipment reviews, and more. The publication is geared toward a market that does international photo assignments for the world's biggest ad agencies and magazines, but it's a good read for the rest of us as well.

▶ *Web Sites*

www.luminous-landscape.com. This is where real pros congregate to inform and argue with each other about things like the latest medium format digital cameras and backs. It's a high-end gathering of the folks in our markets who can drop $40,000 on a single camera. Owner Michael Reichmann is opinionated but generally right.

theonlinephotographer.com. Michael Johnston's been writing about photography for decades, and he's always good at tweaking your mind and making you see a few things differently. He is more concerned with the image or the argument and less concerned with the gimmick or the gadget.

▶ *Best Non-Chain Camera Store in America*
Precision Camera and Video in Austin, TX

www.precision-camera.com, (512) 467-7676
Knowledgeable staff, good inventory, and a lot of staying power. The perfect place to have your expectations exceeded.

Index

A

Accent lights, 61
Accounting, 100
Ad Club, 86
Adobe Photoshop, 29
Advertising photography, 10, 20, 32–33, 47–51
American Society of Media Photographers, 17, 71–72, 97, 111, 116
Annual reports, 56, 79
Apprenticeship, 47, 60; *see also* Assistants, photographer's
Architectural photography, 23–27, 53
Art buyers, 86
Art directors, 33, 86
Assignment fee, 105
Assistants, photographer's, 26, 32, 60–71; *see also* Apprenticeship
Associations, professional, 17, 40, 47, 71–72, 86–88, 97, 111, 116

B

Backgrounds, 27, 39, 53, 119
Background lights, 61
Bardagji, Paul, 24–25
Beauty dishes, 35
Best practices, 17
Bid modification forms, 18
Bids, 85, 109–13
Black & white photos, 7–8
Blogs, 12, 13, 76
Books, image, 83–84

Books, instructional, 89, 123
Brady, Mathew, 6–7
Branding, 74–75, 92
Business name, 99
Business entities, types of, 99–100
Businesses as clients, 38

C

Cameras, 24, 26–27, 29, 39
Capitalization, insufficient, 117
Change orders, 18
Chef, 33
Civil War photos, 6–7
Contact printing, 7
Contracts, 17–18, 38, 58, 115–16
Copyright, 16, 20–22, 38
Corbis, 10
Corporate photography, 51–55
Craft service, 49
Creation fee, 105
Credit, photo, 116

D

Daguerrotypes, 6
Day rate, 14, 108–9
Debt, 118–21
Direct mail, 81–83
Dollar stock, 57–58
Dress code, 53, 55, 61, 85

E

Editoral photographers, 8, 30–32, 72
E-mail, 78–80

Employees, 69–70
Equipment, 7, 23, 24, 26, 27, 29–30, 37, 39–41, 49–51, 55, 57, 67, 122
Estimates, 109–13
Ethics, 94–97
Event photography, 23, 53–54
Existing light, 26, 38

F

Fashion photography, 23, 33–37
Film, 7, 37, 57
First assistant, 32
Flash, 9, 14, 29, 31, 32, 39–40, 50, 55, 63, 67, 68, 69, 70, 77, 107, 110, 114
Flash meters, 70
Flat fee, 14, 108–9
Food photography, 12, 16, 30–33
Fong, Hanson, 15
Freelance work, 113–15
FunTak, 30–31

G

Gatherings, 89
Gallery shows, 88
Getty, 10
Gridspots, 27, 35

H

Hair lights, 61
Hairstylists, 35, 47, 49
Halftone prints, 7
Headshots, 53

I

Industrial photography, 90
Insurance, 102–4
 auto, 104
 disability, 104
 general business, 103–4
 life, 104
Internet, 9, 38, 77–78
IRS, 100–102
ISO, 38, 39

J

Jewelry, 28
Jobs on the set, 32, 33, 35, 37, 38, 47, 48–49
 art director, 33
 chef, 33
 craft service, 49
 first assistant, 32
 hairstylist, 35, 37, 49
 makeup artist, 35, 47
 nurseryman, 49
 producer, 49
 production assistant, 35
 rep, 49
 set builder, 49
 set stylist, 32, 33, 47
 wardrobe stylist, 37

L

Lenses, 12, 23, 24, 26, 27, 29, 30, 38, 39, 49, 50, 55, 98, 117
 fast, 31, 38, 39
 macro, 29, 32, 55
 shift, 26, 27
 tilt–shift, 23, 24, 27
 zoom, 29, 38, 39
Lighting, 9, 14, 24, 26, 27, 29, 35, 36, 38, 39–40, 50, 55, 61, 63, 67, 68, 69, 70, 77, 107, 110, 114
 accent lights, 61

(Lighting, con't)

 background lights, 61
 beauty dishes, 35
 existing light, 26, 38
 hair lights, 61
 flashes, 9, 14, 29, 31, 32, 39–40, 50, 55, 63, 67, 68, 69, 70, 77, 107, 110, 114
 gridspots, 27, 35
 ring lighting, 36
 softboxes, 24, 27, 29, 40, 50, 55, 66, 119
 spotlights, 24
 striplights, 27
 strobes, 29, 30, 63, 103, 119

M

Macrophotography, 28, 29, 32, 55
Magazines, 7, 9, 20, 23, 26, 30, 31, 33, 34, 37, 38, 85, 88, 89, 94, 111, 116, 124
Mailing lists, 85
Makeup artists, 35, 47
Manna, Lou, 29–30
Marketing, 41, 73–93
 articles, 88–89
 books, image, 83–84
 books, instructional, 89
 branding, 74–75, 92
 designing materials, 91
 direct mail, 81–83
 e-mail, 78
 gallery shows, 88
 gatherings, 89
 Internet, 76–81
 lunches, 90–91
 mailing lists, 85
 magazines, 88
 mass marketing, 75–76
 meetings, 85–86

(Marketing, con't)

 newsletters, 80–81, 82–83
 postcards, 81–83
 press releases, 88
 sourcebooks, 83–84
 targeted marketing, 76
McSpadden, Wyatt, 64–65, 66–67
Meals, 90–91
Meetings, client, 85–86
Meters, 8, 68, 70
Middle key, 31
Model releases, 8–9, 36

N

Newsletters, 80–81, 82–83
Newspapers, 21, 84
Niche, 55
Nondisclosure agreements, 70, 97
Nurserymen, 49

P

Payment, collecting, 112–13
Photo Reflect, 16
Pictage, 16
Portrait photography, 41–47
Posing, 36, 38
Postcards, 81–83
Portfolios, 10, 26, 49, 50, 60, 68, 75, 76, 77, 78, 82, 84, 85, 91, 93
Press releases, 88
Pricing your work, 14–17, 41, 47, 56, 67–68, 94–96, 105–16, 122
 assignment fee, 105
 creation fee, 105
 day rate, 14, 108–9
 flat fee, 14, 108–9
 usage fee, 105
Printing, 7
Producers, 49
Production assistants, 35

Production costs, 58
Product photography, 23, 27–33, 53
Professional Photographers of America, 40, 47, 72, 97, 111
Promotions, 79
Property releases, 18–20, 27

R
Referrals, 78
Reggie, Denis, 15
Rep, 49
Retail photography, 38
Retouching, 28
Ring lighting, 36
Royalty-free stock, 9

S
Set builders, 49
Set stylists, 26, 30, 32, 33, 47
Shift lenses, 24
Smugmug, 16

Softboxes, 24, 27, 29, 40, 50, 55, 66, 119
Software, 29, 49, 107
Sourcebooks, 83–84
Specializing, 55
Spotlights, 24
Still life photography, 23, 27–33
Stock photography, 9, 10, 17, 56–58, 72
Striplights, 27
Strobes, 29, 30, 63, 103, 119
Studio, 27, 29
Stylists, set, 26, 30, 32, 33, 47

T
Targeted marketing, 76
Taxes, 97
Tilt–shift lenses, 23, 24, 27

U
Undercapitalization, 117
Usage fee, 105

Usage rights, 14–16, 116

V
Van Overbeek, Will, 44–45, 66
Vision, artistic, 67

W
Wardrobe stylists, 37
Web sites, 16, 55, 76–78, 124
Wedding photography, 11, 12, 14–15, 16, 22, 38–41, 55, 56, 61, 72, 74, 104, 107
Work-for-hire agreements, 16–17, 23
Workflow, 41, 72
Working kit, 70

Z
Zoom lenses, 29, 38, 39